MAKING PEOPLE DISAPPEAR

An Amazing Chronicle of Photographic Deception

ALAIN JAUBERT

PERGAMON-BRASSEY'S
International Defense Publishers, Inc.

Washington • New York • London • Oxford
Beijing • Frankfurt • São Paulo • Sydney • Tokyo • Toronto

Original title of the French edition—*Le commissariat aux archives:*
Les photos qui falsifient l'histoire

Copyright © 1986 Editions Bernard Barrault, 79, avenue Denfert-Rochereau, 75014 Paris

English-language edition © 1989 Pergamon-Brassey's International Defense Publishers, Inc.
Translated by International Translation Center, Inc.

Permamon-Brassey's books are available at special discounts for bulk purchases
for sales promotions, premiums, fund-raising, or educational use through the

 Special Sales Director,
 Macmillan Publishing Company,
 866 Third Avenue, New York, N.Y. 10022.

EDITORIAL OFFICES

Pergamon-Brassey's International Defense Publishers, Inc.
8000 Westpark Drive, Fourth Floor
McLean, Virginia 22102

27.95 PB

Library of Congress Cataloging-in-Publication Data

Jaubert, Alain.
 [Commissariat aux archives. English]
 Making people disappear : an amazing chronicle of photographic
deception / Alain Jaubert.
 p. cm.—(Intelligence & national security library)
 Translation of: Le commissariat aux archives.
 Bibliography: p.
 ISBN 0-08-037430-1 : $25.95
 1. History, Modern—20th century—Errors, inventions, etc.
2. Deception—History—20th century. 3. Photography, Documentary—
History—20th century. 4. Photography in publicity—History—20th
century. I. Title. II. Series.
D426.J3813 1989
909.82'022'2—dc20 89-8458
 CIP

British Library Cataloguing in Publication Data

Jaubert, Alain
 Making people disappear : an amazing chronicle of
 photographic deception.—(Pergamon—Brassey's
 intelligence and national security library)
 1. Photography. illusionism
 I. Title
 778.8

 ISBN 0-08-037430-1

10 9 8 7 6 5 4 3 2 1

Printed in the United States of America

Contents

Preface

The literature on intelligence, security, and statecraft is voluminous and continues to grow. Sifting the wheat from the chaff, however, is not easy. The *Intelligence and National Security series* is intended to make available important studies and firsthand accounts by Western and non-Western intelligence practitioners, scholars, and others who have amassed interesting information and analysis. Individual titles have been reviewed by an Editorial Advisory Board of scholars and former senior intelligence officials from Western Europe and North America. Though every volume stands on its own merit, the series as a whole is intended to improve our understanding of intelligence and its relationship to security.

This volume was originally published in France in 1986. Its author, Alain Jaubert, is a writer and filmmaker. He has brought together an extraordinary collection of photographs that have been doctored or falsified to achieve political effects at various times in the twentieth century. Although deception, propaganda, and disinformation recognize no borders, Jaubert points out that the systematic faking or falsification of history are encountered "anywhere a serious effort is made to copy the methods of totalitarian propaganda characterized by its three major styles: Fascist, Nazi, and Communist. . . ." The falsification of photographs comes easily to those governments and elites that seek to be the sole interpreters of history and have a monopoly on the information media. Jaubert suggests that, with the exception of wartime, it is unlikely that democratic governments would engage in systematic falsification even if they wanted to.

<div align="right">

Dr. Roy Godson
General Editor

</div>

Acknowledgments

I would like to take this opportunity to thank everyone who told me their story, sent documents or information, provided translation assistance, or tracked down forgotten pictures: Martine Aflalo, Jean-Michel Arnold, Francisco Arrabal, Bernard Barrault, Karel Bartosek, Pierre Boncenne, Michel Broué, Pierre Broué, Bernard Cap, Geneviève Chemin, Jean Chesneaux, Claude Clément, Jean-Pierre Cliquet, Jean-Louis Cohen, Jean-Noël Darde, René Dazy, Marielle Delorme, Corinne Deloy, Anne Demazure, Francis Déron, Milovan Djilas, Jean-Marie Doublet, Sonia Drean, Patrice Fava, Carlos Franqui, Alain Gesgon, Pierre Golendorf, Réal Jantzen, Françoise Jaubert, Karel Kaplan, David King, Claude Klotz, Pierre Langlade, Renata Leznick, Silvia Longhi, Giulio Macchi, Pauline de Margerie, Chris Marker, Betty Mialet, Carlos Alberto Montaner, Christine Mordret, Jean Moreau, Louisette Neil, Paul Neuburg, Carla Nicolini, Michel Patenaude, Georges Peltier, Roger Pic, Robert Pledge, Philippe Pons, Romano Prada, François Puyplat, Ariel Remos, Nadia Ringart, Philippe Robrieux, Francis Rumpf, Myriam Sicouri-Ross, David Smiley, Anne-Lise Stern, Ross Terrill, Pavel Tigrid, Armadno Valladares, Juan Vivès, Pierre Wiazemski.

To this list must be added the magazine, *Index of Censorship* (London); the magazine, *Svedectvi*, Paris; the production and records departments of the National Institute of Audiovisual Communications (INA); and the following libraries: Centre de Documentation juive contemporaine (Paris), Bibliothèque nationale (Paris and Versailles), Bibliothèque de Documentation internationale contemporaine (Nanterre), Library of Congress (Washington). Much of the photographic work was done by Yuri Pashkov, who also discovered a number of unpublished documents.

Finally, I would like to thank all those whom I cannot name here: journalists, librarians, and photographers living in totalitarian countries who took considerable risks by receiving me and sending me pictures and documents hidden in the archives.

Introduction

And this hall, with its fifty workers or thereabouts, was only one sub-section, a single cell, as it were, in the huge complexity of the Records Department. Beyond, above, below, were other swarms of workers engaged in an unimaginable multitude of jobs. There were the huge printing shops with their sub-editors, their typography experts, and their elaborately equipped studios for the faking of photographs. There was the teleprograms section with its engineers, its producers, and its teams of actors specially chosen for their skill in imitating voices. There were armies of reference clerks whose job was simply to draw up lists of books and periodicals which were due for recall. There were the vast repositories where the corrected documents were stored, and the hidden furnaces where the original copies were destroyed. And somehow or other, quite anonymous, were the directing brains who coordinated the whole effort and laid down the lines of policy which made it necessary that this fragment of the past should be preserved, that one falsified, and the other rubbed out of existence.

George Orwell, *1984*

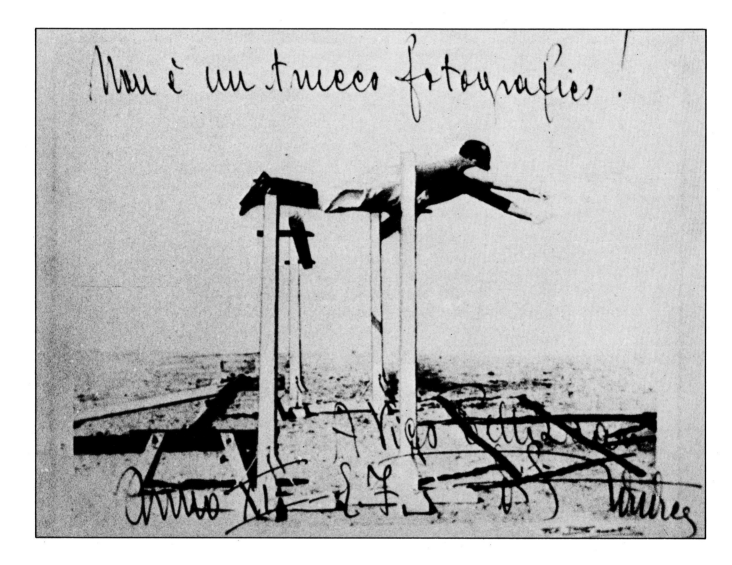

Handwritten by Mussolini on a photograph: "This is not a trick photograph!" From Storia fotografica del fascismo *by Renzo De Felice and Luigi Gola, Editori Laterza, 1981.*

It may be that everything—or nearly everything—has been said about the Auschwitz–Kolyma axis. Dictatorship, leader worship, the systematic extermination of enemies, concentration camps, the absolute power of secret services, political police, obsessive propaganda, terror. Plus disinformation, the rewriting of history, the effects of censorship, the mutilation of memory—all of these topics have interested historians, however belatedly. The role of pictures in the machinery of tyranny has scarcely been examined.

In the smooth, flat, glossy field of a photograph, in its fixed rectangular frame, without exterior, without appeal, there is something oddly disturbing, perhaps infinitely tragic. You are given a picture to look at. For the moment, it matters little what it is supposed to represent. There it is—final, cold, compelling. Since we have been told repeatedly for 150 years that the camera "reproduces reality," there can be no question. We see hundreds of photographic images every day and they are as real to us as clouds. And yet, there is the same evanescence, the same intrinsic ambiguity, the same doubt inherent in the flat image: volume reduced to area, the perspective overlapping of volumes, colors reduced to shades of gray (or else transmuted into other chromatic systems). It is all a trick. . . .

The first photographers, unsuccessful painters, soon discovered the advantage to be gained from the innate shortcomings of the new invention. Attempting to correct flaws in their photographs—specks of dust, gelatin flakes, broken glass plates—they found that a paintbrush and some paint worked wonders. Little by little, the skillful artist touched up a face, erasing wrinkles and pimples, and then, on demand, drove the scandalous uncle or bastard usurper from the family portrait. Photographers moved on to other tricks. Garibaldi's entry into Rome ahead of time, the Commune hostages shot "before the photographers' eyes," the "complicities" of the Dreyfus affair, the Kaiser preparing to invade France, the end of Roger Casement, and the false victories of the First World War all inspired famous montages. However shocking or amusing they may be, these fakes represent only the first faltering steps of modern propaganda. They were produced by uncertain groups or powers, tempered by the comment or criticism of political adversaries more or less at liberty to express themselves, depending on the state of democracy.

9

The phallic streetlamp hanging from Lenin's abdomen, which the retoucher dutifully consigned to obscurity, and the fake picture of the storming of the Winter Palace, circulated as authentic in late 1920, are in an altogether different category. Pictures are no longer released and distributed by independent photographers or by several different agencies: they all come from a single source. They are a manifestation of the totalitarian power that confiscates them for its own purposes, files them away, categorizes them, and distributes them as representative of its truth. No analysis, criticism, or doubt is possible since it is the same organization that controls the distribution of pictures and, at the same time, reinterprets, rewrites, censors, and authorizes (or bans) all newspapers. In the Soviet Union this organization has been given the innocuous name, *Glavlit*, short for *Glavnoe upravlenie po delam literatury i izdatelstv* (Central Administration for Literary and Publishing Affairs). Perfected over the course of thirty years (and directly inspired by the truly stupefying methods of Joseph Goebbels' Ministry of Propaganda and Information), the system has spread to each satellite country. And the model, which also inspired China and Albania, was exported intact to Cuba.

Retouching

There is a basic category of very simple retouching that could be termed routine. Care is constantly taken to erase the *faux pas* and the small, involuntary absurdities that inevitably accompany the public life of important figures, as well as the false impressions and illusions created by the chance occurrences of a scene frozen in a photograph. Newsphotos can never be fitted into the calm sphere of a well-ordered universe. There is always something strange, extraneous, incongruous in the frame that throws the entire composition into the banality of everyday existence: baggy old clothes, someone not in the right place, an object that perspective causes to appear on top of another, the slight distortion that is an unavoidable feature of photography. The subject will therefore be made to float in a neutral, largely empty universe where nothing offensive or ambiguous will detract from the majesty of the despot.

Similarly, portraits of the whole generation of political figures in power in Moscow and Beijing and born at the beginning of the century are released each year with smooth faces and strong profiles, brimming with the false robustness of a prime long since passed. These photographs, acceptable by Soviet standards, seem bizarre to us. Nothing is ever in sharp focus: not the eyes, not the skin of the cheeks, not the nose, not the texture of the clothing. Of course the features are correct, and each portrait has its own personality and is immediately recognizable. But all of the identifying details are lost in a slight haze that clouds perception, as in a dream. Shadows are barely perceptible. The skin never has any texture; it is always satiny. A deliberate throwback to the "artistic softness" and "glamor" of Hollywood portraits of the 1930s, the antithesis of the brutal neorealist clarity of the postwar years. The official photograph renders the viewer astigmatic. Figures float in a uniform, featureless background, a sort of pearl-gray twilight void, a color somewhere between day and night. Dr. Bogomoletz's invention lasted only a while: the secret of youth is not the "biostimulins" of the Kiev Faculty, nor Olga Lepeshinskaya's sodium baths, nor all of those mysterious elements of cell regeneration discovered under Uncle Joe's tender gaze and which change our skin at will, but merely the retoucher's brush and paint. To become an icon, a portrait must slip behind this thin, dream-like veil and rise into the dizzying, neutral gray sky of eternal youthfulness.

Blocking

Routine retouching sometimes required that one or two individuals be removed or separated from the actual setting and its banal details. A few discreet brushstrokes cleared the hero's immediate surroundings. But blocking can also be extensive, erasing a huge area around the figure, causing it to float in a new, magical space. It is possible to erase some or all of the background and secondary figures and thus to establish a special relationship between one person and another. The function of blocking is not confined to routine, occasionally vaudevillian retouching (ugly wives to be hidden, mistresses to be concealed or, rather, to be shown off, as in the case of Clara Petacci beside Mussolini). It generally has a much more serious role. It is linked directly to the sacred face of power. The tyrant is untouchable, unapproachable. He cannot be sullied by the proximity of ordinary objects or secondary figures. Blocking is the glaze that reinforces the religious isolation of the hero, the halo of emptiness around the unique, the ring of light around the sacred body.

Cutouts

It is sometimes necessary to bring together two individuals far removed from one another or in two different photographs, or even to place a large number of people side by side within a single frame to create a historic scene. As in the games played by poor children, a paper figure is cut out, removed from its original setting, and placed in a new one. The result can be the same as that of simple blocking, but the end result is fundamentally different. With blocking there is no change in the relationship between the individual and his support, even when the free surfaces of that support are almost completely painted over. With a cutout, the subject is completely liberated. The final product must be considered as the combining of at least two photographs, and often of several. Here we enter the infinite realm of photomontage, and we are all familiar with the popularity of the genre and the use made of it in political propaganda.

There are no standards for a faked photograph masquerading as authentic in a photomontage created to convey a political message. Most of the time, a photomontage is recognizable as such. The proportions, relationships, shadows, variations of grain or texture, the mixing of genres (photograph, drawing, painting, caricature, etc.), the juxtaposition of dissimilar or anachronistic objects or individuals, the improbability of situations—all reveal the photomontage. The function of a photograph put together to create a false but believable scene is another matter. The edges of the cutouts must not be visible; the proportions and perspectives must be properly adjusted; the direction of the light, the shadows, the whites and the blacks of the various parts must be equivalent; gestures and focuses of attention must coincide. A coherent scene is often difficult to achieve without a great deal of pasting, adjusting, and retouching. It is no longer the "artistic" work that counts, as in photomontage where the goal is to surprise or even astonish by juxtaposing foreign (disparate) elements, the whole of which creates a new sense, a higher truth revealed by dissimilar truths. What counts now is the painstaking, anonymous work of the skilled craftsman: the object is not to astonish, but rather to avoid surprise entirely, to camouflage, to make the world even more coherent, more banal, to erase differences. A faked photograph is not really made to be looked at: if viewed too closely, the fragile web of falsehood tears apart. It is made to be seen in passing, among other ordinary photographs.

Recentering

Recentering is the simplest way to erase. After all, no one is obligated to publish a whole photograph. And of all artistic expressions, the photographer's is the most arbitrary. A window is cut into reality. Certain people are within the frame, others are not. Already it seems like censorship, which we may find intolerable. The censorship of reality, which is never shown in its entirety. A censorship imposed on the photographer's expansionist subjectivity. But that is the law of photography. Everyone submits to it, more or less willingly. Except for inventing devices, cutouts, montages to modify the temporal and spatial parameters of photography. Then there are the accidents or constraints of printing, formatting, and reproduction. The photograph almost always loses in this process. And it never gains anything in return. Each photograph published, republished, cut, re-cut, analyzed in the press, in books, in the records office can be imagined as existing with its successive layers of recentering, like the skin of an onion. Perhaps millions of photographs—even without any retouching at all—are already, in and of themselves, fake photographs, because the frame that the photographer is compelled to choose conceals more than it reveals. And when all is said and done, the work of the most disreputable retoucher will ever be modest compared to that common piece of trickery that photography has been since its invention.

The picture is a familiar one. It appears in every book on the Russian Revolution and in many other works; all alone it symbolizes the life and work of Lenin. The speaker is standing on a platform of boards. His body leans to the right, his face is contorted, his mouth open. He is addressing a crowd. With his left hand, he holds onto the edge of the platform. He holds his cap against the same edge with his right hand.

The original photograph, no doubt widely circulated at the time, has survived. Its frame is horizontal. The narrow stairway on the right side of the platform is visible. On the steps, lower down, are Kamenev and Trotsky, waiting their turn to speak. No Russian has seen all of this photograph since 1930. Lenin the orator and the face of Ché Guevara are the results of recentering and tremendous enlargement. From realistic image to myth. . . .

Effacement

Recentering concerns borders, margins. Sometimes, completely removing a person is not enough. It may be necessary, for example, to eliminate a central figure while preserving the rest of the historic scene. The picture must then be cut, a slit must be made, a sort of umbilicus into which part of the photograph will disappear, causing the unwanted individual to vanish into the void thus created. It will then be a simple matter of joining the two edges. This is what happened in 1968 to a photograph from which Alexander Dubcek was erased by moving a house closer to the porch of the Saint Vitus Church in Prague, Dubcek's disappearance causing only slight discrepancies in the picture's perspectives.

But these simple topological features—the cut, the slit, the fold, the umbilicus—are not always so easily accomplished. To efface someone, to make him invisible, the background or another person must take his place. Black and white paint must be made to imitate shades, textures, and shapes to gradually cover up the persons being effaced and to contribute to the overall balance of the new composition. In another version of Lenin on the platform, Trotsky has melted into the boards of the stairway. Elsewhere, Bo Gu (Po Ku) has dissolved into a Chinese window.

Trotsky's elimination set an example for the rest of the world and has inspired Czech, Hungarian, Yugoslavian, and Cuban retouchers. Ghosts now fade into walls, doors, draperies, fences, mirrors, rugs, and tapestries. Retouching has become an esthetic of evaporation. Exalted brushstrokes that consign rivals, the arrogant, and the ambitious to the eternal dust of scenes frozen forever.

In the final analysis, the masterpieces of this art will be those that combine all of these techniques. Through the seasons, over the years, pictures are reproduced, corrected, touched up. To the point that, in some cases, no one knows anymore just who was eliminated or why. Generations pass, names and faces are forgotten, but faked pictures outlive their creators. Absolute control over the body, which is the hallmark of tyranny, is thus reflected exactly in the world of pictures. To eliminate, to liquidate, to cause the physical body and the name of rivals or opponents to disappear, all of these operations are reflected in the cutting out, the removal, the recentering, the painting, and the effacement of paper figures.

An arrogant power is not always interested in concealing its falsifications. Perfectly faked photographs do exist. But sometimes it is the very act of elimination that enlightens. The Chinese often use effacement to emphasize an absence, thus appropriating for base political purposes the classic pictorial tradition of space and solid, light and dark. Wang Yu: "To achieve a special effect you have to work with the ink so that where the paintbrush stops, something else suddenly emerges." For example, in the series of photographs published a few days after Mao's death and the denunciation of the "Gang of Four," no effort was made to close the row of officials. The paint used to dissolve the four figures into the background leaves their places empty, gaping, unmistakably denoting effacement. A blank space appears in the usual row of solid figures. A way of legitimizing the new regime, of reinforcing its truth and its arrogance: "See how we have liquidated them! See how we are capable of eliminating you!"

The same is true in Albanian museums where there are gaping holes in group photographs. To emphasize the elimination of certain individuals their feet are sometimes left in the picture. Better yet is the singular practice of leaving the individuals but painting masks on them with India ink or gray or yellow mastic, or even making an eye-catching scrawl. In Cuba, Fidel Castro's "bourgeois" sisters, who are either very lukewarm in their support or have left the country, were furiously banished from the family album by their Big Brother.

In Dubcek's case, the provocative nature of the faking is due essentially to what is visible in the left half of the photograph: a crowd of men and children with cameras and photographic equipment. Presumably, the scene was recorded dozens, even hundreds of times that day. And yet, despite the overwhelming evidence that many people may still have in their possession, not even a subtle attempt is made in the new picture published by the regime to suggest that Dubcek was not there. Perhaps, on the contrary, it is the very elimination, the sinister creaking of the scenery as it closes over the subject, the vertigo of the trapdoor, the glacial cold of the flats, the terror of prison slaughterhouses that it is intended to show.

And yet, whether they are executed/erased or whether they survive erasure, all of these political figures are nothing but colorless extras in an opera of much grander scale than even Wagner could have imagined. Falsification is extended to books, newspapers, films, paintings, monuments, historic scenes, and giant construction projects involving millions of slaves under the pretext of forging the new man. But we now know what was behind the backdrop: penal servitude, camps, torture, massacres. Never have icons served so voracious a religion, never have images proved so fatal. Solzhenitsyn reports that when hundreds of police

vans were streaking through Moscow, carting thousands of future "zeks" to Gulag prisons and camps, someone had the brilliant idea of painting them with the words "Bread" or "Meat" and even advertisements for Soviet champagne. A Jew forced by the Nazis to exhume and burn the 90,000 people executed in Vilna told Claude Lanzman in *Shoah*: "Anyone who said 'dead' or 'victim' was beaten. The Germans made us refer to the bodies as *Figuren*, that is . . . marionnettes, dolls, or *Schmattes*, which means rags." Bread, meat, champagne, dolls . . . the petty officials of the satellite *Glavlits* are still not done cutting out, painting, and burning their delicate little *Figuren*. . . .

And what about Orwell? Yes, Orwell was right. Not entirely, though. He forgot about the insanity, the fetishism, and the ultimately reassuring weakness of the system. Hidden furnaces burning the real issues of the *Times*? Perhaps, but in any case, who still believes what *Pravda* says? And in the museums, who really believes what they see there? "Lenin's fake identity card," issues of *Pravda* without Trotsky—are they real or fake? All it took was the barest hint of springtime democracy in Czechoslovakia for faked photos of Czech history to appear immediately *with* their original versions. So, someone kept them! Someone was afraid to destroy them! The terror of photographic evidence triumphed over corporal terror. But those who were hanged, gassed, and shot have no need of our photographic philosophies.

Stalin with his boots on, snoring on a sofa in his *isba*, has nothing beside him but a small piece of furniture containing the papers confiscated from Trotsky. Like those who eat the brains of their enemies, he believed that he could absorb the intelligence of his hated rival. In all probability, those papers are now in the vaults of the Institute of Marxism-Leninism. Like the photos of Trotsky. Like the secret Gulag statistics. And like the records seized by the Red Army at . . . Auschwitz, yes. What historians dream of today is not the library in Alexandria, nor that of the Vatican, but the Great Moscow Library. Auschwitz, Gulag—there is no difference. . . .

And then, after distributing alternate versions of the same photograph, retouchers get their brushes in a muddle and publish books containing different versions from one chapter to another. In Yan'an, Mao's retreat after the Long March, the curator of the museum is upset. Mao's popularity has waned, and his white horse has been eaten up by mites, despite glass and moth balls. In a country where monuments last a thousand years and more, his museum will not have lasted thirty years. The curator is sad. He has several sets of photos and does not know which to hang up. He has seen Lui Shaoqi (Liu Shao-ch'i) with his pitted nose, the fat Peng Zhen (P'eng Chen), and even that joker Lin Biao (Lin Piao) reappear in Beijing magazines. But he has received no instructions. He hesitates, the poor curator, forgotten in the march of the empire. He never imagined that little paper dolls could be so restive.

The Legendary Life of Lenin

Prior to the October Revolution, few photographs of Lenin had appeared in the Russian press. During the revolutionary period, photos published in the few illustrated newspapers sometimes show Lenin, but always with other Bolsheviks.

About 1920, Communist Party propagandists begin using Lenin's picture: giant portraits hung on the façades of buildings during meetings, in postcards or pictures intended to replace traditional religious icons, photographic essays in *Pravda* or other newspapers. Although it sometimes annoyed Lenin, he nevertheless allowed a "cult of personality" to develop.

After his death in 1924, the pictures multiply. In March 1931, the Institute of Marxism-Leninism reverently collects everything Lenin left behind. History is rewritten by recasting the brutal takeover by a core of Bolsheviks as a mass revolution and Lenin as its only great leader. The cult reaches its zenith with the publication of Stalin's book on Lenin in 1931.

Then, Lenin is more and more rarely mentioned, and his pictures disappear to make way for Stalin's. With destalinization in 1955, the Leninist imagery reappears, but on a previously unprecedented scale. Its main purpose is to obliterate Stalin's regime. More than thirty years after Stalin's death, the cult of Lenin is still as vital as ever, and the old photographs play a vital role.

Over the years they have undergone various changes, depending on the policy line. Thus, the exile and assassination of Trotsky, the waves of trials in Moscow followed by the extermination of all former Bolsheviks, the cult of Stalin, and then destalinization are accompanied by photographic disappearances, montages, and the occasional reappearance. Only Trotsky is completely effaced. For the others, it is not unusual to find photographs retouched at different times appearing in the same works or in successive editions.

15

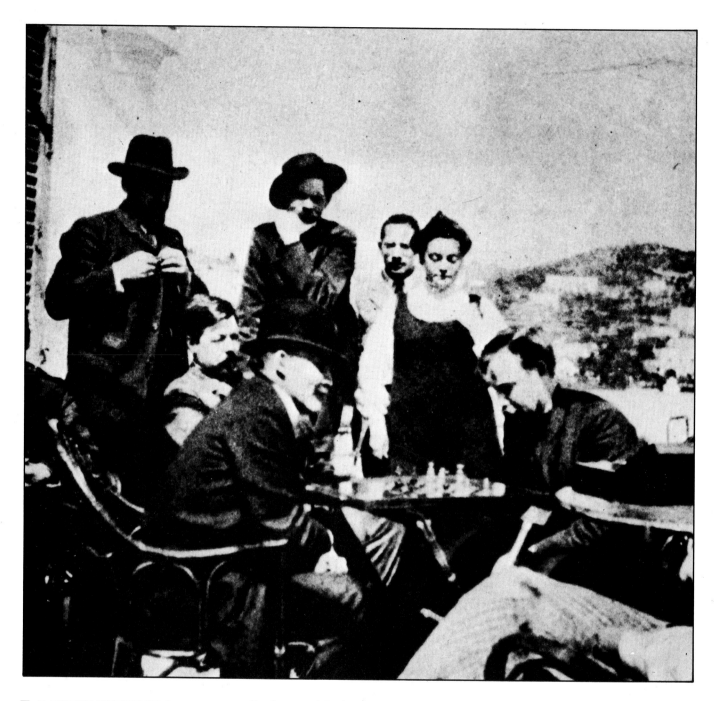

■ A CHESS PARTY IN CAPRI

April 1908. On the terrace of a villa in Capri, Lenin and Alexander Bogdanov play chess while their host, the writer Maxim Gorky (seated on the balustrade), looks on. With them are A. Ignatiev (seated, cut off by the photograph), I. Ladyzhnikov (seated behind Lenin), V. Bazarov (standing behind Lenin), Z. Peshkov (beside Gorky), and V. Bogdanova. Gorky made the villa where he lived for seven years, after leaving Russia soon after the 1905 revolution, available to Russian Social-Democratic emigrés for use as a school for propagandist revolutionaries. Lenin himself helped to establish this school, which he visited twice, once in 1907 and once in 1908. But since

Bogdanov and Gorky insisted on an atmosphere too "spiritual" for his tastes, he refused to teach classes there and founded his own school near Paris, at Longjumeau. This issue was to divide Lenin and Gorky for many years: "By embellishing the concept of God, you embellish the chains they use to enslave uneducated muzhiks and workers," Lenin was still writing Gorky in 1913. Lenin came to Capri to try to convince the Gorky group that it was on the wrong track. Lenin's opponent at chess is Alexander Bogdanov (who died in 1928), a writer, scientist, and philosopher who was a follower of Mach, whose ideas Lenin attacked in his essay *Materialism and Empirocriticism*, which he was in the process of finishing in that year of 1908.

Until then, Bogdanov had been a very close associate of Lenin's. Following his break with Lenin, he devoted himself to scientific work. After the 1917 revolution he was one of the promoters of "proletarian culture" (*"Proletkult"*).

The man in the hat standing near Gorky is Vladimir Bazarov, an economist in the Gorky group. A leftist Bolshevik, he will later have very harsh words for Lenin: "He is an incurable maniac who signs orders as the head of the Russian government instead of taking hydrotherapy treatments under the supervision of an experienced therapist. . . ." A victim of the first Stalinist trials in 1930, he is accused of counterrevolutionary plots and industrial sabotage and is

deported along with several thousand other economists, engineers, and officials.

Standing between Gorky and Bogdanov's wife is the young Zenovi Sverdlov (1884–1966), the brother of Jacob Sverdlov, Lenin's Bolshevik friend who was to become president of the Soviet Executive Committee. Zenovi Sverdlov, disowned by his father, had been adopted by Gorky, who gave him his own name of Peshkov. After following Gorky to France and Italy, Peshkov joins the Foreign Legion in France in 1914. He loses an arm in the trench warfare of 1915. He is then sent to Admiral Kolchak's White Army. Having become a French citizen in 1923, he fights in Morocco and becomes an associate of Lyautey before being sent to the United States and Lebanon. In London in 1941, he rejoins General De Gaulle, who, during and after the war, will send him on several important missions to Africa and the Far East. Of particular note is General Peshkov's apppointment by De Gaulle as ambassador extraordinary to Chiang Kai-shek.

This photograph is important to Lenin's biography: it is one of the few showing him in exile and the only one illustrating a decisive phase in his philosophic battle against "deviations" from the revolutionary movement. Because of this, it could not be left out of the history books altogether and was altered several times. It was therefore recentered to focus on Lenin and to eliminate the undesirable Bazarov. Peshkov was eliminated from another version because he left the Soviet Union to serve other countries and was therefore considered a traitor. Bogdanov, Lenin's opponent at chess, could hardly be erased. However, he is only rarely mentioned in the captions of this photograph.

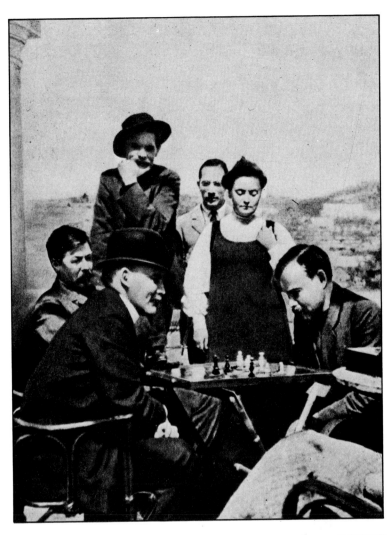

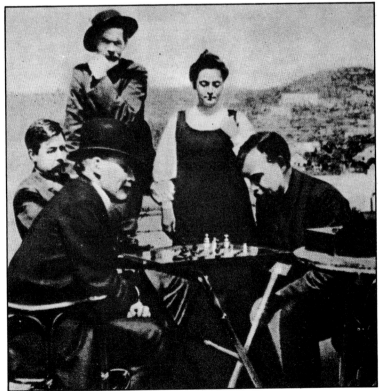

1. Y. Zhelyabuvsky. Between April 10 and 17, 1908, Capri (Italy). Proletarskaya revolutsia, *no. 1, 1926. A whole series of photographs was taken that day and others appeared in* Ogonyok *(no. 17, 1928),* Rabotnitsa *(no. 3, 1931),* Trud *(no. 55, March 6, 1966).*
2. Tass News Agency (about 1936) and numerous publications.
3. Récits sur Lénine (1968) and numerous other publications. Variations in I.M.L., V.I. Lénine, 1964 and Lénine et Lounacharsky, mélanges littéraires, *Moscow 1971.*

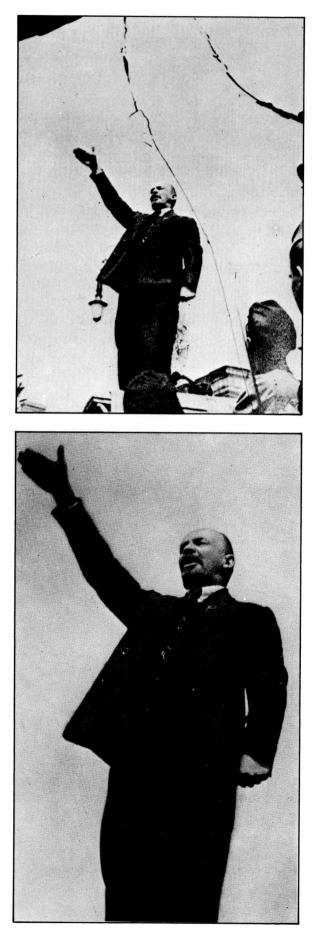

■ BLOCKING AND RESTORATION

May 1, 1919. Lenin gives a speech on Red Square during the dedication of a temporary monument to Stefan Razin, a hero of the eighteenth-century Cossack Revolt. As is true of many photographs of the period, the original negative is a glass plate that has been handled a great deal and is therefore chipped and broken. In the most widely circulated version, the picture has been restored and the area around the figure of Lenin blocked out. In particular, the somewhat incongruous streetlamp has been eliminated. This striking image of Lenin the orator, taken from a low angle, was to be widely used by the creators of posters and photomontages in the Soviet Union as well as in many other countries.

1. *G.P. Goldstein, May 1, 1919, Moscow. Krasnoarmeets, no. 62, 1924.*
2. *Lenin, Leben und Werk, Vienna, 1924; Lénine par l'image, 1950, and all publications.*

18

■ ON THE TRUCK

May 25, 1919. The situation has been extremely tense for several months: the White Army is advancing, threatening Petrograd and Moscow. During this period Lenin has to give speeches every day to encourage the troops. Here he is seen standing in the bed of a truck, addressing the people's militias assembled in Red Square. The person standing behind him is Tibor Samuelli, special envoy from the Hungarian revolutionary government of Bela Kun, in Moscow to request assistance from the new Soviet government. Under Stalin, the space around Lenin is blocked out in order to bring him into sharper relief and, at the same time, to eliminate any allusion to a possible internationalization of the Bolshevik revolution.

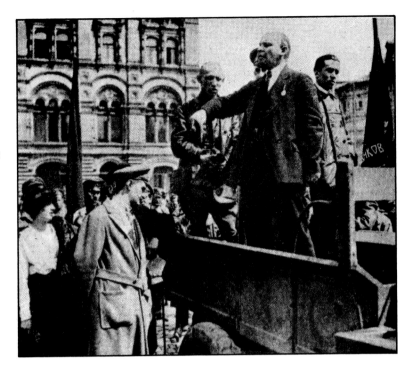

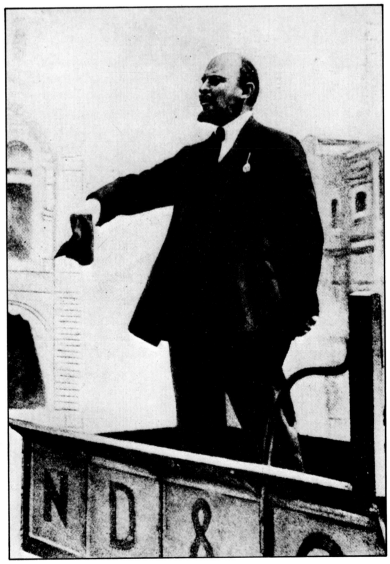

1. K.A. Kuznetsov. May 25, 1919. Krasnaya letopis' *(Red chronicle), no. 1, 1924. There is also a sequence filmed by Kinokhronika and reproduced in* Kinopravda *no. 21 of Dziga Vertov.*
2. Early 1930s. Numerous publications in the Soviet Union and elsewhere, for example: Alexander Bramin, Vingt ans au service de l'URSS, *Paris 1939.*

19

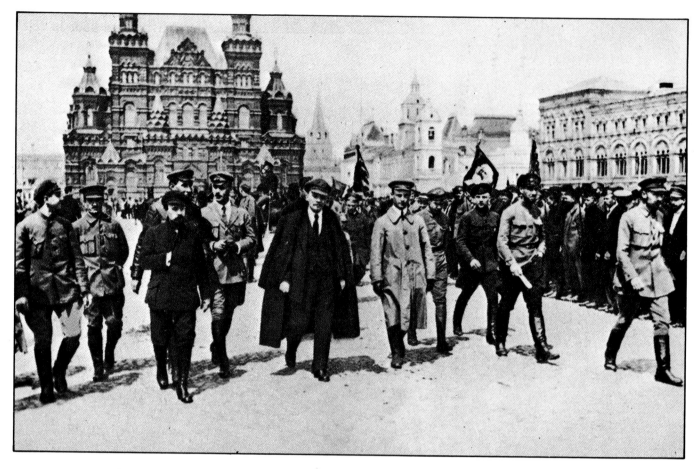

■ MILITARY REVIEW

May 25, 1919. Lenin and the military leaders inspect the people's militias in Red Square. Illustrators will generally choose to show Lenin alone, even though it means erasing the men next to him. The figure of Lenin, completely removed from the setting, was also widely used in posters, stamps, badges, and countless illustrations.

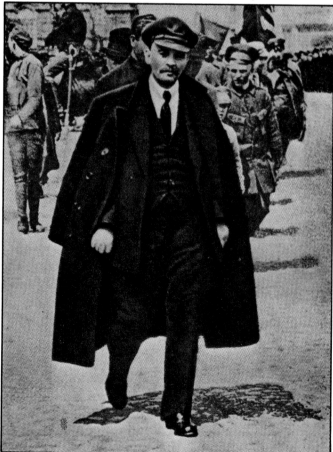

1. *Possibly N. Smirnov, May 25, 1919, Moscow. Brochure entitled* Ilitch, *undated.*
2. *Tass, after 1930. The photo exists in many forms, variously recentered or even with the background completely blocked out.*

■ RECORDING IN THE KREMLIN

March 1919. Lenin records a speech on a disk in a studio set up in the Kremlin. Since Lenin is slightly disheveled and the buttons of his vest and trousers are visible, the iconographers at the Institute of Marxism-Leninism who look after the photographic records and are in charge of distributing them have these particularly sensitive areas retouched. They also take the opportunity to accentuate the speaker's face and various objects in the scene.

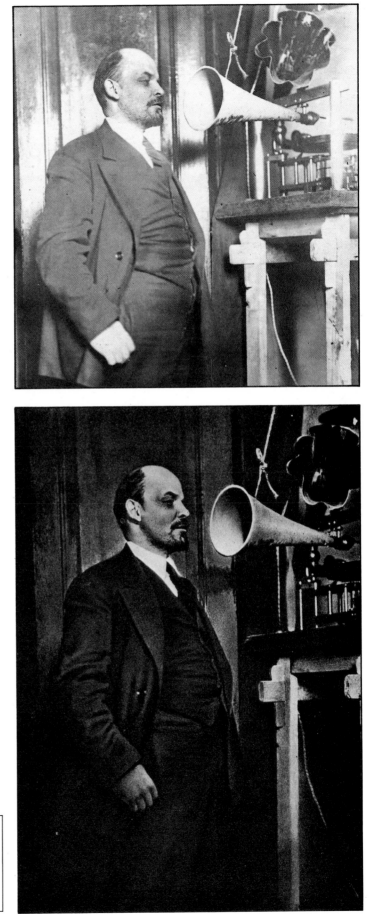

1. L.Y. Leonidov. March 29, 1919, Moscow. Ogonyok, no. 9, 1924.
2. Récits sur Lénine (1968). Nearly identical variations in numerous works, including Lénine en images (1950). Several paintings in the Lenin museums (Moscow, Leningrad, Prague).

1. *L.Y. Leonidov, November 7, 1919, Moscow.* Pravda, *no. 251, November 9, 1919, p. 3.* Lenine album, *Moscow 1920.*
2. *All collections after 1930.* Lénine, recueil de photographies et d'images de films *(Moscow, 1970).*
3. *Newsreels,* Les solennités d'Octobre à Moscou, *cinematographers G. Guiber and A. Lemberg, 1919.* Recueil de photographies . . . *(1970).*
4. Essai biographique *(1970),* Bref essai biographique *(1972), and countless brochures, even folding postcard sets such as* Leninskie mesta v Moskve *(In Moscow, in the steps of Lenin, undated).*

■ TROTSKY'S ELBOW

Kamenev, Lenin, and Trotsky in Red Square during a celebration of the second anniversary of the October Revolution (November 7, 1919). Trotsky gives the military salute. Around the three are several Bolsheviks, bodyguards, and, in front of them, children.

Leon Kamenev, Trotsky's brother-in-law, a member of the Politburo, and later an opponent of Stalin, will be tried and executed in 1936. Leon Trotsky, even more prominent than Lenin, a signer of the Brest-Litovsk Treaty, minister of war, leader of the leftist opposition, and Stalin's chief adversary, will be deported to Alma-Ata in 1928 and then, while in exile in Mexico,

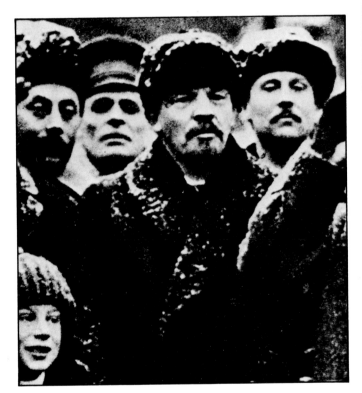

assassinated by order of Stalin in August 1940.

In history books, magazines, and encyclopedias of the Stalinist era, a version of this photograph appears with a narrower field; that version still exists today. The frame is tightened around Lenin: who knows anymore that the shoulder is Kamenev's and the elbow Trotsky's?

Several times during this same ceremony, Kinokhronika photographers and cinematographers photograph the three main subjects from various angles. But, later on, Soviet illustrators, touching up photos and stills from the films, will select a frame more or less tightly focused on Lenin and will paint over faces and clothing.

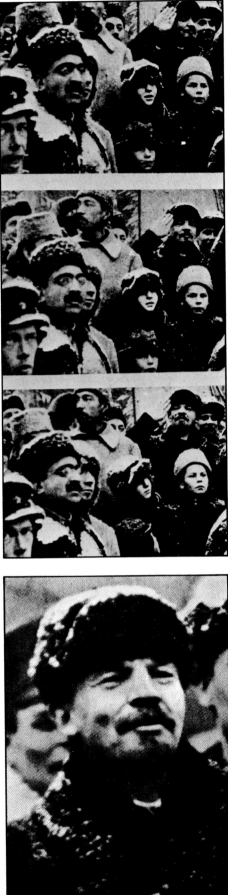

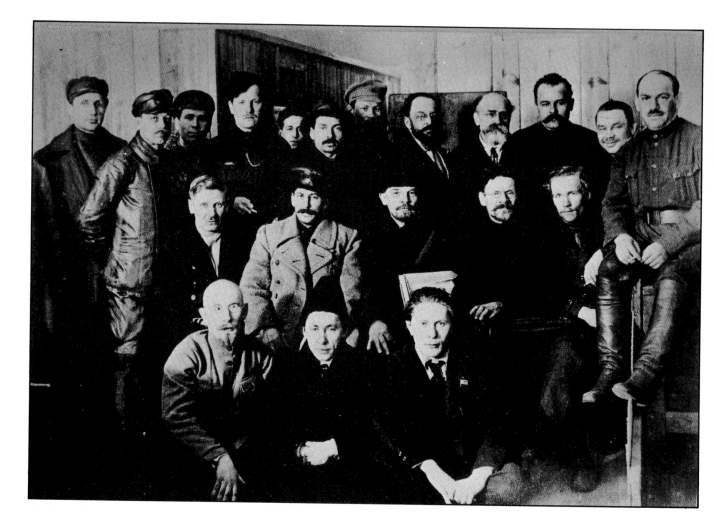

■ FROM CENTRAL COMMITTEE TO TROIKA

A single photo can have numerous progeny. Witness this group photo taken during the VIII Congress of the Bolshevik Party in 1919. Present are Tomsky, Lashevich, Smilga, and fifteen others who will later be assassinated by Stalin. A fairly rare occurrence in documents from this era, Stalin is seated next to Lenin. After the 1930s all that remains of this photograph is a horizontal section framing Stalin, Lenin, and Kalinin. The foreground and background were painted over to erase collars, jackets, hats, hands, or parts of the faces of the rest of the group. Thus, the three appear in various frames: rectangles of varying length, sometimes reversed, or even oval. And always retouched: Lenin does not necessarily keep his portfolio under his arm; his features are softened as well as Stalin's. The young leaders of the Bolshevik Party are thus transformed through the magic of recentering into a sort of "troika" (the first Troika in 1922 consisted of Stalin, Zinoviev, and Kamenev, but the USSR later had many others, real or imaginary). Kalinin will become president of the republic and will remain a prominent figure in the Stalinist regime until his death in 1946. It has been said that his political survival was perhaps due to his extraordinary resemblance to Trotsky: in the literacy campaigns, pictures of the leaders—who, moreover, often changed their names—replaced the old icons.

But in a number of Stalinist-era magazines and historical works, Kalinin, who was seated very close to the two leaders, is also eliminated to strengthen belief in their close friendship (there are two types of retouching: Lenin with or without his portfolio). Years pass. XXII Congress. Destalinization. In the textbooks given to Soviet students under Leonid Brezhnev, the same picture appears, but this time the frame is shifted to the right and only Lenin and Kalinin are shown. Sometimes, Lenin even appears alone, with or without his portfolio, as though surprised by a photographer in a dark hallway after leaving a working meeting.

In the 1980s, while Stalin is being cautiously mentioned again in the history books, this same photograph is used to provide a portrait of the dictator. But he is now shown alone, separate from Lenin.

1. *Probably L.Y. Leonidov, March 29, 1919, Moscow.*
2. Istoriya SSSR *(Russian and French versions, Moscow 1947 and 1949).*
3. Lénine vu par Staline, *Moscow, 1939; and Tass News Agency, about 1950.*
4. Istoriya SSSR, *9th form (final), Moscow, 1979.*
5. Lénine, sa vie et son oeuvre, *Moscou, 1985.*

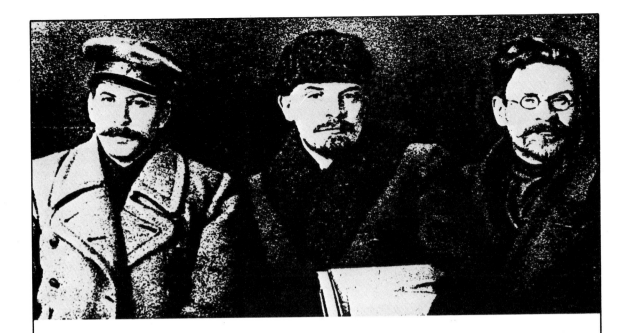

И. Ленин, И. В. Сталин и М. И. Калинин на VIII съезде РКП(б). Март 1919

Фото.

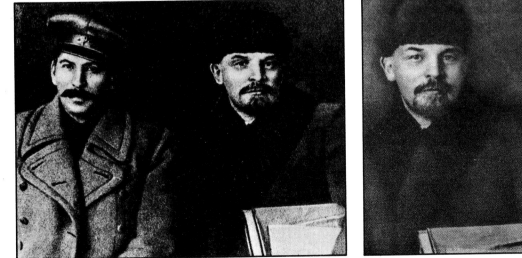

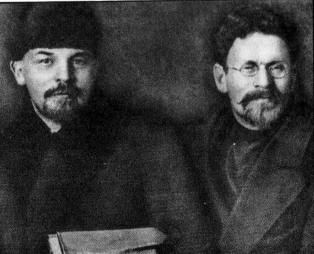

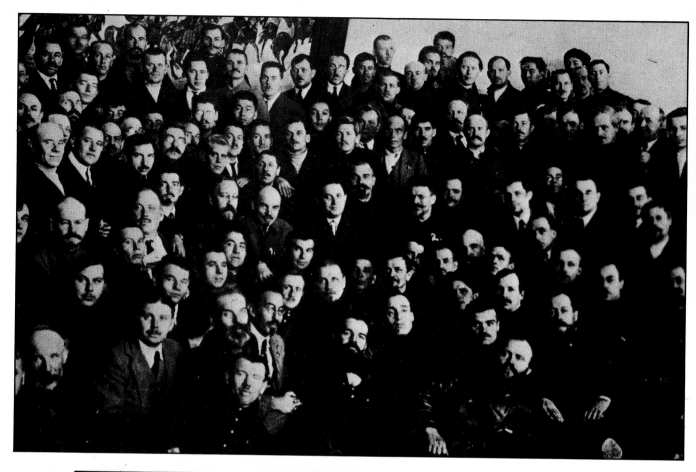

■ ZOOM ON THE CENTRAL COMMITTEE

From a group photograph taken in 1922 of more than one hundred members of the Bolshevik Central Committee gathered around Lenin and Trotsky, a Stalinist iconographer singles out Lenin's face, greatly enlarged and touched up with a paintbrush. Trotsky (a little to the right in the center of the photograph) and Kamenev (on Lenin's immediate left) are eliminated, along with everyone else executed between 1936 and 1940 by order of Stalin. Lenin was only one person in a crowd. Today, only his face appears in the books. A dozen group photographs in which Lenin appears have become "portraits" of Lenin in this same way.

1. Anonymous. October 31, 1922, Moscow. Al'bom Zhizni Lenina—Istoriya RKP (sd).
2. Lénine, recueil de photographies . . . (1970).

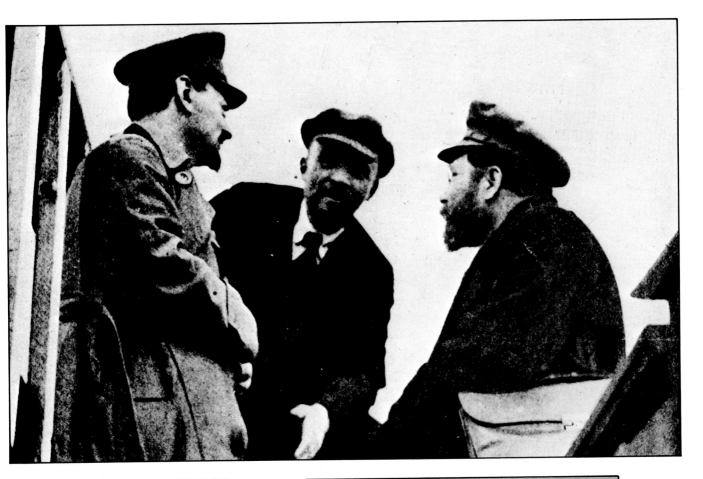

■ WITH TROTSKY AND KAMENEV

At the conclusion of the meeting of May 5, 1920, the photographer L. Leonidov photographed the three Bolshevik leaders deep in discussion. In Soviet publications today only Lenin's face appears.

1. L.Y. Leonidov, May 5, 1920, Moscow. Ogonyok, no. 4, 1924. Also appears in the work of Henri Guilbeaux, op. cit., 1924.
2. Lénine, recueil de photographies . . . (1970). Another photograph, taken at the same time and showing Lenin in the same frame with his face turned toward Trotsky was recentered in the same way.

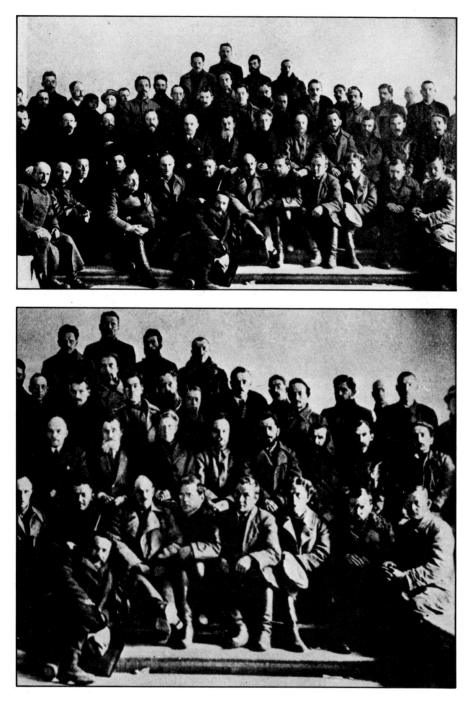

■ FACES IN THE CROWD

Petrograd, Palace Square, July 1920. On the occasion of the convening of the II Congress of the Communist International, Lenin gives a speech in support of Karl Liebknecht and Rosa Luxembourg. A crowd at the base of the platform, a crowd surrounding Lenin. An unexceptional photograph signed Viktor Bulla, a photographer credited with several large Soviet historical scenes and several portraits of Lenin, later touched up to create sacred images. The picture circulated and was distributed by press agencies worldwide. In the official Institute of Marxism-Leninism version, which is also found in numerous historical publications of the institute as well as in the Mayakovski Museum in Moscow, the two faces just behind Lenin have disappeared, as well as the third person standing to the left. It is impossible to identify the person whose face is hidden by Lenin (he may have been eliminated to accentuate Lenin's face). However, we do know the name of the tall man in the cap whom retouchers have caused to fade, along with his comrade, into the tangle of flags at the edge of the platform. We can also name the man in the gray coat whom retouchers have caused to melt·into the dark clothing of the person in the soft felt hat just behind him, forgetting, however, a section of his coat sleeve on the other side of one of the flagpoles. The man with the round, cheerful face, huge mustache and tilted cap who vanished into the flag is surely Nikolai Bukharin (1888–1938). The man with the bare head, thin, severe-looking face, prominent cheekbones, and small mustache who disappeared into his neighbor's clothing is undoubtedly Anastas Mikoyan (1895–1978).

Bukharin was executed in 1938. Mikoyan lived a long time, even longer than Stalin. His removal from the photograph is no doubt due to a short period of disgrace. Or maybe just jealousy. Stalin appears beside Lenin in very few authentic photographs and could not bear to think that some of his colleagues might have been more "revolutionary" than he was.

■ THE OLD GUARD OF 1905

In 1920, Bolshevik Party members who had participated in the 1905 Revolution meet and pose for a photograph. Beside Lenin are Kamenev and several others later executed by Stalin. The version of this photograph released by the Institute of Marxism-Leninism is cropped next to Lenin.

1. V. Bulla, either March 29 or April 5, 1920.
Leningrad, *No. 2, 1925, and Henri Guilbeaux,*
Le portrait authentique de Lénine, *Paris 1924.*
2. Lénine, recueil de photographies . . .
(1970).

1. V. Bulla, July 19, 1920, Petrograd, Krasnaya
panorama, *no. 3, 1924.*
*2. Mayakovski Museum, Moscow; and
Novosti News Agency, about 1950. See also C.
Frioux,* Maïakovski par lui-même, *Paris, 1961.*
*The original version resurfaced about 1960
and subsequently appeared in numerous
works:* Sowjetische Fotografen *(1980) and*
Lénine, sa vie et son oeuvre *(1985).*

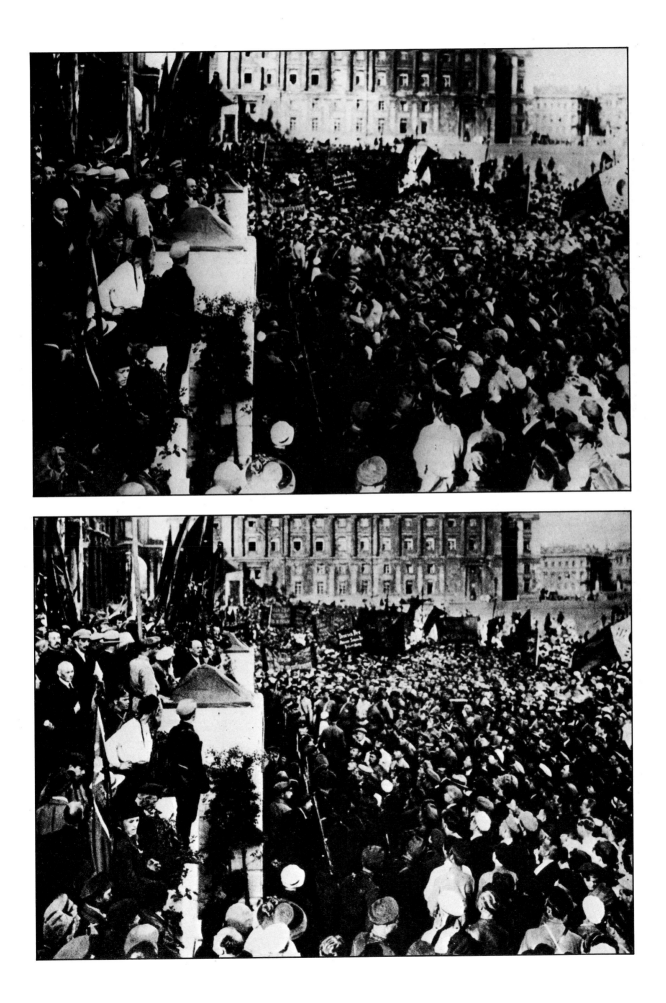

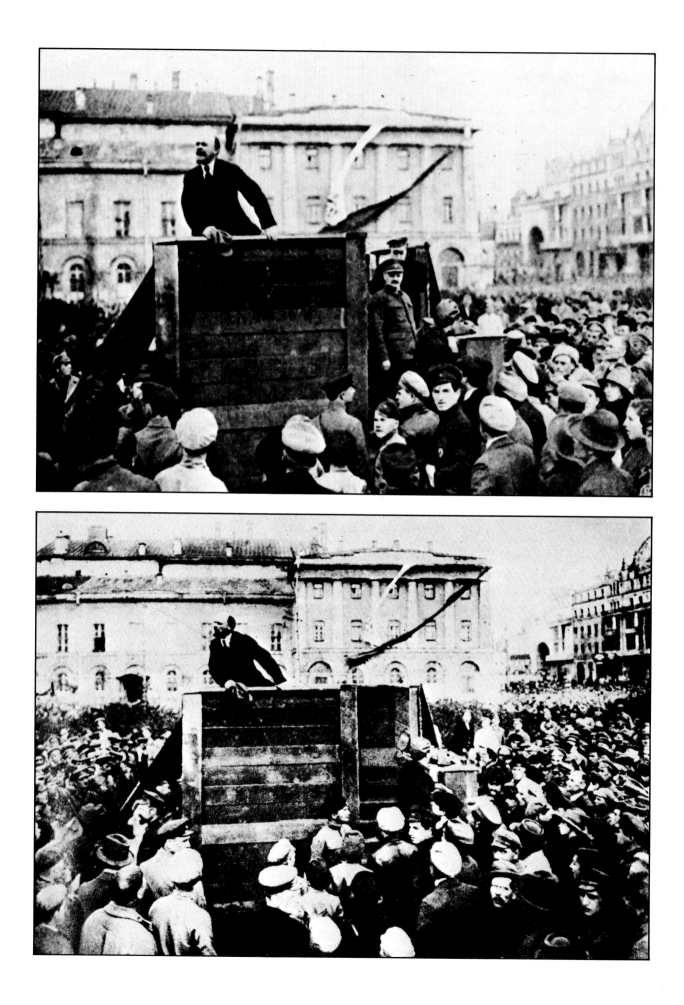

■ TROTSKY DISAPPEARS

May 5, 1920. Trotsky, Kamenev, and Lenin take turns addressing the troops before their departure to fight the Polish army (which had invaded the Soviet Union in March). Two photographs of Lenin on the platform were taken several seconds apart, but from slightly different angles: they are undoubtedly the most famous in the entire revolutionary canon. They have inspired a staggering array of posters, photomontages, bookcovers, statues, frescoes, mosaics, badges, and postage stamps. But it was only the figure of Lenin that illustrators used. In the 1930s, after Trotsky was exiled, the photograph appears only in its various recentered and retouched forms (3 and 4). The censors, however, wanted to give a complete version showing the platform and the square, which they finally did by eliminating Trotsky and Kamenev and painting in the stairway and the planks of the platform in their place (2). Conventional painters handle this same subject in a variety of ways, but always without Trotsky and Kamenev. Thus, in 1932, I. Brodsky, a painter of the "realist-socialist" school and a follower of Gerasimov, rebalances the composition (5) by placing a journalist where the two Bolshevik leaders had been!

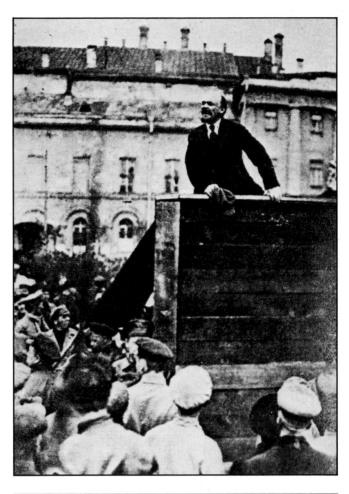

1. *P. Goldstein. Two other photographs with roughly the same frame and showing Lenin in other positions still exist. There is also a photograph of Trotsky speaking while Lenin and Kamenev wait at the bottom of the platform (see David King,* Trotsky, *1979).* Leninsky sbornik, *1924, and H. Guilbeaux, op. cit., 1924.*
2. *From the Institute of Marxism-Leninism,* V.I. Lénine, *1964. First published in* Krasnaya niva, *no. 8, 1923 (complete version with Trotsky).*
3. Lénine, recueil de photographies, *1970. Sergei Morozov,* Tvorcheskaya Fotografiya (Creative photography), *Moscow, 1985.*
4. Lénine en images, *1950.*
5. *Painting by Brodski,* Sovetskoe Iskusstvo 1917–1957, *Moscow 1957. And* Lénine, sa vie et son oeuvre, *1985.*

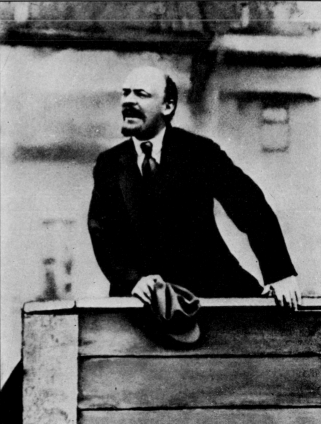

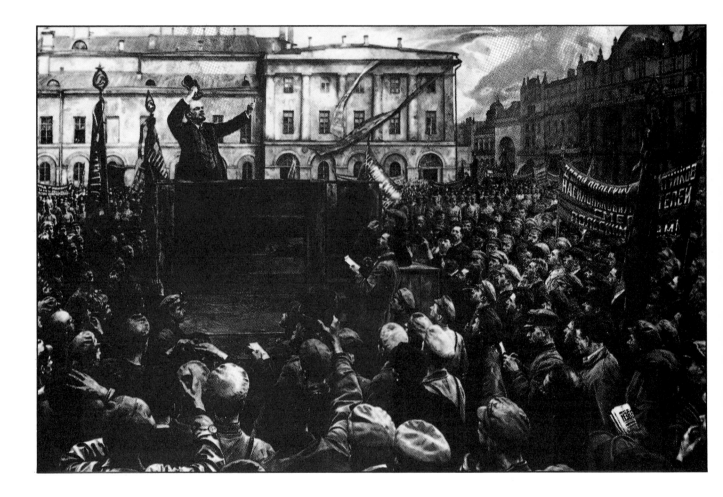

■ WITH HIS COLLEAGUES

Lenin is surprised by the photographer among his closest associates during a meeting of the Bureau of the IX Congress of the Russian Communist Party in 1920. The person in the foreground is Rykov. Seated, left to right: Enukidze, Kalinin, Bukharin, Stalin, Lashevich, Kamenev, Preobrazhensky, Serebryakov, Lenin. In the second row, behind Bukharin, Meshcheryakov, Krestinsky, Berzin, Milyutin, Smilga. Enukidze, Bukharin, Kamenev, Preobrazhensky, Serebryakov, and Rykov were executed between 1936 and 1940. Lashevich committed suicide in 1928. Tomsky killed himself as he was about to be arrested in 1936. Versions of this photograph published after the Second World War by the Institute of Marxism-Leninism are recentered on the right part or sometimes show only Lenin's face.

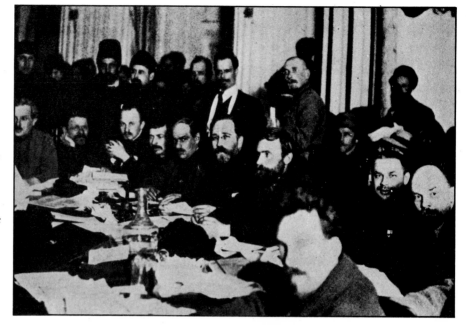

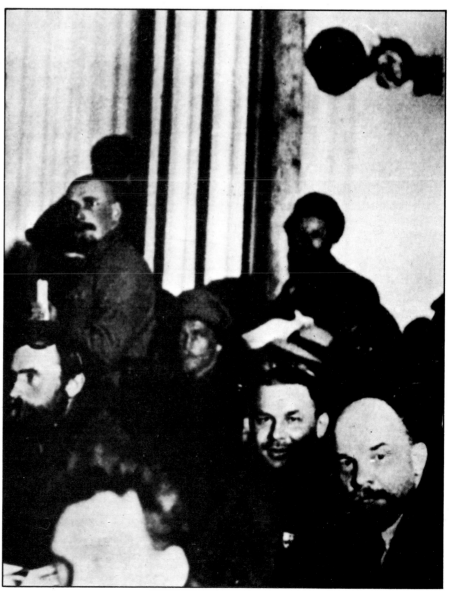

1. *V. Bulla, either March 29 or April 5, 1920, Moscow. Leningrad, no. 2, 1925 and H. Guilbeaux,* Le portrait authentique de Lénine, *Paris, 1924.*
2. *Lénine, recueil de photographies . . . (1970).*

■ LENIN AND GORKY

July 1920. The Second Congress of the Communist International (Comintern) held at the Uritsky Palace in Petrograd. During a break, photographer Viktor Bulla takes a picture of a group of delegates gathered around some broken-down steps. Around Lenin are Radek (seated on the balustrade and smoking), Bukharin (second after Radek), Gorky (behind Lenin), and, just after Gorky, Zinoviev, the Indian delegate M.N. Roy, and Lenin's sister, Maria Ulianova.

An early version of this photo from the 1930s shows only a narrow vertical section containing Lenin and Gorky, thus eliminating Radek (executed in 1939), Bukharin (executed in 1938), Lenin's sister (possibly poisoned in 1937 by order of Stalin), and Zinoviev (executed in 1936), whose shoulder is still visible. This "classic," recentered version was sent abroad and shown in exhibitions on Soviet photography, for example.

In other versions, however, even the people around Lenin are erased. The balustrade is repaired and the broken steps are painted over; the badge and the ribbon in Lenin's lapel are removed. Gone is the simple watch-chain across his vest. His shoes are polished, the frayed threads of his vest and trousers are gone, the weeds at his feet are cut. The stern face, hollowed by shadows, is softened. The eyes are opened. The neck is thickened to diminish the prominence of the ears. The little finger, casual, ambiguous, which Lenin held outside his trouser pocket, is tucked in. Twenty-five people eliminated, all sorts of details erased, and what remains is the uplifting picture "Lenin and Gorky in 1920," which can be seen at the Lenin Museum in Moscow and which was reproduced in the *Great Soviet Encyclopedia* (and in every Soviet or Western book about Lenin or Gorky). Another version of the picture appears in the complete works of Gorky, but the treatment is even less skillful. And Lenin's badge is back in his lapel. . . .

Despite his quarrels with Lenin, his being sent into exile again and again, his reservations about the revolution (followed by bursts of enthusiasm), his distrust of Stalin and his set, Gorky finally agreed to return to the Soviet Union and allowed himself to be dubbed by Stalin "a great proletariat writer" and "the father of Soviet literature." He was named a member of the Lenin Academy and of the Central Executive Committee. Schools, theaters, and factories were named after him. Even his birthplace, the former Nizhny-Novgorod, was renamed in his honor. But Gorky's end is shrouded in mystery: disillusioned by Soviet life, he may have been poisoned by order of Stalin (1936).

1. V. Bulla. July 19, 1920, Petrograd. Komunisticheski internatsional *(The Communist International), no. 13, 1920, and* Ogonyok, October 2, 1927 *(the right side of the photo is cut off).*
2. Tass News Agency, after 1945. Sowjetische Fotografen *(1980),* Lénine, sa vie et son oeuvre *(1985). Appeared in this form in the exhibition celebrating the one-hundredth anniversary of Lenin's birth at the Grand Palais in Paris (May-June 1970).*
3. Giant photomural in the Lenin Museum in Moscow. Lenin Museum catalogue. See also N. Gourfinkel, Gorki par lui-même, *1954. And Soviet works on Gorky such as A.M. Gorky 1868–1936, Moscow, 1962.*
4. Volume 16 of the works of Maxim Gorky, Moscow 1979. Different, heavily retouched versions in the Great Soviet Encyclopedia, *2nd edition, 1949–1960, volume 12, p. 148.*

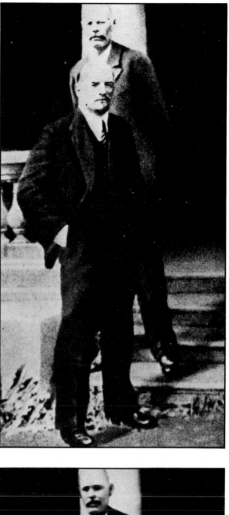

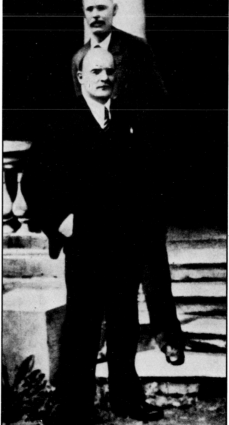

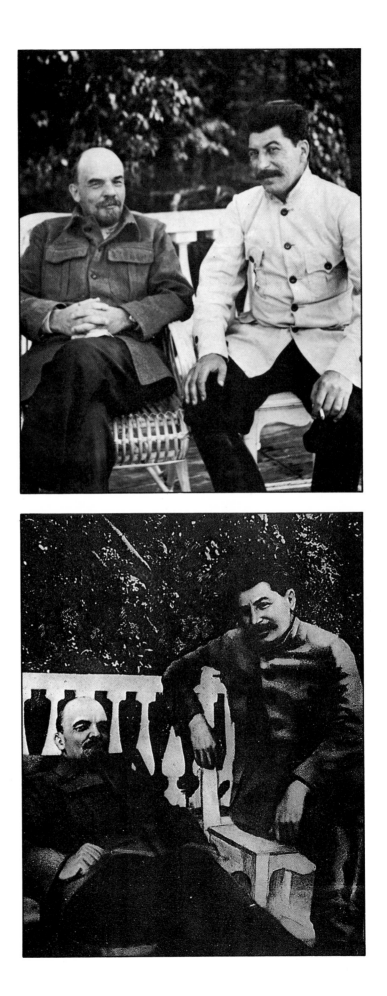

■ STALIN VISITS LENIN

In early 1921 it is discovered that Lenin is seriously ill with arteriosclerosis. He now spends most of his time in Gorky, near Moscow. At this retreat he receives few visitors, mostly close friends such as his sister or Kamenev. The authenticity of this photograph has long been doubted. However, even though this picture appeared in various retouched versions (the paper in Lenin's lap, the cigarette in Stalin's hand), it seems that in the files of the Institute of Marxism-Leninism there are several authentic photos taken by Lenin's sister, Maria Ulianova, during a visit of Stalin's to Gorky in the summer of 1922. This must not have satisfied Stalin, however, since a wholly fabricated picture was published in the early 1930s. Lenin is slouching in his chaise lounge and a paternal Stalin, seated on a barely visible but nevertheless higher chair, looks down on him. Another composition shows the two men standing side by side in the garden. But this is either a very fuzzy photograph taken by Maria Ulianova the same day, with the faces painted over, or else a photograph showing Lenin with another visitor whose face has been replaced by Stalin's.

All of these photographic manipulations had a specific function: to offset the terms of Lenin's "testament," a confidential memorandum long kept secret. "Comrade Stalin, by becoming General Secretary, has concentrated immense power in his hands and I am not convinced that he can use it with sufficient wisdom," Lenin writes. And, further on, "Stalin is too brutal, and this fault, fully acceptable to us Communists in our relations with each other, becomes intolerable in a General Secretary." Many of the propaganda images of the Stalin era will thus be aimed at wiping out the memory of this "testament" and showing, instead, the "close friendship" between the two men.

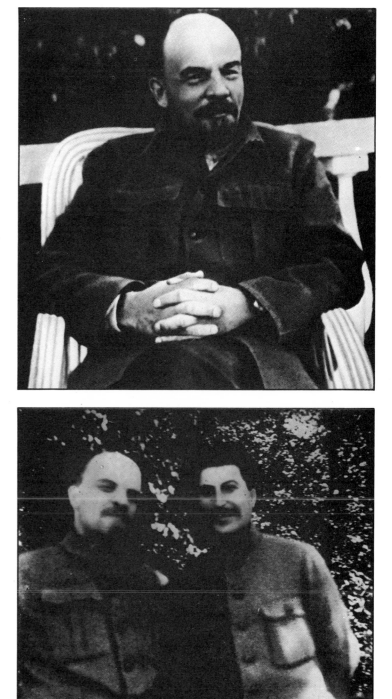

1. Maria Ulianova. August or early September 1922, Gorky. Illustrated supplement of Pravda, *no. 215, September 24, 1922.*
2. Tass News Agency, Fotokbronika, no. 281343, December 1938.
3. Lénine, sa vie et son oeuvre, *1985. In the same book is another photo, very similar to the first and appears to have been taken several moments later.*
4. Lenin Museum, Moscow, 1939.

■ GRADUAL ELIMINATION OF A TELESCOPE

In Gorky (now "Leninskie-Gorky")—in seclusion on the estate of a former governor of Moscow—where he died January 21, 1924, Lenin devotes his many hours of enforced rest to reading. Sometimes he looks at the sky through a small telescope. This picture, awkwardly composed by Lenin's sister, Maria Ulianova, has always been a problem to censors. Thus, over the years, the tube of the telescope, which looks exactly like a gun pointed at the head of Nadezhda Krupskaya (1869–1939), Lenin's wife, was progressively

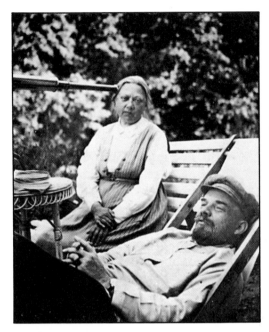

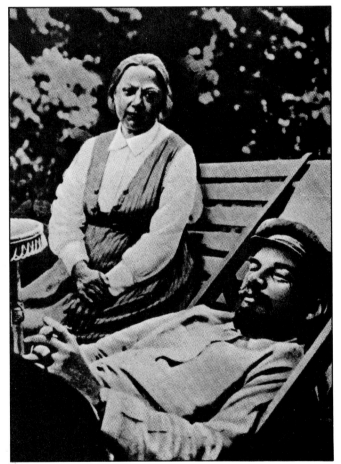

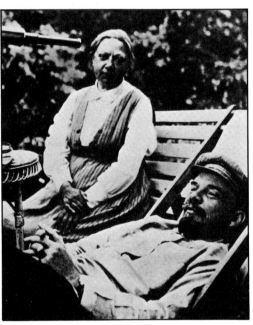

shortened. In the most recent versions published by the Institute of Marxism-Leninism, the problem has been settled once and for all by simply eliminating the annoying and intrusive telescope altogether!

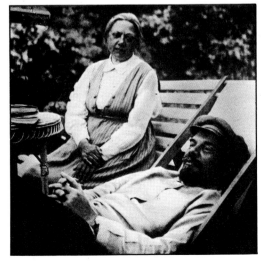

1. Maria Ulianova, August or early September 1922. Pravda, no. 215, September 24, 1922.
2. Novosti News Agency, about 1970.
3. Lénine, sa vie et son oeuvre, 1985.
4. A. Nenarokov, Vladimir Lénine, Novosti News Agency, 1985.

Scenes of the Revolution

A few years after the October Revolution, when Soviet historians first became interested in writing the history of the revolutionary movement, it was noted that the pictures were frequently inconsistent with the official line. The revolutionary movement had been complex, numerous parties were represented in the Duma, the unrest was not the work of the Bolsheviks alone, and a number of political figures had been in the spotlight for some time while Lenin was still unknown. Most of the street demonstrations in Petrograd attracted very disparate crowds, composed primarily of soldiers, tradespeople, or civil servants and relatively few of the city's workers. After the Bolshevik victory, the repression was bloody. Civil war followed, with extraordinarily gruesome massacres and torture on all sides.

Thus, the first type of meddling with photographs was censorship: of the thousands of photographs taken at the time, the only ones still shown today are those concerning the Bolshevik movement, a few demonstrations in February or July 1917, the October events, and the massacres perpetrated by the White Army. Some of these photographs have also been discreetly retouched to make them coincide with the official version of history: addition of red flags to demonstrations, elimination of the banners of "bourgeois" political groups, including religious banners, the faking of posters or insignias on uniforms.

It was also found that during the revolution, inclement weather, unpredictability, and general disorder made it impossible for every phase of the situation, every speech, and every attack to be recorded by the photographers or cinematographers present. The photos taken at the time were rarely of decisive moments (with one notable exception: the July 26 massacre on Nevsky Prospekt, photographed by Viktor Bulla). Instead, they show the intervals, the lulls: the Red Guard bivouacked in the streets or at the Smolny Institute, the Winter Palace the day after the attack. . . . Nothing giving a clear, comprehensive picture of the "great proletarian revolution." Street theater reenactments and then the cinema of the 1920s were to provide historians with the missing iconographic element, enabling them to work their way back to the fateful revolution of 1905.

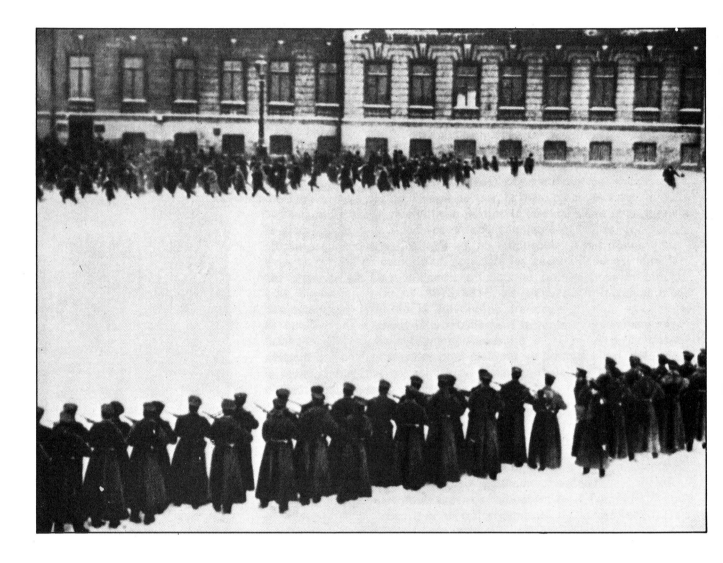

■ "BLOODY SUNDAY"

January 1905. Petrograd. General strike at the Putilov factories. Shipyards, factories, textile mills are won over to the movement. Sunday morning, January 9, tens of thousands of workers from every district walk in procession toward the Winter Palace, which is protected by the army. At the head of one of the columns is the priest, Gapon, surrounded by men carrying icons. Their objective is to present a petition to the Czar. At the Narva Gate the demonstrators are stopped and the soldiers open fire. Many are killed or wounded. In the afternoon there are other incidents around the Winter Palace. The troops, in considerable disarray, fire on the demonstrators as well as the curious who have climbed trees or pressed against the fence. The day will become known as "Bloody Sunday" (sometimes also referred to as "Black Sunday").

Although there were several photographs of the streets and barricades that day, none approaches the intensity of the striking photo that appeared in the press only toward the end of the 1920s. The line of soldiers and that of the crowd in the snow, the stark contrast between black and white, the jolt of the diagonals, all contributed to the success of this picture, which is suggestive of the Soviet cinematic style of the twenties. In fact, it is a scene from *Devyatoe Yanvarya* (January 9, alternately titled *Krovavoe voskresenie*, or Black Sunday), a film by Vyacheslav Viskovsky, which is a plodding historic reenactment incorporating fictitious characters, filmed in Leningrad in 1925 with Evgeny Boronihin in the role of the priest Gapon and A. Edvakov as Nicholas II. The last part of this otherwise dull film is remarkable for its crowd scenes and its graphic detail, reminiscent of Eisenstein. Ever since the release of the film, this picture—a frame taken directly from the film and retouched, or else a photograph taken during the filming—has symbolized the 1905 revolution in all Soviet publications.

Distributed 1927–1930 by Tass News Agency. Used as an illustration in almost every history book in the Soviet Union and, for example, in *Lénine, sa vie et son oeuvre* (1985). It also appears in various anthologies on the history of photography: *Les premiers reporters photographes 1848–1914, Paris, 1977*. Distributed by Viollet News Agency with the caption: "October 1917, the Great Czar fires on the crowd!"

■ THE ODESSA STEPS

June 27, 1905, aboard an armored ship of the Russian Black Sea fleet, the *Knyaz' Potemkin Tavrichesky*, a mutiny breaks out among the 670-man crew over some spoiled meat. The mutineers, led by seaman Afanasi Matushenko, take over the ship, kill several officers, throw several others overboard, and drop anchor in the Odessa harbor. Since April the city has been the scene of strikes and revolts. On the morning of the 27th, General Kokhanov, military governor of the region, had decreed martial law. Upon arrival, the *Potemkin*'s sailors display on a wharf the body of Gregori Vakulinchuk, a sailor killed at the beginning of the mutiny by the second in command. The next day, the crowd at the harbor is so large that the general orders the Cossacks to disperse it. An appalling massacre ensues (there were at least 6,000 deaths), but, contrary to all expectations, the *Potemkin*'s guns are not used. Several other ships in the fleet follow the *Potemkin*'s lead and hoist the red flag. However, the gesture is not successful, and after several days the ship leaves Odessa. It first enters the Romanian port of Constantsa, where the welcome is neutral, and then the coal port of Theodosia, in the Crimea, where the mutineers are greeted by gunshots. Returning to Constantsa on July 8, the *Potemkin* is scuttled, and the mutineers surrender to the Romanian authorities, who offer them asylum.

As violent as this adventure was, there was almost no trace of it in Russian history when Sergei Eisenstein, commissioned to commemorate the twentieth anniversary of the 1905 Revolution, chose it as the subject of his film. Completed in 1925, the film was rather coolly received by the Soviet authorities. But its enormous success abroad eventually made it a hit in its own country. Since then, images from the film have been so often reproduced and the film has been seen by so many people that myth has replaced history. Moreover, the available records are very scarce and historians, both Russian and foreign, constantly argue over all sorts of minute details. Especially the most haunting scene of the film, that of the famous Odessa steps, the origin of which Eisenstein clearly recounted:

Those steps were to be used simply as a dramatic and rhythmic link between the victims of the tragedy who had fled there, only to die. But none of the preliminary versions, none of the scripts called for a massacre on the Odessa steps. The massacre was conceived in a flash, as soon as I saw those steps. As one story would have it, the entire sequence popped into my mind one day while I was sitting at the top of the

steps—at the base of the statue of the Duc de Richelieu—eating some cherries and spitting out the pits to watch them bounce from step to step. It's a myth—a charming myth, but a myth nevertheless. In fact, it was just the movement on the steps that gave me the inspiration for that scene. The people running from the statue gave the director an idea for a new dramatic twist. And it seems to me that the panic of the crowd hurrying toward the bottom of the steps is in fact nothing but a visual manifestation of the feelings I had when I first saw that statue.

By focusing the entire imagery of repression on the steps, Eisenstein unleashed a flood of violent and striking images so convincing that historians now describe events in those days in great detail, without realizing that they are only describing scenes imagined by a film director.

Before the mutiny there were various photographs of the ship and of its officers posing on the bridge. During the mutiny, no photographer was on board, and the ship was too far from land for any details to be made out. No photographs were taken during the charge of the Cossacks: photographers were not yet in the habit of participating directly in events. In the following weeks, however, the European press published numerous photographs taken after order was restored, showing the after-effects of the looting and fires and the piles of corpses. The only known photographs of the mutineers were taken in Romania when the *Potemkin* was anchored at Constantsa.

In the late 1920s, Soviet historians, excited by Eisenstein's film, began to take an interest in the mutiny; they had no qualms about using pictures from Eisenstein's sequences to illustrate their books. They even used the famous Odessa steps scene, which, from a historical viewpoint, is the most doubtful in the movie (photo 1). Later, tourist photos taken by visitors to Constantsa were retouched (visitors posing with sailors were erased, especially women) and passed off as photographs taken in Odessa (photo 2, usually with the caption: "Aboard the *Potemkin*, shortly after the mutineers took over the ship").

On the other hand, photographs of the looting and the fires, and also of the pogroms, which were numerous in Odessa—a fact which Soviet historians generally tend to pass over—were carefully hidden away. Finally, highly idealized portraits were made of the two main heroes of the mutiny, Matushenko and Vaculinchuk, no doubt using the only documents available, the identification photos in the

41

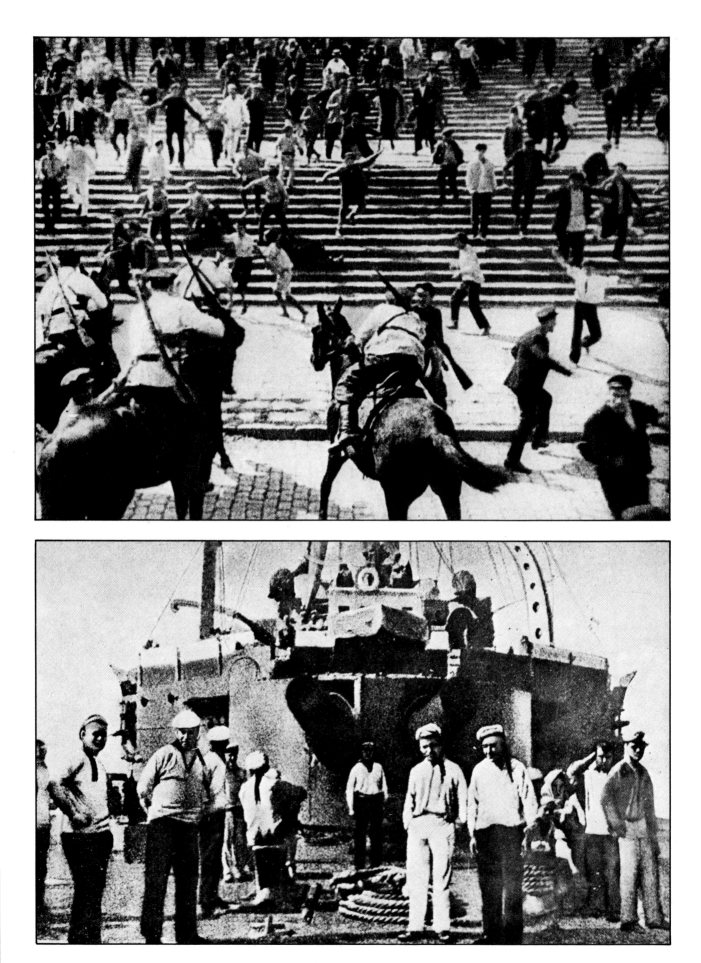

military files. Thus, Matushenko's pronounced Asian features, as seen in the photographs taken in Constantsa (photo 3), are completely eliminated in the portrait published by Soviet historians (photo 4). The artistic softness of such a "photograph" contrasts with the stark, anthropometric realism that was the rule for military identification pictures at that time.

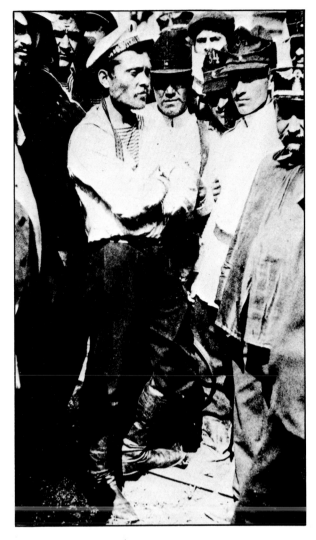

1. A. Fedorov, Revolyutsionnye Vosstaniya v Chernomorskom flote v 1905 godu *(The revolutionary revolt in the Black Sea fleet in 1905), Moscow, 1946. The book is in fact illustrated with a photomontage composed of scenes from the film. The fragility of the only copy kept at the National Library prevented an exact reproduction of this picture.*
2. Photograph signed M.A. Forst and published in various European magazines (for example, L'Illustration, *July 22, 1905). Reproduced in retouched form in most Soviet history books.*
3. L'Illustration, *July 22, 1905.*
4. A. Fedorov, op. cit., 1946. And Lénine, *sa vie et son oeuvre, 1985.*

■ THE ATTACK

Of all the images of the October Revolution, the photograph entitled "The Attack" is undoubtedly the best known and the one most often reproduced. It is in every history book published in the Soviet Union, in every brochure on the revolution, and in countless works published throughout the world. It is supposed to show a key moment in the "ten days that shook the world," the taking of the Winter Palace, October 25, 1917. Shown in the photo is the vast façade of the Palace and, on the left, in the middle of the square, the base of Alexander's column. In the foreground and to the right, soldiers are running toward the building behind what looks like an armored car engulfed in smoke. The composition is perfect. Its centering, its density, its dynamics make it an authentic and strong revolutionary image, truly worthy of inclusion in every history book. But it is that very perfection that makes it suspect.

First, it is difficult to imagine what miraculous platform could have suddenly sprung up under the photographer's feet. It is equally difficult to imagine how the daring photographer, perched atop the Eagle Gate like the soldier/actor in the film *October*, could have managed this exceptional composition from such an unstable position.

Second, it was late 1917, all around the palace were log and sandbag barricades over three meters high (which, paradoxically, are shown—sometimes in the same books—in other, authentic photographs taken the day before or the day after); but in this photo the barricades are gone.

Finally, and no doubt most important, when this photograph was allegedly taken, i.e., shortly after the flight of the Cossack cavalry, at the very moment when, the gate having fallen, the Red Guard and the revolutionary soldiers rushed toward the Winter Palace, it was October 25 (or November 7 according to our calendar), around midnight, in the middle of the northern autumn, in a city with no street lighting. "It was totally dark," reported John Reed, who followed this groping crowd and could not make out the first rows of soldiers until they were directly under the palace windows, which glowed with the faint light of the fires lighted by the Cossacks.

Every picture, even a fake, has its truth. This photograph does indeed show an attack on the Winter Palace. It really is November 7. And, no doubt, most of the soldiers running across the square are revolutionary soldiers. But the event took place three years later, in 1920, in broad daylight, during a huge street celebration organized to commemorate the October events by the Military District of Petrograd, with the help of the Free Comedy Agitation Theater (*Vol'naya Komediya*), also known as the "Theater of Revolutionary Satire" (*Terevsat*). Prior to 1924, the theater (which gradually became less and less political) performed in the city, in the streets, in factories, and on bridges and made the public participate in its shows. When it had to stage the large crowd scenes of the revolution, it called on factory workers and often used real Red Army soldiers (there were several theatrical troupes in the army as well). This was the case with the restaging of the attack on the Winter Palace, which involved 8,000 soldiers, 500 musicians, tanks, cannons, and even the cruiser *Aurora*. The set decorator was Yuri Annenkov and the "executive producer" was Nicolai Evreinov. Both later left the Soviet Union and thus were able to tell the truth about these scenes while in exile, but the images they created have remained in Soviet books as authentic pictures of the revolution.

At first, since this picture did not really coincide with what participants in the October Revolution may have remembered, a darker version was printed, in which the windows of the Winter Palace were painted white to give the illusion of a building seen at night and lighted from within. It was later replaced by a more restrained version. As two historians of the Soviet theater later wrote, commenting on the 1920 spectacle: "One of the lucky things about the 'Storming' was, of course, the opportunity to use the real Winter Palace."

1. Anonymous. November 7, 1920. Version 1: John Reed, Ten Days that Shook the World, *Moscow, and Paris, 1927.*
2. Numerous publications in the Soviet Union. For example, Lenin, Partiya, Oktyabri *(Lenin, the Party, October), Moscow 1977. And also history books, brochures, tourist guides, postcards, etc.*

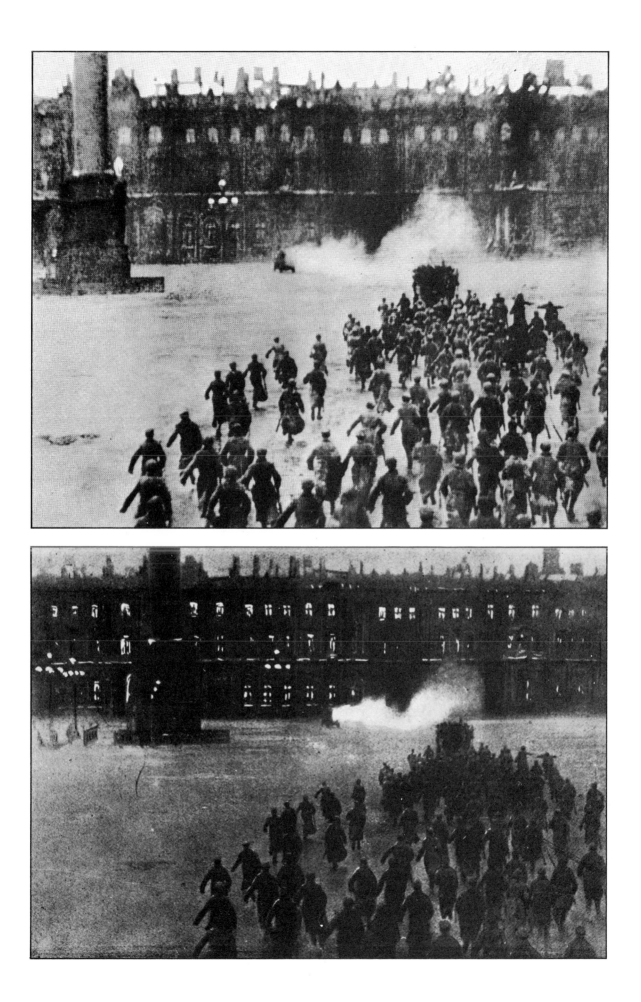

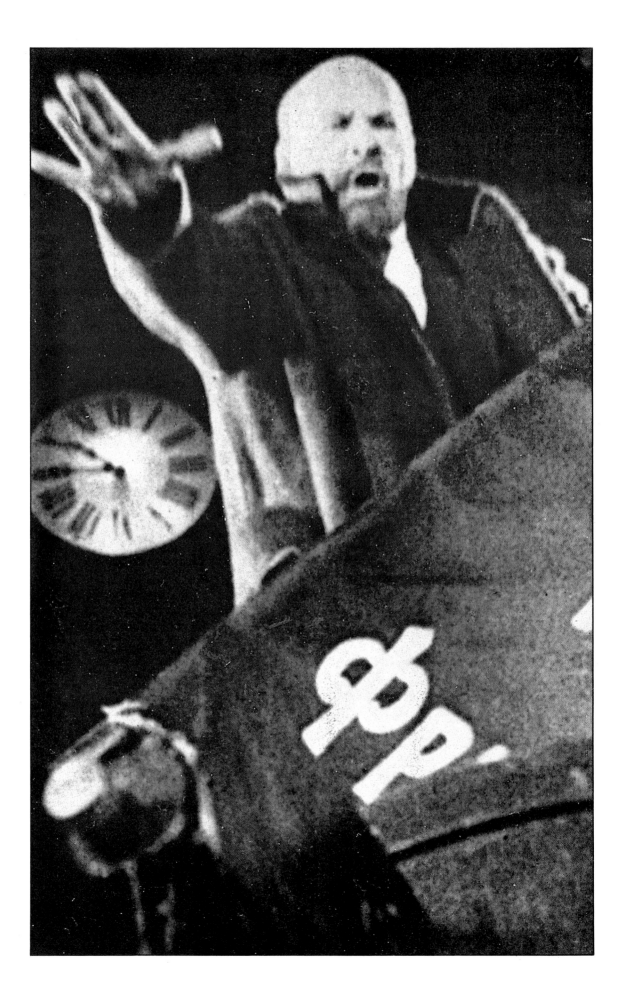

■ THE CZAR'S HAND

The filming of *October* in 1927 was to provide Soviet historians with the revolutionary imagery they lacked. In a somewhat truculent text, Eisenstein recounted how, within the space of six months, he made his film in Petrograd (which by then had become Leningrad), upsetting the rhythms of several sections of the city and the nonchalant, stay-at-home habits of the people living there. Eisenstein used over 100,000 men to reenact large crowd scenes in factories, in the streets, on bridges, around and within the Winter Palace. Cinematographers and photographers now had the time, without wasting a single shot, to take beautiful pictures of well-directed scenes showing each of the ten days "that shook the world," in all their splendor and in their entirety. As one critic of the Communist cinema put it, "Some of the passages in *October* are among the very finest historic reenactments." It is not at all uncommon to find scenes from *October* reproduced in historical works and described as newsphotos, for example: Lenin giving a speech (the actor Nikandrov, 1), the Central Committee (played by actors, 2), the factories revolt (3), the attack on the Winter Palace (4).

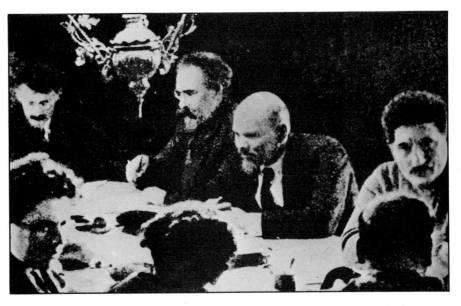

Another aspect of *October* has escaped historians for a long time. Criticizing Eisenstein today is a rather difficult and sensitive matter since we know that the original version of *October* shown by the director in late 1927 was 3,800 meters long, the version shown to the public in early 1928 was only 2,800 meters long, and the copies now stored in various film libraries in the West are barely over 2,200 meters long. Although it is easy to imagine what kinds of cuts Stalin demanded (just as the film is released, Trotsky is transported to Alma-Ata and will be expelled from the Soviet Union the following year), it is nevertheless impossible to accept the simplistic view of history presented in what remains of the film: the Bolsheviks as the only participants in the Revolution; the absurd Mensheviks; Kerensky as a hateful, cowardly, megalomaniacal dictator placed on the same footing with the right-wing Kornilov; the Church won over to the revolution, etc.

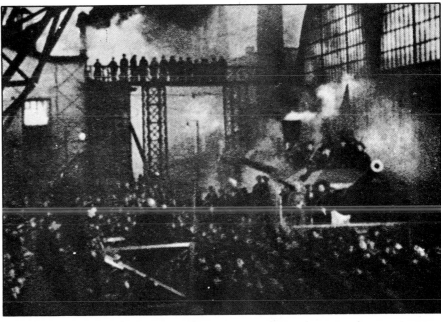

Seen in the opening scenes of the film is the enormous statue of Alexander III. The Czar is seated on his throne with his crown on his head; in his right hand he holds his scepter and in his left hand the imperial globe. He is surrounded by a crowd of workers and peasants. Men and women are winding a dozen or so ropes around the bust and limbs. Then we see the statue— this time without the ropes—breaking

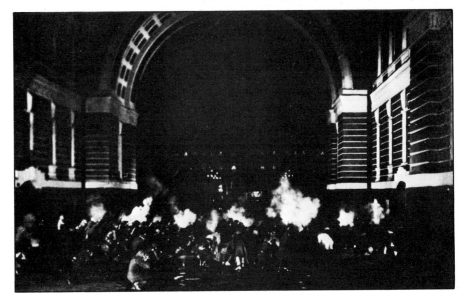

apart, piece by piece. Throughout the film, it crumbles or reassembles, depending on the progress of the revolution. The statue's fall was treated by Eisenstein as a symbol, and since it is woven into a linear plot development involving several thousand shots, the question never arises—indeed, there is no time for it—of what relationship this image has to actual historic events.

The first discrepancy is that the film takes place entirely in Petrograd, whereas the statue was in front of Christ the Savior Church in Moscow. More important, it was not actually knocked down until 1921, four years after the October Revolution, when the new regime was solidly established. It was not destroyed by a group of workers and peasants representing "the Russian people," but by Moscow city officials.

Nevertheless, close-ups of the Czar's hand holding the globe and fallen to the ground now appear in all Soviet works to illustrate the events of October 1917. Even more bizarre is the fact that this photograph is always printed backwards, showing a right hand. Thus, when he made his film in 1927 evoking the revolutionary events of 1917, Eisenstein incorporated an occurrence from 1921 (which he of course recreated with models). It was then appropriated by Soviet "historians," who used its images to illustrate the revolutionary saga. The picture, then, is four times fake. Fake because it shows a motion picture model; fake because it purports to show an event that had not yet occurred; fake because it implies that the event took place in Petrograd and not in Moscow; and, finally, fake because it shows a right hand instead of a left hand.

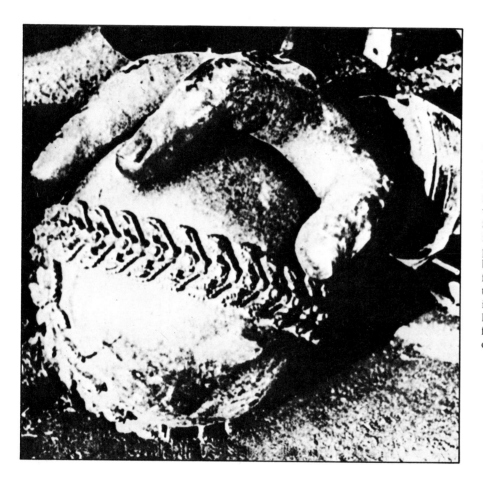

1, 2 and 3. Released by Tass News Agency about 1930–1936, no source mentioned. Reproduced by most of the major news agencies in the West (Keystone, Viollet) with the captions: "Central Committee meeting in Petrograd," "Lenin speaks," "Factories in revolt." They are also found in numerous history books, for example: G. Soria, Les 300 jours de la révolution russe, *Paris 1967; and* Lénine, Génies et réalités, *Paris, 1972.*
4. V.I. Lénine, Bref Essai biographique, *Moscow, 1972. With the caption: "November 7, 1917, Petrograd rebels storm the Winter Palace, stronghold of the provisional counter-revolutionary government."*
5. A. Nenarokov, 1917 en Russie, La révolution mois par mois, *Moscow, 1977.*

■ CAMOUFLAGE AT SMOLNY

The Smolny Institute was a boarding school built by order of Catherine II to provide a new form of education for daughters of the aristocracy. It was in this building, located on the banks of the Neva, away from the center of the city, that the Central Executive Committee of the Councils (Soviets) of Workers' and Soldiers' Deputies was established, with Kerensky's approval. The II Congress of Soviets proclaimed the Soviet government there (October 25-27, 1917). The institute remained the headquarters of the councils until their transfer to Moscow in March 1918. Thus, it was from here that the Bolsheviks directed the insurrection and the establishment of the new regime. Numerous photographs taken during the revolution show the façade of the Smolny Institute covered with posters and handbills. One of these photos is a frame taken from a contemporary newsreel and then retouched (photo 2). The poster on one of the columns of the entrance was rather crudely painted over. In a frame from the same newsreel (photo 3), as in Pyotr Ozup's photograph of the front of the institute (photo 1), the objects painted over are a bit more discernible.

According to the eyewitnesses and experts we consulted, the posters may have been announcements written and signed by Trotsky himself.

The photograph by Pyotr Ozup was first published in John Reed's book Dix jours qui ébranlèrent le monde, *Paris 1927. But even there it was retouched. It appeared in an exhibition entitled* Pionniers de la photographie russe soviétique, *Musée des arts décoratifs, Paris, in 1983 (catalogue with the same title, Paris, 1983).*
The retouched photo appears in A. Nenarokov, 1917 en Russie, *Moscou, 1977.*
The other frame is in Shagi sovetov, *1917–1936, Moscou, 1977.*

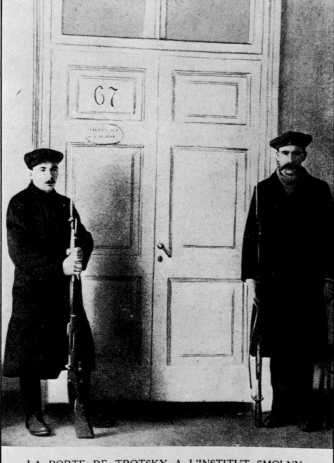

LA PORTE DE TROTSKY A L'INSTITUT SMOLNY.

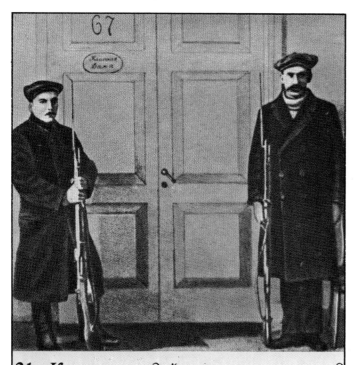

21. Красногвардейцы охраняют вход в кабинет В. И. Ленина в Смольном. 1917 г.

■ TROTSKY'S DOOR

This picture, published in the original illustrated editions of John Reed's book, *Ten Days that Shook the World*, bore the caption "Trotsky's Door at the Smolny Institute." Later, in the 1930s, several passages in the book, especially those referring to Trotsky's role in the October events, were deleted, not only in the Soviet editions but also in the foreign-language editions published by Communist parties in the West. Of course, the photo portrait of Trotsky in the original, illustrated edition was also deleted. "Trotsky's Door" became "Lenin's Door" in John Reed's book, as it did in many other illustrated history books. Similarly, at the Smolny Institute, which is now a museum, Lenin's apartment was restored, but there is no trace of the other Bolsheviks who participated in the revolutionary events and were later eliminated by Stalin.

Anonymous. First publication in John Reed, Ten Days. . . . *The caption in Russian is taken from* Lénine, sa vie et son oeuvre, *Moscow, 1985.*

Mussolini, Master of Images

In Milan, in March 1919, Benito Mussolini, former Socialist activist, forms the *Fasci italiani di combattimento* (Italian combat units), which, two years later, will become the *Partito nazionale fascista*.

In October 1922, after 40,000 "blackshirts" march on Rome, King Victor Emmanuel calls Mussolini to power. First named prime minister, Mussolini, following the crisis in 1925 caused by the assassination of the Socialist deputy, Matteoti, inaugurates a totalitarian regime with himself as "Il Duce" (chief). Phony elections, secret police, bureaucracy, a people's party, indoctrination of all citizens from birth, imprisonment of opponents, emergency courts: even before the Soviet regime became Stalinist, before Hitler triumphed in Germany, or Franco in Spain, Italy provided Europe with the model of the modern totalitarian state.

In 1924, Mussolini founds *L'Unione Cinematografica Educativa* ("LUCE," which also means "light" in Italian). For almost twenty years the Luce Institute produces almost all of the regime's propaganda pictures, whether cinematographic, photographic, or simply graphic. Films, photos, postcards, banners, posters, and statues proliferate Il Duce's portrait *ad infinitum*. Retouching is constant: trivial details and people near Mussolini are erased, backgrounds are blocked out, and photographs are mounted in such a way as to produce the greatest emotional impact. The dictator, quick to don a costume and rather fond of dramatic scenes and every sort of symbolic gesture, becomes the model of the virile and militant virtues of Fascist Italy.

■ THE GRAIN BATTLE

Giacomo Acerbo, minister of agriculture in the Fascist government, announces the results of the "grain battle" in Il Duce's presence. Fascism enlisted workers in large "battles," organized militarily: grain battle (1925–1931), land improvement battle (1928), lira battle, birthrate battle, etc.

All members of the government wear the Fascist uniform: the workshort worn by farm workers in Emilia-Romagna, as well as the uniform of the *arditi*, commandos in the 1914–1918 war (some of whom followed the poet Gabriele d'Annunzio in 1919 when he seized control of the city of Fiume and established a protofascist regime that was to last only a year). No doubt there was also some identification with Garibaldi's "red-shirts," who played a prominent role in Italian history between 1848 and 1867.

From a photograph taken during this ceremony and showing Il Duce standing stiffly erect with his arms crossed, a stern face, and a set jaw—a pose he was fond of—the Luce Institute created a rather striking portrait simply by blocking out the background. It was immediately reproduced, millions of times, in the form of postcards, handbills, posters, awards for well-behaved schoolchildren, enameled plaques, and of course, photographs suitable for framing and hanging up at home or in public places.

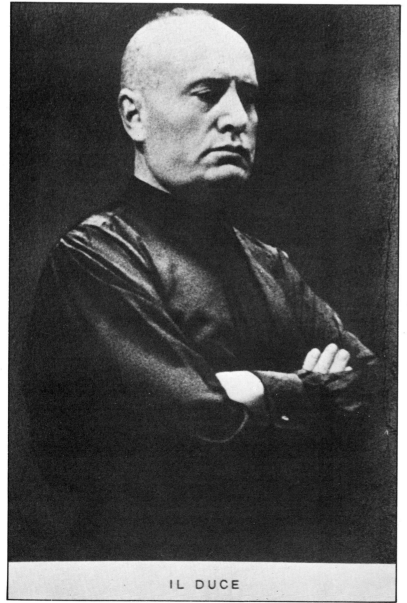

IL DUCE

1. Anonymous. Probably about 1926–1928.
2. Poster, photo, and postcard, the Luce Institute, 1930s.

■ THE SWORD OF ISLAM

June 29, 1942. Mussolini, who has just landed in Tripoli, gets on a horse and waves the gold sword of Islam, presented to him by the Moslems of Libya. In the preceding weeks, German-Italian troops led by Erwin Rommel have taken Tobruk and advanced toward Egypt. Mussolini already pictures himself in Cairo. But in Libya he learns that Rommel, recently promoted to field marshal by Hitler, has stopped at El Alamein. Mussolini returns, disappointed, to Rome. In the fall, Montgomery will take El Alamein and begin relentlessly repulsing

Rommel's *Africa Korps*.

Incidental details such as the person in the background and the groom are eliminated from the photo in order to show Il Duce in splendid isolation.

1. *June 29, 1942. Anonymous, distributed by the Luce Institute.*
2. *Louise Diel,* Mussolini mit offenem Visier, *1943. And Giorgio Pini,* Mussolini, l'uomo e l'opera, *1953–1958.*

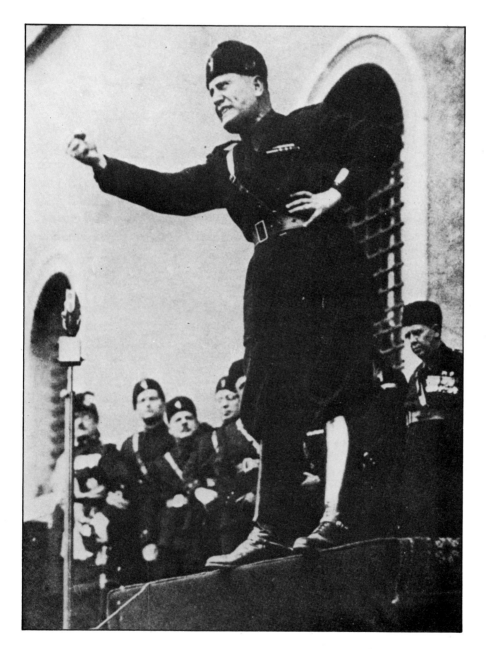

Mussolini gives a forceful speech on the occasion of the Fascist Labor Festival, April 22, 1934. The Labor Charter of 1927 created a type of corporate system that, of course, provides a form of full employment for a time, but also regiments workers' lives well beyond their working hours.

The photographs taken that day are retouched in various ways. The figure of the speaker, with the background blocked out, is reused in posters, magazine covers, and postcards. In one version from the Luce Institute, Il Duce is even turned into a kind of statue: the platform has been transformed into a pedestal engraved with the date of the ceremony according to the Fascist calendar.

Another picture taken the same day is blocked and retouched to separate Il Duce from the background and to remove the heavy rope hanging in front of him. These pictures of Il Duce gesticulating with his fist raised, but isolated from trivial details, are simply captioned: "Mussolini the Orator" or, more pompously still, "The Wordsmith," or "The Founder of the Empire." And sometimes the most frequently repeated slogans of the day: *"Credere, Obbedire, Combattere!"* (Believe, obey, fight!) or *"Mussolini a sempre ragione!"* (Mussolini is always right!).

1. April 21, 1934.
2. Released in this form by the Luce Institute.
3. Same day.
4. Published in this form in Louise Diel, op. cit.

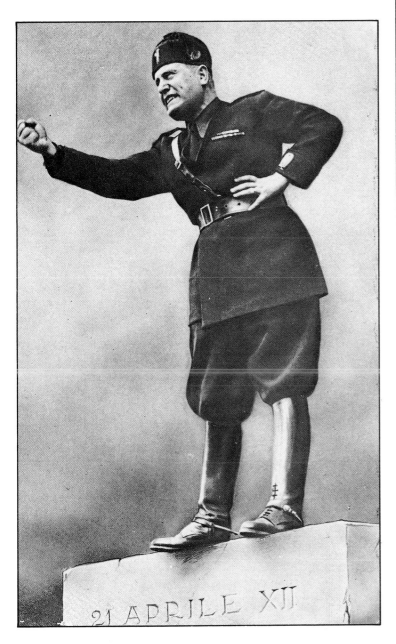

21 APRILE XII

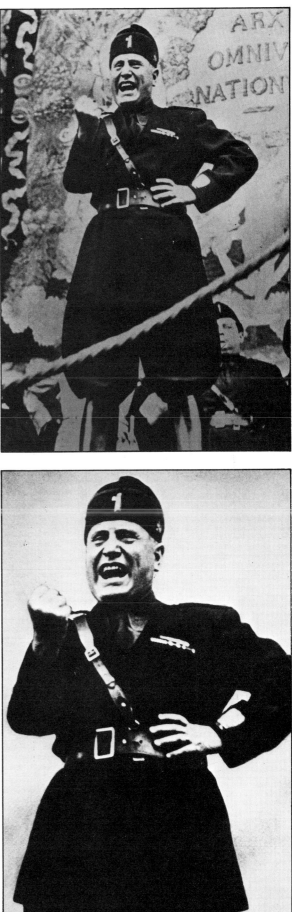

■ A FLOOD OF PICTURES

Rarely has a head of state ever left behind such a wealth of pictures. Mussolini dabbled in everything, showed up everywhere, and invariably invited photographers to accompany him. He was seen in public playing the violin, fencing, diving, shooting a rifle, harvesting, and working as a blacksmith. He appeared dressed as a peasant, a worker, a fireman, a sharpshooter, a deep-sea diver, an equestrian, an aviator, a motorcyclist, a sailor, a miner, or as a member of any other occupational group he was planning to visit. He was unafraid of posing barechested or in a bathing suit. From gas mask to top hat, from bowler to Fascist fez, from fedora to helmet, reporters tried—unsuccessfully—to keep track of all of Il Duce's many hats. No doubt Mussolini's somewhat deranged behavior was perfectly suited to the requirements of propaganda. Il Duce as the model of military courage, heroic work, Italian virility, and his pictures exemplify the major Fascist themes: outdoor life, violent sports, the tradition of ancient Rome, etc. Many of these photographs are retouched to give them a more forceful impact. Thus, in the treatment given a photograph showing Il Duce in his race-car (1), his gaze is intensified and the background is flattened: the pictorial effect makes the picture more dynamic. Or Il Duce's stern face is engulfed in darkness (2) to heighten the disquieting effect (compare this with what Hoffmann will do with a cut-out portrait of Hitler for an election poster). Naturally, Italian antifascists distorted this picture by printing prison bars over it (3). The positioning of Il Duce's figure against a classical background, here the Coliseum (4), or, on the contrary, making him a cutout (5) both stem from a desire to sanctify in the style of classical antiquity. Sometimes the "painter" allows himself to be carried away by the lyricism of his subject and the result is far removed from photography (6).

1. Giorgio Pini, op. cit.
2. 1925 poster from an earlier photograph.
3. Antifascist postcard in reaction to the assassination of the Socialist deputy, Matteoti (1925).
4. 1936. Published in the form of a handbill.
5. Several versions, among others in Giorgio Pini, Mussolini, Berlin, 1940, and Louise Diel, op. cit.
6. April 27, 1924. Giorgio Pini, op. cit., 1953–1958.

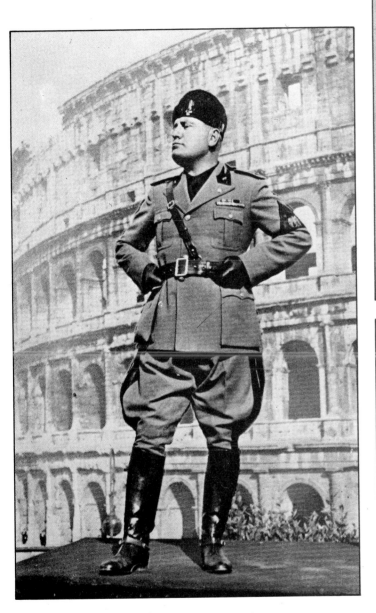

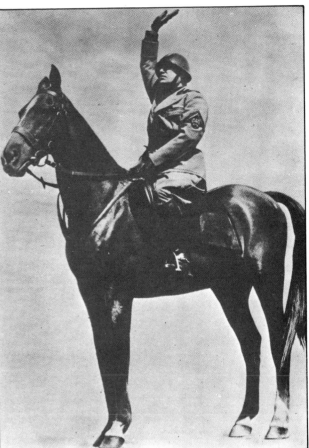

■ THE TWO SHADOWS OF THE AXIS

One of the meetings between Mussolini and Hitler. The propaganda of both countries heavily exploited these historic meetings in order to strengthen the Berlin-Rome axis, but without always realizing how ludicrous this pair of decked-out military men could sometimes look, that aspect Charlie Chaplin underscored so effectively in his film, *The Dictator* (1940). Still darker versions of this clever backlighted scene were made to heighten the dramatic aspect of the conversation, but the effect was that of a Chinese shadow play

1. Photograph probably taken at the conference in Munich in September 1938.
2. Distributed in the form of a postcard.

■ FROM FUTURISM TO PHOTOMONTAGE

The futurist movement, which emerged before the First World War and was developed primarily in northern Italy, ranked in the forefront of its interests the social contract, urban civilization, and the machine. Its antibourgeois ideology, however, was highly nationalistic and interventionist (Libyan War, 1911), and its mystique of action, strength, heroism, and even aggressiveness ultimately led to the glorification of war as the "world's only means of purification." This illustrates how well the second wave of the movement accorded with Fascism, to the point of becoming a sort of official art of the regime (see the manifesto, *Futurisme et fascisme*, 1924).

One of the great specialties of the movement was the photomontage. Concurrently with constructivism in the USSR, or, in Germany, with John Heartfield, Lazlo Moholy-Nagy, or the Dada movement, the photomontage enjoyed enormous popularity, boosted by the sudden proliferation of illustrated magazines after the First World War. Italian photomontages exalted the machine, airplanes, trains, large ships, metropolises, and skyscrapers. The amassing of multiple images in a single frame provided propaganda departments with an inexpensive means of producing images of abundance (fruits, grains, motors, factories), fertility (nursing mothers, children), or strength (gymnasts, soldiers, tanks, airplanes). One of the principal forms of visual propaganda, photomontages were produced linking modern and ancient Rome (1) as well as terrifying collages of a Mussolini multiplied to infinity (2).

1. *"Legions of the disabled march on the new highway of the Empire." L'Italie fasciste, Rome, 1932. The montage incorporates at least four elements: the arch, the Forum, the procession, and the airplanes.*
2. *Photomontage from 1936, unsigned.*

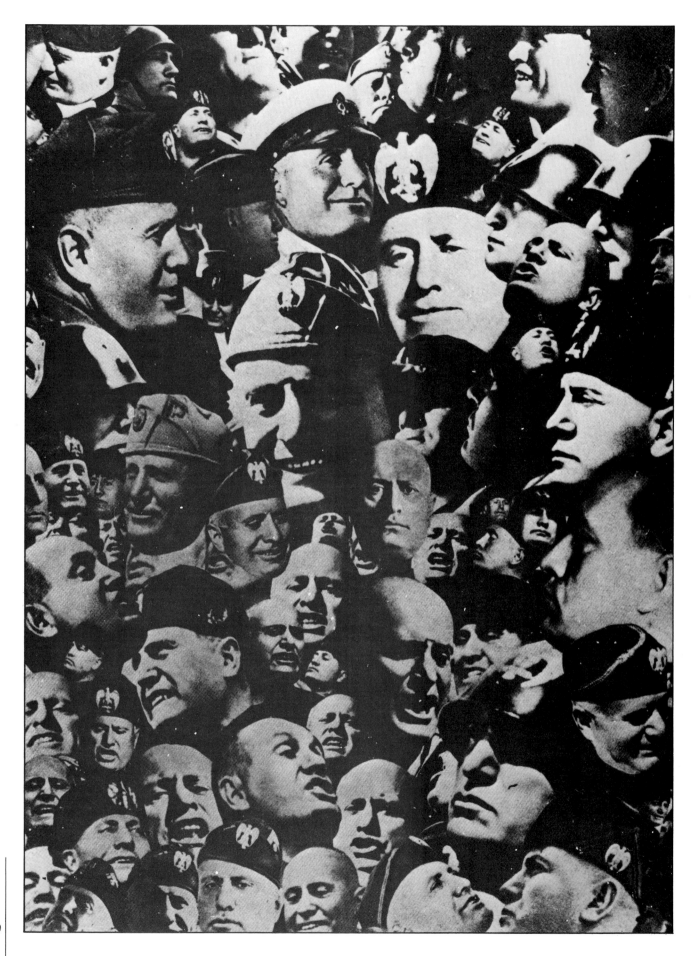

Productions of the Third Reich

During the Third Reich (1933–1945), the manipulation of images was raised to the level of a state art. The enormous productions designed by Albert Speer, architect of the regime, with their flags, banners, torches, and immense colonnades framing masses of men in uniform, blend perfectly with the innumerable, garish, brutal, persuasive posters of Propaganda Minister Joseph Goebbels and the floods of photographs of the Führer distributed daily by his official photographer, Heinrich Hoffmann. Photography and the cinema are used systematically as propaganda tools to assist in the fabrication of racist myths and the glorification of party leaders and the army, as well as campaigns supporting a return to the land, the fight for *lebensraum*, and attacks on enemies at home and abroad. Photographic retouching is about as common as it is in the Soviet Union at the time, but is less a question of remolding a still-recent history (photographs of undesirables are simply suppressed) than of making pictures reflect a political utopia: concentration camps are represented in 1933 as a sort of enjoyable vacation work camp; the Jewish ghettos of Europe are depicted in major ethnographic reports as enclaves of idleness, vice, and contagious diseases; and whole magazines are devoted to pictures of young German "Aryans" armed with shovels, perfectly disciplined soldiers, babies raised to love the Führer, and German mothers dedicated to perpetuating the "master race."

During the Second World War there is no longer any limit to propaganda, even in the field of pictures: fake newsreels, fake battle scenes, fake landscapes, and fake heroes are created to fuel the rumor campaigns and the terror spreading throughout Europe by Nazi order. Or to conceal the terrifying secret of the "final solution."

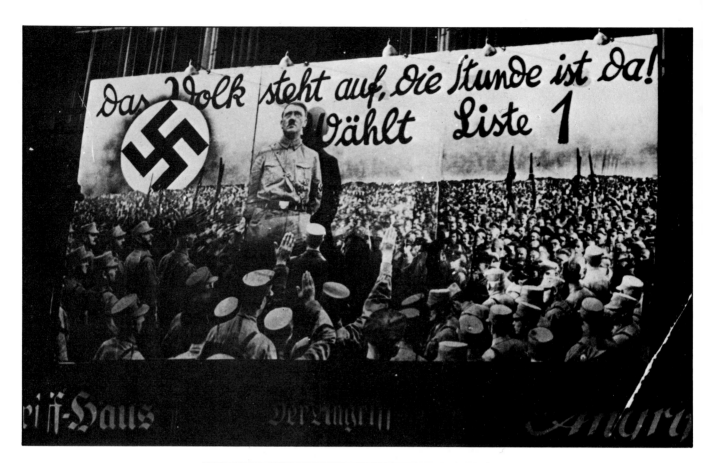

■ A PHOTOGRAPHER IN THE FÜHRER'S SERVICE

Hitlerian imagery owes everything to one man, Heinrich Hoffmann (1885–1957), who attached himself to Hitler in Munich in 1919 and remained a member of his entourage until the end. After joining the Nazi Party to provide coverage for the Hearst news agency, Hoffmann became a friend of Adolf Hitler, who, in 1933, gave him exclusive photographic rights and even made him a member of the Reichstag. He founded an agency that controlled all newspapers; his business sense and his absolute control over all pictures of the regime enabled him to amass an immense fortune within the space of a few years. Hoffmann published a large number of propaganda albums, focused essentially on the person of the führer. Throughout the Third Reich he controlled the distribution of photographs of the führer or, on the other hand, had them suppressed. He was responsible for the pictures used in photomontages (photo 1) and the portraits selected for highly stylized election posters (photo 2), as well as simple propaganda photos, which were often heavily retouched (photos 3 and 4). Arrested after the war and sentenced to 10 years in prison, that sentence was afterward shortened to five years, Hoffmann was finally removed from the list of war criminals and classified as an accessory. Some of his files were seized by the Americans and removed to Washington. Freely available from then on, most of his photographs were reproduced and distributed throughout the world by major news agencies, and still are today, despite a lawsuit filed and won by his son and heir, Heinrich Hoffmann.

1. Giant poster on the front of the building of Der Angriff *(The attack), Goebbels' newspaper. The slogan says, "The people rise, the hour has struck. Vote for List 1." Berlin, July 1932.*
2. Election poster, July 1932.
3 and 4. From the album Jugend und Hitler *(Youth and Hitler), Munich, 1935.*

■ THE PUTSCHIST IN PRISON

This photograph of Hitler with General Erich Ludendorff is a montage created in 1924 by Heinrich Hoffmann. The figure of Adolf Hitler is from a photo taken by Hoffmann during the Munich putsch (November 7-9, 1923).

Although they were both leaders and active participants in the putsch, there was no good photograph of Hitler and the general in uniform together. The two men quickly became estranged (Ludendorff founded his own nationalistic, antisemitic, anti-Masonic group, the *Tannenberg bund*). But in that year of 1924, Hitler, sentenced to prison and politically isolated, could not afford to disagree publicly with the hero of the Great War.

The montage, showing the two men standing very close together, can thus be interpreted as a way of blackmailing Ludendorff, a way of reminding him that although his prestige as a hero of the Great War saved him from going to prison, he had responsibilities toward the German nationalist movement. This "photograph" is almost always dated "August 1924," which is obviously impossible since at that precise moment Hitler was behind bars in the Landsberg fortress and Ludendorff was free.

1. November 1923.
2. Montage released in the summer of 1924.

■ THE MARSHAL AND THE CORPORAL

This photograph shows Hitler with Marshal Paul von Hindenburg. It was taken in November 1932, when von Hindenburg, president of the Reich, met with Adolf Hitler after the resignation of the von Papen government.

The next year, when Hitler had become chancellor, this same photograph was used in an election poster. Both figures were retouched. Hitler was given a military jacket and overcoat and the two faces were touched up to correct the flattening effect of the magnesium flash. Of particular interest is the fact that the two men were moved much closer together. The future führer's stiff appearance in the original photo and the respectful distance he maintained between himself and the old soldier disappear in the poster. Hitler now appears as the political equal of the field marshal, but, even so, slightly in the rear, as dictated by his military rank. The German text says: "The field marshal and the corporal are fighting with us for liberty and equality." But this poster, which is not represented as an authentic document (it is signed, "Montage Bauer, Munich") also serves as blackmail because it closely links Hitler to the old field marshal, who thought little of the man he nicknamed "the Bohemian corporal."

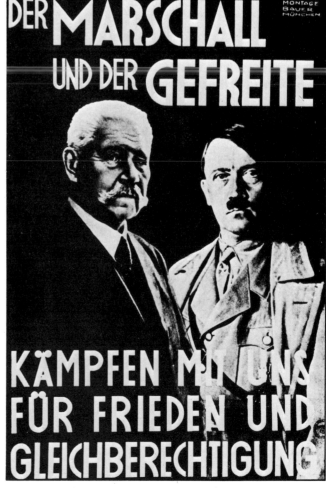

1. *Probably November 19, 1932.*
2. *Poster from 1933.*

■ PORTRAIT OF A LEADER

For the poster subtitled *Ein volk, ein Reich, ein Führer*, created at Goebbels' instructions, no doubt in 1938, and very widely distributed throughout Germany, a much older photograph by Heinrich Hoffmann was used, showing Adolf Hitler standing with his arms resting on the back of a studded chair. He is wearing a double-breasted jacket with metal buttons and a dark armband on his left arm; on his chest are the Iron Cross and two other decorations. The stern gaze into the distance, the shadows on the face (the lighting, which is horizontal, comes from the right), the collar, and the necktie to which a small insignia is pinned were duplicated exactly in the 1938 version. But the back of the chair, too prominent in the photographic version, has been pushed aside. Now, only Hitler's left forearm is resting on the chair. His right hand is on his hip—a sign of determination, authority—and is closed into a fist, which is almost never seen in classic easel portraits, from Velasquez to Franz Hals. The chair has somehow been "ennobled:" the studs are larger, farther apart, beveled. The addition of pockets with flaps and the khaki color make the jacket more distinctly military. On the armband, which is blood red, the edge of the white circle containing the swastika is visible. Finally, the unknown artist removed the figure from the background and gave it a strange and somewhat disturbing resonance by adding a halo around Hitler's neck, of the same red color as the armband. The new pose and pictorial treatment recall the portraits of condottieri, doges, or emperors and accord well with the slogan "One People, One Empire, One Leader."

Another version of this composition was published with the word *Ja!* (Yes!) as the only caption. The führer's face also graced a postage stamp issued in 1937. In 1943, in the midst of the war, this same photograph with the same wild-looking face was used again, but this time with a different treatment of the jacket, hands and chair, and the caption: "Adolf Hitler Is Victory!"

Ein Volk, ein Reich, ein Führer!

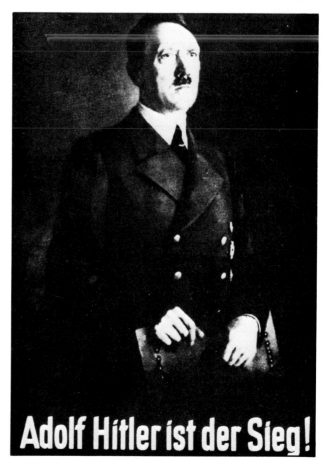

Adolf Hitler ist der Sieg!

1. *Date unknown.*
2. *Anonymous, 1938.*
3. *Poster by R. Gerhard Zill, 1943.*
4. *German postage stamps issued in 1937.*

■ FORBIDDEN PHOTOS

The first picture book about Hitler, *Hitler Wie ihn Keiner Kennt* (The Hitler nobody knows) was published in 1932 by Heinrich Hoffmann. It contained about a hundred photographs showing the infant Hitler, Hitler the soldier, Hitler on a picnic, etc. The photos were intended to illustrate the political figure's life. On January 30, 1933, Hitler was appointed chancellor of the Reich. On June 30, 1934, during the "night of the long knives," he had Ernst Röhm and the other S.A. leaders killed. In the second edition of Hoffmann's book, which appeared that year, one photograph was missing: the one showing Hitler talking affably with Röhm. Goebbels had every photo destroyed that showed Hitler with Röhm or the S.A. chiefs. Even Leni Riefenstahl's film, *Sieg des glaubens* (The victory of hope), which was dedicated to the Nazi Party of 1933, was destroyed because it showed Hitler surrounded by all those who would later be assassinated.

Later, Hitler asked that *The Hitler Nobody Knows* be withdrawn from circulation and not republished. The pictures of baby Adolf, of the corporal wounded in the eyes or celebrating with his regimental buddies (2), the grown man in shorts (1), or the little slip-ups of his photographer (4), did not seem to him compatible with the dignity of a head of state who made the world tremble.

To study his poses and gestures during his speeches, Hitler had Hoffmann take a series of photos. But he forbade him to publish them and asked him to destroy the negatives (3). Hoffmann did not publish these photos until after the Second World War, in 1950.

1. *Dated 1925.*
2. *Anonymous; no doubt taken in 1918. From* **Hitler Wie ihn Keiner Kennt** *(1932 and 1934).*
3. *Date unknown, probably 1933.*
4. **Hitler Wie ihn Keiner Kennt** *(1932 and 1934).*

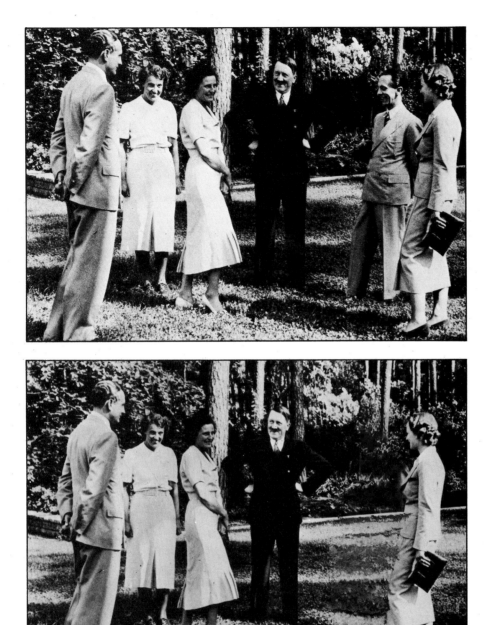

■ GOEBBELS IN THE FOLIAGE

The scene was recorded in 1937 by Heinrich Hoffmann. In the park of the Chancellery of the Reich, in Berlin, Hitler is talking with the actress Leni Riefenstahl, who became the official filmmaker of the Nazi regime, and Joseph Goebbels, propaganda minister.

A second version of this photograph was found in Hoffmann's files well after the war: Goebbels had vanished into the grass and the foliage. The führer was very close to Leni Riefenstahl, whom he had known in 1932: the international press made the actress a sort of *éminence grise* of Adolf Hitler, possibly even a prospective "fiancée."

But, in no time, rumor also made Goebbels Riefenstahl's lover. Was it a fit of jealousy or some sort of moral outburst that made Hitler ask Hoffmann to efface Goebbels? We will probably never know. Moreover, it seems unlikely that this photograph, retouched merely because of a whim of the führer's, was ever published at the time.

1. Left to right: Heinz Riefenstahl (Leni's brother), Dr. Ebersberg, Leni Riefenstahl, Hitler, Joseph Goebbels, and Ilse Riefenstahl (Leni's sister-in-law). Exact date unknown (summer 1937).

■ THE CIGARETTE BUTT FROM THE PACT

August 23, 1939. Joachim von Ribbentrop, foreign affairs minister of the Third Reich, shakes hands with Joseph Stalin, leader of the Soviet Union, with whom he has just signed a nonaggression pact. His hands untied, Hitler orders the invasion of Poland only a few days later, setting in motion the first phase of the Second World War. The next day, when he receives the photographs Hoffmann took during the signing of the pact, Hitler studies them very closely. He wanted, in particular, to be sure that his important new ally, Stalin, was not Jewish, which would be proved, according to a naive racist belief in vogue at the time, if he did not have attached earlobes. Reassured on this point, Hitler, who was a vegetarian and staunchly opposed to tobacco, was extremely annoyed, however, to see that Stalin had not stopped smoking during the ceremony. "The signing of a treaty is a solemn act which you do not attend with a cigarette stuck in your mouth," he told Hoffmann and asked him to get rid of Stalin's cigarette butts before releasing the photos to the press. Hoffmann immediately touched up the background of the photo showing the historic handshake and made the annoying cigarette butt disappear into it.

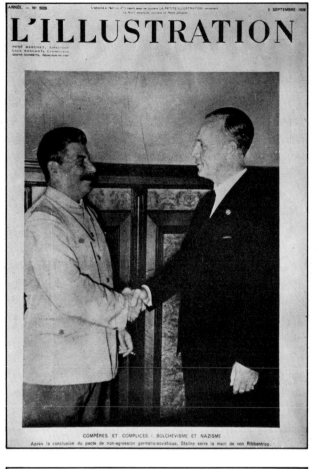

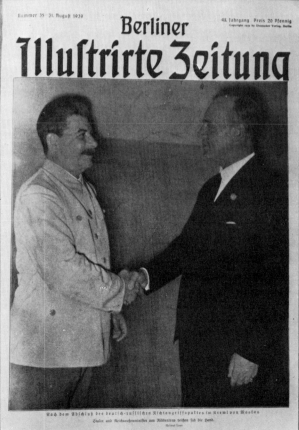

1. Version sent abroad by Hoffmann: L'Illustration, *no. 5035, September 2, 1939.*
2. Retouched version: Berliner Illustrierte Zeitung, *no. 35, August 31, 1939.*

Kommunisten überfallen Horst Wessels Leichenzug

Der Kommunist Ali Höhler,
der Mörder Horst Wessels

■ FROM CINEMA TO HISTORY

Of all the heroes of the Nazi movement, Horst Wessel is certainly the one about whom legend was the most false. A law student born in 1907, he joined the S.A., where he became a very aggressive leader (2). A poem he had written, "Raise the flag . . ." was published by *Der Angriff* and then set to the tune of a Viennese song, thus becoming the famous *"Horst Wessel Lied."* He was in love with a prostitute with whom he was living in 1930, when their landlady, wanting to evict them, sent round another thug, Ali Höhler, who killed Wessel (3). While the young man lay dying in the hospital, Joseph Goebbels mounted a fantastic propaganda campaign portraying the seedy, little pimp as "a Christ of Socialism" and his assassin as a Communist. The funeral was magnificent, and the procession was even treated to "a Red attack." Beside the grave, Goebbels called out "Horst Wessel!" and the S.A. responded "Present!" under a hail of Communist rocks In Berlin three years later, after the Nazis had assumed power, a film glorifying Horst Wessel was shown, the title of which was *Hans Westmar*. Adapted by the filmmaker Franz Wenzler from a book by Hanns Heinz Ewers and containing crowd scenes played by the actual S.A., this fictional film account contributed to the myth to such an extent that Nazi historians used it to illustrate episodes in the struggle for power in Berlin. The camera angles and the centering of photos from the film are obviously superior to the newsphotos. Such is the case with the picture of the funeral (1), taken directly from the film but with a caption claiming that it is a Communist attack on the funeral procession of Horst Wessel.

1. Photo from the filming of Hans Westmar, *Berlin, 1933. Reproduced with the caption "Communists attack the funeral procession of Horst Wessel," in the book by N. Bade,* Die S.A. erobert Berlin *(The S.A. conquers Berlin), Berlin, 1937.*
2. Source unknown.
3. Same book by N. Bade, with the caption: "The Communist Ali Höhler, assassin of Horst Wessel."

■ CHURCHILL, AS SEEN BY THE GERMANS

A Nazi propaganda poster dated 1941 shows Winston Churchill wearing a high bowler hat, a bowtie, and a dark, pin-striped suit, with a fat cigar stuck on his bottom lip and a submachine gun under his arm. He is standing behind a wall, and the poster says simply, *"Heckenschützen,"* which may be translated as "sniper." The circumstances are strange, but this is undoubtedly a photograph. The creator of this poster did not have to put Churchill's head on a gangster's body: he simply used a newsphoto of the British prime minister holding a submachine gun during a visit to a military base. He cut out the figure of Churchill, tilted his head a bit to give him a more sinister appearance, and then put him in a new, very simple setting with a black strip suggesting a wall. Another version of this retouched, cut-out picture was also distributed in the form of leaflets dropped over England from German aircraft. This photomontage has a fairly distinctive character, however. No one, not even the most naive of those for whom such a poster was intended, believed for a moment that the British prime minister was a sniper. Even though, in this case, the original situation was real, the scene in the poster is improbable. And it was understood as such by everyone who saw the poster, but the message it was intended to convey was nevertheless immediately perceived: Churchill is a crafty, double-dealing, dangerous enemy. ("He is not even a gentleman," Hitler said of him.) Interestingly enough, the original photograph was itself used in the British press as a propaganda image conveying exactly the opposite message (the prime minister is interested in every contribution to the war effort).

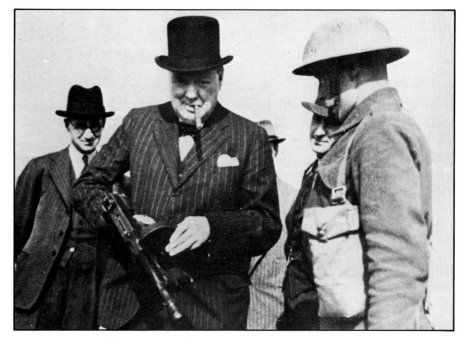

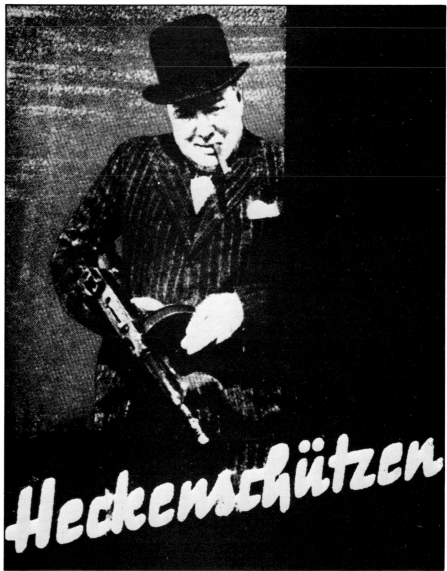

1. Churchill inspecting the defenses of the northeast coast, July 1940.
2. German poster, 1941.

■ "THE FÜHRER GIVES THE JEWS A CITY"

In 1944 the Propaganda Office of the Third Reich decided to make a film to counteract the information circulating about the concentration camps and to influence the International Red Cross committees. The film was planned and shot entirely in Czechoslovakia at the Terezin concentration camp (called Theresienstadt by the Germans) by young Jewish prisoners under the supervision of the SS. Responsibility for the project was entrusted to Kurt Gerron, a fairly well-known German actor who was arrested in Holland by the Gestapo and imprisoned at Terezin. The filming took from August 16 to September 11, 1944, and involved several hundred actors, set decorators, musicians, and several thousand extras (there were 60,000 prisoners at Terezin at the time). Gerron wrote a script and shot the film in a highly professional manner, assisted by Czech cameramen and technicians and a very large budget. Included in the film were scenes shot in a café and shown on a split screen with scenes of trench warfare. The narration added later by the Germans said: "While the Jews have coffee and dance in Theresienstadt, our soldiers bear the full weight of a dreadful war and suffer anguish and privations to defend the Fatherland." Prisoners were shown playing football, gardening, harvesting a field of corn, taking showers, visiting well-stocked libraries, and stopping by the post office for large packages. Men worked quietly in spacious, well-lighted workshops, and women looked after children in flower-filled rooms. Also shown was the "community hall" where meetings of the "Council of Elders" were held, as well as an opera for children and a symphony concert conducted by Karel Ancel (an Auschwitz survivor, he later became conductor of the Czech Symphony Orchestra). Jews were seen browsing in a clothing store, playing chess, reading in chaise lounges, and diving into a pool fed by the nearby river. Small children were shown playing in a garden while nurses sliced loaves of bread for them. In a beautifully furnished dormitory young girls were shown fixing their hair, admiring themselves in a mirror, and chatting. In the library two teachers were shown discussing a book, and in the bank a customer presented his passbook to withdraw money, while the manager's secretary handed him some letters to sign. Efficient firemen were shown putting out a fire that had just started. Prisoners were seen in the evening in a cabaret watching musical numbers, an impression of Charlie Chaplin, a magician, a Spanish dance, and joining in on the choruses of *The Threepenny Opera*.

The cabaret, the community hall, the flower-filled rooms, the workshops, the post office, the bank, and the library were nothing but sets built by the prisoners of the camp in the summer of 1944. Some of these sets were designed for both the film and for the Red Cross visits. The postal packages were taken back immediately after being handed out. Fake fires were lighted for fake firemen. A Czech diving champion was summoned to give demonstrations in a pool usually reserved for the SS. Since there were many blond women among the Jewish prisoners, they were banned from the filming so that pictures of the camp would show only inmates with dark hair. As soon as the filming was over, all those who had played a role or who had appeared in the film were sent to Auschwitz, in eleven separate groups. Kurt Gerron died in a gas chamber, but, at the last moment, gave a friend his papers, his notes on the shooting of the film, and his correspondence with the camp authorities and actors. All of the prominent Jews who had appeared in the film—the composer Haas, General von Hanish, and former Czech, German, or French ministers, university professors, actors, theater directors, etc.—were also sent to Auschwitz. Most of them died in the gas chambers. The 1,600 children who had appeared in the film were among the last groups and all were exterminated.

In 1945, representatives of the International Red Cross returned to visit Terezin, and the SS showed them Gerron's film, which, in the meantime, had been edited in Berlin, dubbed, and provided with a narration. Title: *So schön war es in Terezin* (It was so beautiful in Terezin). Subtitle: *"Der Führer schenkt den Juden eine Stadt"* (The Führer gives the Jews a city). Clips were shown in German newsreels shortly before the end of the war. So far, only twenty-five minutes of the complete version of the film have been found, but Gerron's script and the file on the making of the film are in the Archives of the Federal Republic of Germany.

Stills from the footage stored at the Koblenz Archives.

74

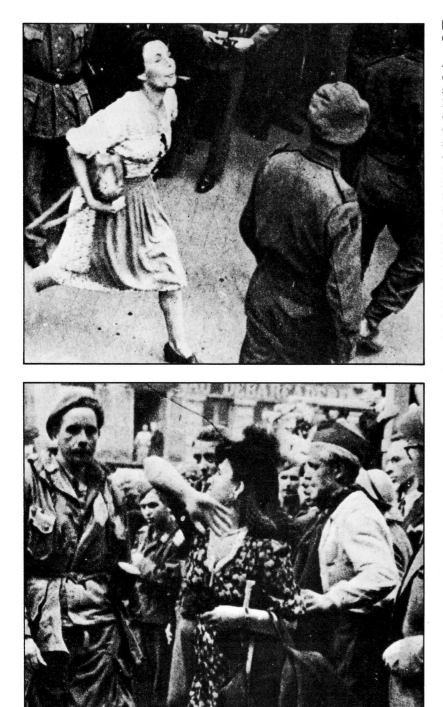

■ A STREET SCENE DURING THE OCCUPATION

A French newsreel sequence in June 1944, certain scenes of which were reproduced in a series of newsphotos, shows a column of English and American prisoners walking down a street in Paris, surrounded by German soldiers. The prisoners are pulled aside, insulted, and spat upon by a small crowd of angry spectators. The Nazi officer in charge of the prisoners is forced to intervene personally, and the soldiers have to use their rifle butts to repulse the overexcited Frenchmen. The sequence was intended to supplement the campaign of posters, rumors, and false reports launched after the Normandy invasion and the English and American bombing. Shown in its original form today—it is frequently used without any critical commentary in film montages and historical documentaries—it still evokes a deep sense of unease, dozens of years later. It might be believable were it not for the fact that numerous sources (Ernst Jünger's diary entry of July 2, 1944, and that of Jean Guéhenno dated July 5, among others) have explained that this event was staged by the Propaganda Office. The Germans hired street people to play the Parisian crowd, a German colonel in civilian clothes directed them, and the organizers even provided them with briefcases to give the impression that their presence was purely coincidental. Photographers and cinematographers were also there "by chance." Jünger—naive or hypocrite?—comments: "It is nevertheless surprising to see what the Prussians have come to, they who have always objected to such things."

Photographs taken June 29, 1944. Photographer unknown. They did not appear in the French press but were published several times in the German press. The French newsreel sequence, however, was widely distributed. A clip is included in Français, si vous saviez *by André Harris and Alain de Sédouy (1972).*

Icons of the Stalinist Cult

The December 21, 1929, issue of *Pravda* ("Truth" in Russian) celebrates the fiftieth birthday of Iosif Vissarionovich Dzhugashvili, a Georgian Bolshevik who gave himself the nom de guerre Stalin ("Man of Steel") and who, seven years earlier, had been elected general secretary of the Communist Party, making him the virtual head of the Soviet state. Blaring headlines and huge portraits are matched by columns full of extravagant praise. This early manifestation of mass submission and admiration seems almost tame, however, compared with what will happen in later years.

Superlatives, hyperbolic praise, repetitive slogans, and catch phrases form a strange linguistic unit, recalling the excesses of religious adoration and litanies, but out of all proportion to anything ever seen before: the first printings of certain brochures and books run to 500,000 copies and millions of people are caught up in outpourings of enthusiasm and adulation.

Similarly, the life of the "Father of the People" is rewritten in its entirety. All of the fake historic documentation necessary to the myth are created when required. Photographs are faked and reproduced en masse. The dictator's face is everywhere, in government offices and the humblest cottage. The servile respect and melodramatic veneration accorded these new icons will reach the heights of absurdity. Russians will be sentenced to five years of hard labor for accidentally tearing newspaper pages with Stalin's picture on them. Virtually all of the historic photographs in circulation are retouched. Under Stalin, propaganda images become a veritable industry. And photos of giant construction projects or industrial successes conceal the most extensive network of penal institutions ever created by any civilization.

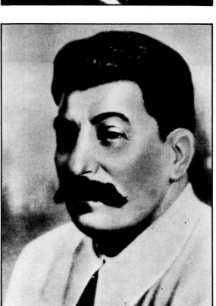

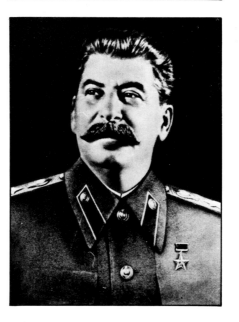

■ A LIFE IN PICTURES

In the early 1930s, when what will later be known as the "cult of personality" is just beginning to take hold, few people are familiar with Stalin's past. Everyone close enough to the dictator to have witnessed his revolutionary adventures or his private life will die a violent death: Nadia Allilueva, his wife (committed suicide in 1932); Kirov, his "beloved brother" (mysteriously assassinated in 1934); Yenukidze, his friend since 1900 (executed in 1937); Mdivani, an old Georgian friend (executed in 1937); Ordzhonikidze, undoubtedly his best friend (executed or forced to commit suicide in 1937). Apparently there really were no photographs, no "family album" telling of Stalin's early years. Using the two or three known photographs (admission to the seminary, police file photo . . .), illustrators created portraits of Stalin at various ages. These portraits were either painted, by copying the texture of the photograph as closely as possible, or, in certain cases, were made from actual photographs. They were reproduced *ad infinitum*, with a whole series of minor variations and were often painted in bright colors in the style of popular folk images.

1. Stalin upon admission to the Gori seminary, 1894. Staline en images, Paris, 1950.
2. Stalin in 1905, op. cit.
3. Stalin in 1910 ("photograph" inspired by the Czarist police file, published after 1920). Staline en images, 1950.
4. Stalin in 1924 at the XIII Party Conference, op. cit.
5. Stalin in February 1934 (retouched portrait, detail from a group photograph), op. cit.
6. Magazine cover at Stalin's death (Ogonyok, March 15, 1953).

■ LENIN'S SUCCESSOR

Until 1924, Stalin is practically unknown outside the Bolshevik circle. Before his death, Lenin warned his closest associates of Stalin's dictatorial tendencies and brutality. But, gradually, as he gains ascendancy, ousts Trotsky, and then finally becomes the absolute master, articles, brochures, and even fake documents reshape Stalin's life. Historic quotations and decisive battles are invented for him. He is made a close associate of Lenin, and even his chief source of inspiration.

The three or four rare photographs showing the two men together and the two photographs taken in Gorky, where they are seen side by side, are obviously not enough, so others are fabricated. Sometimes they are elaborate (see "Stalin Visits Lenin"). But, as often as not, they are simple photomontages of the two faces placed side by side to emphasize, in a very radical manner, the new despot's revolutionary legitimacy. In the rough draft of the 1948 *Biographie abrégée*, the following sentence appeared: "Stalin is the Lenin of today." According to Nikita Khrushchev in his famous secret report (1956), Stalin made the following correction himself: "Stalin is the worthy continuator of Lenin's work, or, as we say in our Party, Stalin is the Lenin of today."

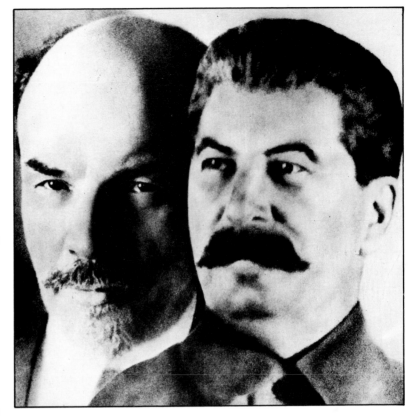

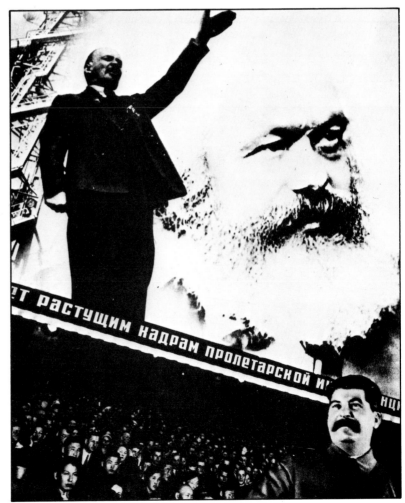

1. Photomontage published by Tass News Agency, late 1930s.
2. Page from L'URSS en construction, *no. 6, June 1934.*

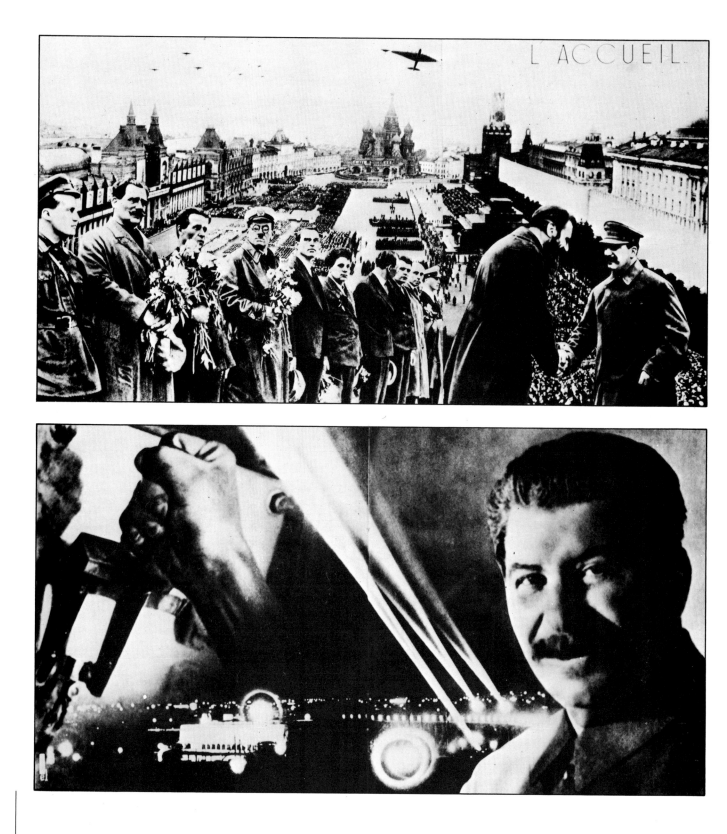

■ PHOTOMONTAGE AND THE CULT OF PERSONALITY

In the Soviet Union between 1920 and 1930, the photomontage enjoys unprecedented popularity. Artists such as Alexander Rodchenko, Lazare Lissitzky, and Gustave Kloutsis invent new forms of formatting and photographic expression. They are in touch with the artistic currents that, in Germany, inspire the same kind of experimentation. Their posters, book covers, and illustrations create a highly characteristic style that will later have a strong impact on other European artistic currents. The collaboration of Mayakovski and Lissitzky on poetry anthologies and Rodchenko's work in the magazine *Lef*, later renamed *Novy Lef*, are still talked about.

The artistic explosion of the 1920s in the USSR quickly faded. Accused of "formalism" (i.e., anti-Marxism) in 1928, the "constructivists" gradually conformed. Their work appeared in international propaganda magazines such as *L'URSS en construction*. Thus, Lissitzky and Rodchenko devoted their talents to increasingly academic montages, which the image of Stalin eventually came to dominate. The starkly contrasting perspectives of a collage such as "The Welcome" do not obscure the official, formulaic aspect of the composition: Stalin "himself" ordered searches to find the members of the *Chelyuskin* polar expedition who had been shipwrecked and stranded on the ice. Following their rescue by pilots, he welcomes them ceremoniously (1). Each time an industrial victory is achieved it is due to Stalin's foresight; it is therefore only logical to juxtapose the start-up of the gigantic Dnieprostroi dam and the leader's smiling face. Had not Lenin said in 1920: "Communism is the power of the Soviets—that, and the electrification of the entire country"? (2)

1. Welcome of the Chelyuskin *expedition. Photomontage by El Lissitsky,* L'URSS en construction, *no. 10, October 1934.*
2. "The current is turned on," L'URSS en construction, *November 1932. Photomontage by El Lissitsky.*

■ A LITTLE GIRL IN *PRAVDA*

All dictators love to be photographed with children. No wonder, then, that there are countless pictures of Stalin laughing and playing with little boys and girls on flower-banked rostrums or at farming collective festivals. Sometimes there are terrible stories behind these otherwise mundane propaganda pictures, as attested by the following commentary that appeared in a clandestine "samizdat" magazine in Moscow in 1976.

In his arms Stalin is holding a little dark-eyed girl wearing a sailor suit: everyone familiar with the 1930s remembers this photograph. But who is this little girl and what happened to her? Very few people know.

This child is Guelia Markizova, the daughter of Ardan Angadykovich Markizov, People's Commissioner of Agriculture of the Buryat-Mongol Autonomous Soviet Socialist Republic.

The photo was taken January 27, 1936, during the "reception held in the Kremlin by Party and government officials to honor the workers of the Buryat-Mongol Autonomous Republic." Sixty-seven delegates from this Republic attended, headed by the Secretary of the Party's Regional Committee, M. N. Erbanov, the President of the Council of Buryat-Mongol People's Commissioners, D.D. Dorzhiev, and the President of the Central Executive Committee of the Republic, I.D. Dampilov. Guelia's father was there that day and was awarded the Order of the Red Banner of Labor.

During this solemn meeting, little Guelia, then six years old, came forward to present a bouquet of flowers to Stalin. Stalin took her in his arms and the moment was captured on film. The photograph, reproduced an astronomical number of times, was later the inspiration for countless paintings, which in turn became an almost essential fixture of every establishment for children—schools, kindergartens, Pioneer halls, children's homes. This photograph became the official symbol of the happy childhood of little Soviets "warmed by Stalin's smile." With little Guelia in his arms, Stalin asked: "What would you like as a present—a watch or a phonograph?" (This was the standard choice: according to the minutes of the meeting, each of the delegates received a gift, either a watch or a phonograph and a record collection). "Both: the watch and the phonograph," answered Guelia. Stalin laughed and so did everyone else.

The next day, Guelia received a phonograph with a record collection and a

gold watch. Both were engraved with the words: 'To Guelia Markizova from Party Leader J.V. Stalin.' Shortly after his return to Oulan-Oude, Guelia's father was arrested along with Erbanov, Dorzhiev, and other leaders of the Buryat-Mongol Republic. They were shot as enemies of the people. Next, Guelia's mother was arrested and upon her release from camp was sent to a penal colony in Turkestan, where she committed suicide. Guelia and her brother were orphans. Throughout her life the little girl in the sailor suit—the symbol of the happy childhood of little Soviets—kept the gifts engraved with her name, "from Party Leader J.V. Stalin."

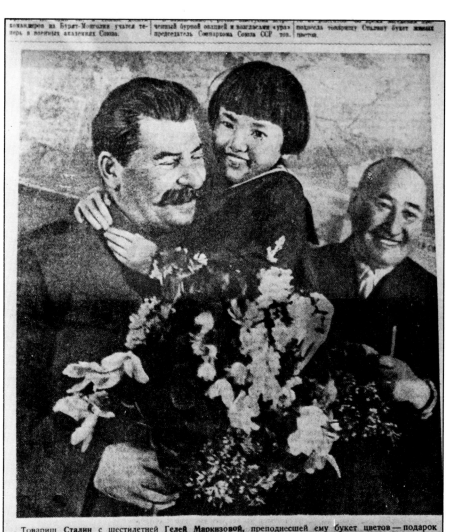

Товарищ **Сталин** с шестилетней **Гелей Маркизовой**, преподнесшей ему букет цветов — подарок делегации Бурят-Монгольской Автономной Советской Социалистической Республики. Справа на снимке — секретарь Бурят-Монгольского обкома ВКП(б) тов. **Ербанов.**
Снимок сделан в Кремле 27 января 1936 года. Фото М. Калашникова.

January 27, 1936. Moscow. Photograph in Pravda, *January 30, 1936, signed M. Kalashnikov. Translation of the caption:* "Comrade Stalin and little Guelia Markizova, six years of age, who brought him a bouquet of flowers, a gift from the delegation of the Buryat-Mongol Autonomous Soviet Socialist Republic. On the right is the secretary of the Regional Committee of the PCR(b) of Buryat-Mongol, Comrade Erbanov." *Note that this photograph is probably itself a photomontage.*

The commentary in Pamiat (Memory), *no. 1, Moscow, 1976, signed with the initials "L.A.," was reprinted in* L'Alternative, *no. 29, September-October 1984.*

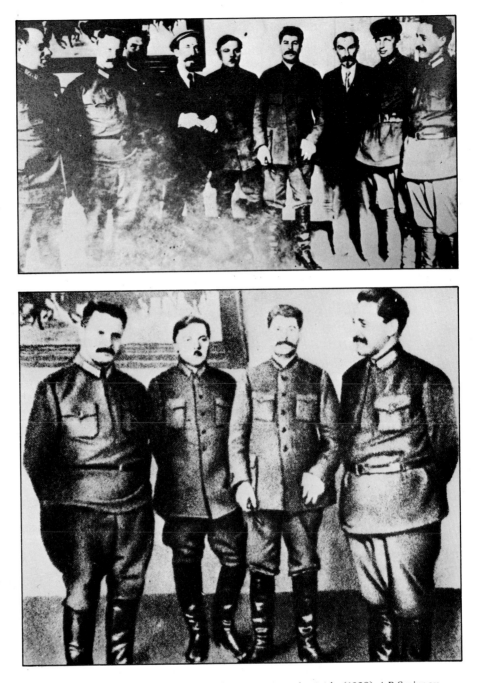

■ GROUP REDUCTION

April 1925. Several post-Lenin leaders. Left to right: Mikhail Lashevich, vice commissioner of war; Mikhail Frunze, Trotsky's successor as head of the Red Army; A.P. Smirnov, commissioner of agriculture, Alexei Rykov, president of the Council of People's Commissioners; Kliment Voroshilov, who will succeed Frunze; Stalin; N. Skrypnik, a Ukrainian leader; Andrei Bubnov, head of the army's political department; and Grigori Ordzhonikidze, a Georgian friend of Stalin's. The same photograph reappears fourteen years later. Only Frunze, Voroshilov, and Ordzhonikidze are seen with Stalin. In the interval, Lashevich committed suicide (1928), A.P. Smirnov disappeared, Rykov was shot (1938), Skrypnik committed suicide (1933), and Bubnov was executed (1938).

It must not be imagined, however, that the individuals left in the photograph all survived: Frunze died in very suspicious circumstances in 1925 following an operation, and Ordzhonikidze was executed (or forced to commit suicide) in 1937!

1. *Photograph dated April 1925. Source unknown.*
2. *Album Staline, Moscow, 1939.*

83

Photographs, paintings, and painted likenesses were no doubt insufficient for mass reproduction of the features of one upon whom propaganda would confer increasingly sonorous titles: "Our Beacon," "The Sun of Humanity," "Glorious Pilot of the Worldwide October," "Father of the People," "The Party's Brightest Diamond," etc. In the 1930s the cinema begins portraying Stalin. While the overall production of Soviet films declines quite sharply, a large number of the films that are made contribute to the creation of a powerful mythology, unique in history and still not fully understood.

Two historic periods are revised and corrected. First, the October Revolution, in which Stalin actually played only a secondary role. Films such as *Lénine en Octobre* (Mikhail Romm, 1937), *Le quartier de Vyborg* (Gregori Kozintsev and Leonid Trauberg, 1938), *L'homme au fusil* (Sergei Yutkevich, 1938), *Lénine en 1918* (M. Romm, 1939), *Yacov Sverdlov* (S. Yutkevich, 1940), and *L'inoubliable année 1919* (Mikhail Chiaoureli, 1951) depict an omniscient Stalin, constantly at Lenin's side, giving him helpful advice, participating in all phases of the revolution, and even risking his life while Lenin was in hiding. Thus, in *Lénine en 1918*, the character of Stalin was on screen for nearly 40 of the 133 minutes of the original version of the film.

The other period is the Second World War. Although Stalinist strategy proved to be largely ineffectual throughout the war, *Le tournant décisif* (Fridih Ermler, 1945), *Le serment* (M. Chiaoureli, 1946), *Le troisième coup* (Igor Savchenko, 1948), *La bataille de Stalingrad* (Vladimir Petrov, 1949 and 1950), and *La chute de Berlin* (M. Chiaoureli, 1949) portray a military leader with the intuition of a genius, single-handedly directing decisive battles in his office between puffs on his pipe. In the *Biographie abrégée* (1948), Stalin is glorified as "the greatest strategist of all time." As Khrushchev revealed, it was Stalin himself who wrote various passages such as "Comrade Stalin's genius enabled him to guess the enemy's plans and thwart them."

For twenty years, one actor played the part of Stalin in almost all of these films: Mikhail Gelovani. Like Stalin, he was a Georgian. He was showered with honors. His range of roles was fairly limited; he later said that he had felt like "a granite monument." Certain passages in *Le Serment* (Stalin meditating and hearing Lenin's voice in the snow-covered garden where he had once visited Lenin; Stalin diagnosing the trouble with a tractor engine) and *La chute de Berlin* (a pink and khaki Stalin lovingly watering his

pastel-tinted plants, a group of young girls among the flowers crying out, with touching spontaneity, "Long live Stalin, who has awakened us to a happy life!") are worthy of inclusion in a world anthology of kitsch.

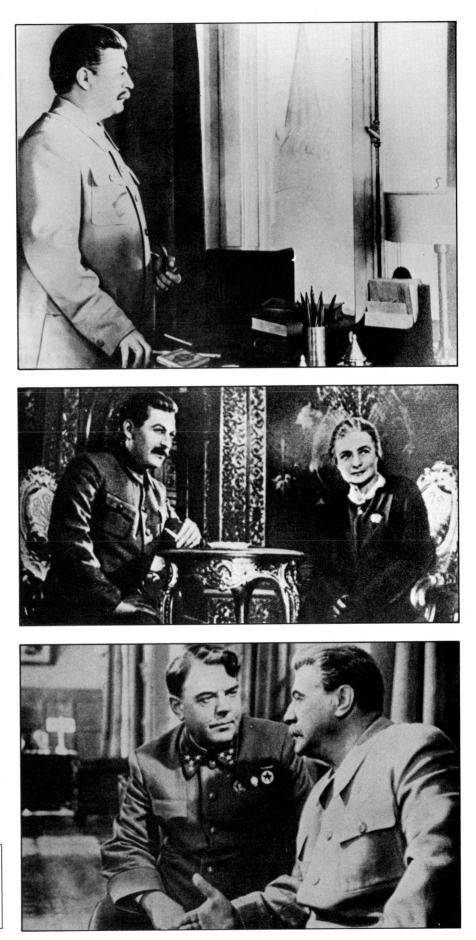

1 and 3. Le serment, *Mikhail Chiaoureli, 1946*.
2. La chute de Berlin, *Mikhail Chiaoureli, 1949*.
4. La bataille de Stalingrad, *Vladimir Petrov, 1949 and 1950*.

■ BEHIND THE PICTURES, THE GULAG

In the mid-twenties, Soviet magazines, books, brochures, picture books, postcard sets, and posters ceaselessly tell the epic tale of large construction projects. Gigantic canals, metallurgic and chemical combines, railways, pipelines, gold and silver mines, and new cities are built, sometimes in record time. Writers and photographers are marshalled to praise and show off the great achievements of the "country of the Soviets."

In reality, most of these large projects were built with forced labor. Instituted in Russia

in 1919, it initially facilitated the deportation of "class enemies" and then larger and larger segments of the population, in an ever-expanding system that culminated under Stalin, between 1937 and 1950. Mobilizing armies of officials, requisitioning wagons, trucks, and boats, filling hundreds of camps and prisons, creating huge penal colonies spread out over several thousand kilometers, the phenomenon reached proportions unprecedented in the history of humanity.

These pictures of the construction of the Kuznetsk combine in Siberia were published in the magazine, *L'URRS en*

construction, accompanied by epic texts. The combine was in fact built mostly by deportees working day and night in unhealthy bogs and, in winter, in ice and frozen mud. "Each day, with bands playing, the name of the crew that has set a new record is announced. Loudspeakers broadcast the winners' names to 50,000 workers. The work has become a matter of honor and glory." So say the magazine's reporters. The result: several thousand anonymous workers died on the job. Dozens of other articles depict large, ambitious projects in the same way. Some of them—absurd, useless, or technically impossible—were started without funds, but at the cost of tens of thousands of human lives. Such was the case, for example, with the White Sea canal (1932) and the Kotlas-Vorkuta railroad. The text and the pictures of the propaganda invariably showed the work sites as places where young, enthusiastic volunteers were building Communism. But, in the photos, it is sometimes possible to make out the tiny figures of rifle-toting guards or watchtowers, which the censor forgot to erase.

Several tens of millions of Russians, representing three generations, were sent to work camps between 1919 and 1960. Many never returned. The methods used by demographers to calculate such things have produced conflicting figures: for the most optimistic, "Stalinism"—not counting war-related deaths—cost the Soviet Union 17 million lives; for the most pessimistic, the figure is 60 million.

1 and 2. Article on the Kuznetstroi work sites in Siberia, L'URSS en construction, no. 4, April 1932. The caption of the first reads: "Communist Saturdays at the Electrical Plant."
3. Digging the foundations for the Nizhni-Novgorod automobile plant, L'URSS en construction, no. 1, January 1933.

■ A MARKER IN KATYN

1939. Caught in a vise-grip between the then-allied Red Army and the German Army, the Polish Army surrenders. More than 200,000 solders are taken prisoner by the Soviets and sent to Siberian camps. Fifteen thousand officers and noncommissioned officers are sent to other camps and disappear completely. Two years later, Hitler turns on his ally, Stalin, and attacks the Soviet Union. The Soviet government then tries to forge an alliance with the Polish government in exile in London. The Polish representatives demand the release of their officers, but receive no answer.

Early 1943, the Germans, who have invaded the Smolensk region, are informed of the existence of cemeteries in the Katyn forest. The bodies of several thousand Polish officers are exhumed. They all have their hands tied behind their backs with cords. They were all killed by a bullet in the back of the head. Despite the war and its other horrors, the repercussions are considerable. Goebbels seizes upon the incident and conducts a violent campaign against Russian barbarism. The Soviets accuse the Nazis of the crime. An international commission, working at the site in 1943, places the date of the massacre in the spring of 1940, i.e., when the region was still under Russian control: 4,143 Polish officers were killed and buried in seven graves in the Katyn forest. Nearly 3,000 of them are identifiable because of their papers. When the Smolensk region is retaken by the Soviets, another investigative commission is appointed in Moscow, which estimates that the graves contain 11,000 bodies (a deliberately exaggerated figure) and the date of death as the fall of 1941 (after the capture of the region by the Germans). But the Germans are not charged with the Katyn massacre by the Nuremberg Court. In fact, according to the findings of the international commission, borne out after the war by other testimony, the 4,143 Polish officers were killed one at a time by agents of the NKVD, the Soviet political police, under direct orders from Beria. Thus, the massacre was only discovered because of events in the Second World War. The location of other cemeteries containing the bodies of the other 10,000 officers remains a secret. According to some allegations, 6,000 of them were drowned in the Baltic Sea.

The Katyn massacre was a genuine trauma in the history and the memory of the Polish people. And yet, it is absolutely forbidden to mention it in Poland (this was one of the first political gestures of the independent union, *Solidarnosc*). Books in the USSR and in other Eastern-bloc countries always attribute the massacre to the Nazis. On several occasions, carefully "documented" works have appeared, aimed primarily at the Polish, to support the Soviet argument. Faked documents (the NKVD laid the groundwork for the Soviet investigative commission by slipping letters and papers here and there among the corpses proving that the Poles were still alive in 1941), false reports and photos with false captions, for example, make up the voluminous report, *The Truth about Katyn* (1952). And to cap it all, this photo of a commemorative marker, erected in the Katyn forest by the Soviets, says:

*Here, in the Katyn forest,
in the fall of 1941,
11,000 Polish soldiers and officers,
prisoners of war,
were shot to death by Hitler's executioners.
The Red Army troops will avenge them!*

1. *From the book by Boleslaw Wojcicki,* Pravda o Katyni (*The truth about Katyn*), War- saw, 1952. *Since this area is off-limits to for- eigners and Soviet citizens alike, we were unable to determine whether this marker still exists.*
2. *Photo by the international investigative commission published in* Zbrodnia Katynska w s'wietle dokumentow, London, 1948.

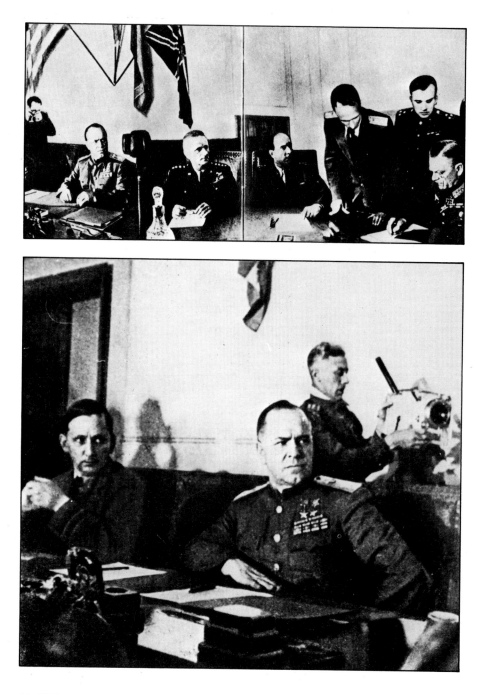

■ SURRENDER IN CINEMASCOPE

May 9, 1945. The cease-fire took effect a week earlier and General Keitel signs the treaty of surrender. Opposite him is the American general, Spaatz (in the center of the photograph), and on the left the Russian general, Zhukov.

This photograph, with its strangely distorted perspectives, was published in Soviet history books. It is in fact a composite picture: several photos were put together to give an overall view of the event. Comparison with another photo taken at the same time (2) shows that the flags on the wall in the background were

also lowered so that they would appear within the frame of the picture.

1. Composite photograph found in the memoirs of Marshall Zhukov, which is replete with other retouched and faked photographs (Vospominanya i razmishtlenia, Moscow, 1974; English version, Reminiscences and Reflections, Moscow, 1985) and in the book by Marshall Chouikov, Stalingrad-Berlin, Le chemin de feu, Moscow, 1985.
2. Photograph published in Roman Karmen, Moscow, 1983. The man behind Zhukov is Roman Karmen, the director.

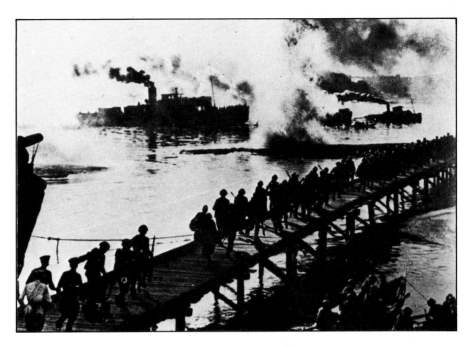

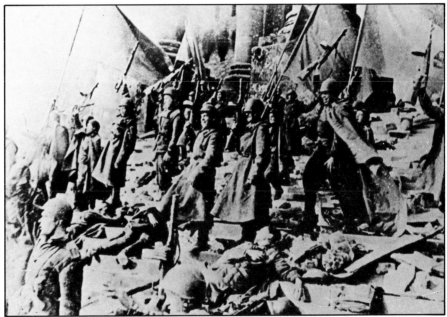

■ WAR AND THE CINEMA

The Second World War, which the Russians call the "Great Patriotic War," has been the favorite (or compulsory) theme of Russian directors since 1945. As soon as the war was over, Stalin ordered directors to make films about the victories of the Red Army, and despite the many shortages, enormous budgets were set aside for war films. The most famous are *La bataille de Stalingrad* (V. Petrov, 1949 and 1950), *Le tournant décisif* (F. Ermler, 1945), and *La chute de Berlin* (M. Chiaoureli, 1949). But, by some inexorable process observed previously on numerous occasions—the October Revolution, for example—the historic iconography is gradually tainted with fictional film images and, over the years, the most successful pictures of battles reenacted for the cinema become actual historic pictures.

1. La bataille de Stalingrad, by Vladimir Petrov, 1949 and 1950. Several scenes from the film appear in Stalingrad, Moscow, 1966, and in Velikaya Otechestvennaya 1941–1945 (The great patriotic war 1941–1945), Moscow, 1984.
2. Similarly, scenes of the fall of the Reichstag from La chute de Berlin appear frequently in history books.

■ THE ART OF THE PHOTOMOSAIC

To demonstrate their virtuosity, early nineteenth-century photographers invented a sort of game of skill: they put a large number of people, photographed at different times, together in a single print; this technique was called the "photomosaic."

One of the most striking photographs of this type is undoubtedly the one published in the Soviet Union the day after a ceremony in Moscow's Bolshoi Theater celebrating Stalin's 70th birthday (December 1949). Fifteen Russian officials and foreign guests are lined up on the stage on either side of the old dictator. Present are Togliatti, Kosygin, Kaganovich, Mao Zedong (Mao Tse-tung), Bulganin, Ulbricht,

photograph" was revised and rearranged, with each person in his proper place according to the complex hierarchic and protocolar criteria and showing an impassive, uniformly lighted face to the public. The entire "family" (a family of flat cardboard cutouts) and the entire space of the Bolshoi (a theater space filled with flags, immense soldiers, slogans, and, one guesses, waves of programmed applause) are under the gaze of the "leader and educator" (as he is described by the letters hung in the arch).

These group photographs—retouched and rearranged or sometimes even completely painted over—are the Soviet Press Office's specialty. After 1945 they began to have real political significance. Despite the overwhelming sense of boredom they communicate, they were of great interest to

chart the courses of Kremlin officials, discern the leader's moods, and speculate on his successor.

One of the official photographs of Stalin's funeral on March 8, 1953, shows all of the representatives of international Communism standing on the tomb a few moments before the glass coffin is carried in (the man of steel's name already appears on the front of the tomb, beneath Lenin's). Again we see Dezh, Ulbricht, Dolores Ibarurri, and Togliatti, flanked by Nenni, Bulganin, Molotov, Voroshilov, Malenkov, Khrushchev, Beria, and Mikoyan. Zhou Enlai (Chou En-lai) represents China, Duclos the French Communist Party. Gottwald is there too, catching the fatal chill that will kill him five days later (Stalin, however, will rob him of his own death: in the "worldwide" mourning for the "Father of the People," Gottwald's death goes almost unnoticed, except in Czechoslovakia, of course). In this new family portrait, everyone is again uniformly lighted and facing the photographer, the tops of the pine trees no longer conceal the far ends of the dais where the secondary players usually crowd together; although in this case the faces are all distinctly separate, no one is standing in front of anyone else (with the notable exception of Palmiro Togliatti, secretary general of the Italian Communist Party, who partially obscures Pietro Nenni, secretary of the Italian Socialist Party, coincidentally the only one on the dais who is merely a common "fellow-traveler"), and the features of those in the back are just as clear as those in the front row.

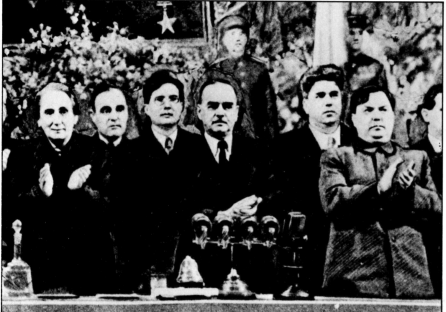

Khrushchev, Dolores Ibarurri, Georghiu-Dezh, Suslov, Malenkov, Beria, and others. It is immediately apparent that such a scene is practically impossible to photograph correctly (lack of perspective and lighting; figures in the middle ground, in shadow, hidden or moving; some loss of detail). In this ambitious composition, which is supposed to show the event in its entirety, not a face or a detail was overlooked. It was therefore probably made from several different photographs. The figures of all the important guests were cut out, retouched, and lined up on the stage, which becomes apparent if the photo is examined closely. The background—its banners, flag-bearing soldiers, palm trees, flowers, foliage, immense portrait of Stalin, and three lines of gigantic lettering hung in the arch—was undoubtedly also faked using one or more original photos. Thus, the entire "family

diplomats and Sovietologists, who quickly learned to decipher the secret signs of "history" in them. In fact, they are coded messages: during May Day parades, on anniversaries of the October Revolution, and at various memorial ceremonies the dignitaries lined up on the tomb next to Stalin in strict order, revealing both a rigid protocol and the whims of the old dictator. 1948: Molotov, Beria, Kaganovich, Malenkov. 1949: Bulganin, Molotov, Malenkov, Beria, Mikoyan. 1951: Malenkov, Beria, Mikoyan, Kaganovich, Molotov, Khrushchev. 1952: Malenkov, Beria, Molotov, Mikoyan, Kaganovich, Khrushchev.

The disgrace of Molotov and Bulganin, Malenkov's steady rise, the wanderings of Kaganovich and Mikoyan, Beria's tenacity, Khrushchev's discreet appearance—from season to season it was thus possible to

1. December 1949. Tass News Agency. The slogan above the participants proclaims: "Long live the great leader and educator of the Communist Party and the Soviet people, Comrade J.V. Stalin."
2. Detail of the abovementioned photo.
3. May Day Parade on Red Square, May 1, 1952.
4. Photograph of March 8, 1953. Released by Tass. Reproduced on the front page of Pravda, March 10, 1953, and in Ogonyok, March 15, 1953.

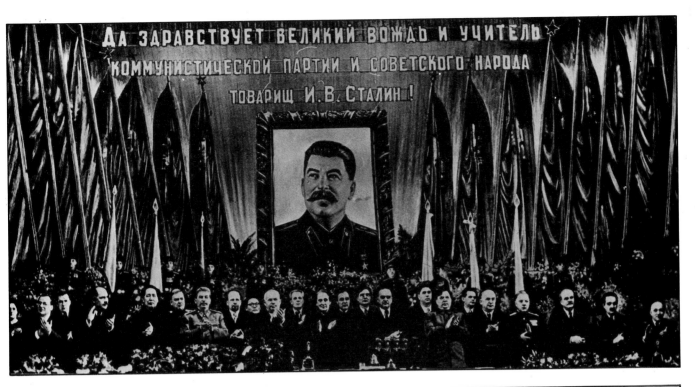

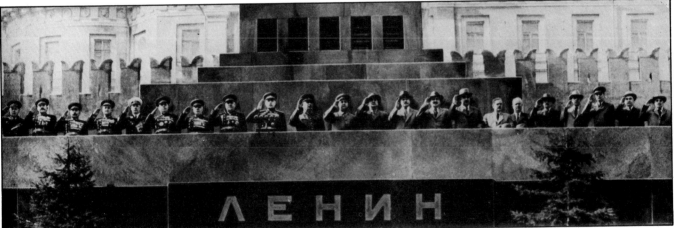

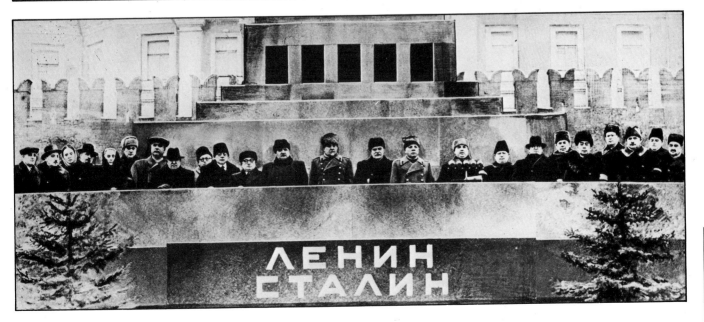

По уполномочию Президиума Верховного Совета
Союза Советских Социалистических Республик
А. ВЫШИНСКИЙ.

По уполномочию Центрального Народного
Правительства Китайской Народной Республики
ЧЖОУ ЭНЬ-ЛАЙ.

Подписание Договора и Соглашений между Советским Союзом и Китайской Народной Республикой. Подписывает Договор А. Я. Вышинский. На снимке (слева направо): А. А. Громыко, Н. А. Булганин, Н. В. Рощин, г-н Чжоу Энь-лай, А. И. Микоян, Н. С. Хрущев, К. Е. Ворошилов, В. М. Молотов, И. В. Сталин, г-н Мао Цзе-дун, Б. Ф. Подцероб, Н. Т. Федоренко, г-н Ван Цзя-сян, Г. М. Маленков, г-н Чен Бо-да, Л. П. Берия, г-н С. Азизов, Л. М. Каганович.

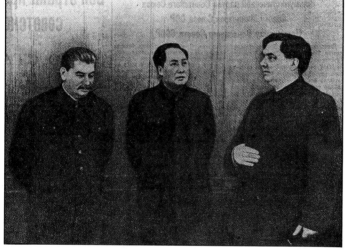

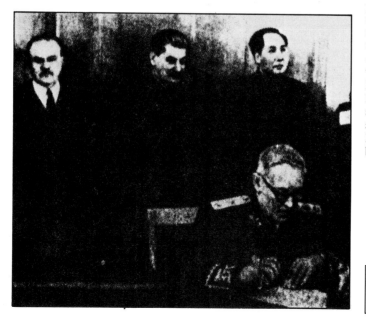

■ A PACT OF CHANGING GEOMETRY

1950. Stalin and Mao sign the Sino-Soviet friendship pact. The People's Republic of China is barely six months old. Zhou Enlai and Mao Zedung have come to Moscow. It is an important event. *Pravda* accords it a large photograph showing all of the participants, the composition of which is clearly impossible. Several Soviet painters will join forces to create a giant painting in which Stalin will naturally occupy a prominent position. The Chinese will also make a painting, but darker and placing Stalin on an equal footing with Mao. Only a small portion of the photograph showing the two main protagonists will be used. In 1953, Stalin dies. A few days later, part of the photograph of the signing of the pact appears once more in *Pravda*. But this time another person is with Stalin and Mao, and to better emphasize the effect, Vyshinsky, one of the ministers who signed the pact, was erased, as well as everyone around him. The new arrival is Malenkov, who hopes to succeed Stalin and is therefore attempting to slip into history by approaching the great men. For two years he will almost succeed but, in the end, will be ousted by Nikita Khrushchev.

1. Pravda, *February 14, 1950.*
2. Pravda, *March 10, 1953.*
3. People's China, *vol. 1, no. 1, April 1, 1950.*

■ THE WALTZ OF THE HEIRS

March 5, 1953. Stalin is dead. The photograph of his embalmed body is immediately released to the international press. The same photograph is used in a rather tasteless montage in the March 7 issue of *Pravda*. The group of officials, friends, and possible successors was positioned in the background with little regard for protocol. Malenkov, however, stands clearly apart from the group. The next day, a new photograph. This time, the six highest officials are lined up symmetrically in front of the body: on one side are Khrushchev, Beria, and Malenkov; on the other, Bulganin, Voroshilov, and Kaganovich. This solemn, official photograph seems somewhat doubtful, however, when examined closely. The hangings of the catafalque and the flowers around them are painted in, as are the details of the clothing and the shading. Of particular note is the fact that Stalin's head is much too large, given his position in the background. These doubts are further strengthened by comparing the different versions of this photo circulated at the time or printed in books and magazines: the distance between Beria and Malenkov changes, as does the background behind Bulganin and Voroshilov. These figures were obviously placed over the background (possibly to cover up the soldiers standing guard over the body).

But this picture did not give a full account of the balance of powers then existing since, on March 9, *Pravda* published another line-up just as contrived as the first, but this time including two new arrivals, Molotov (left) and Mikoyan (right). This photograph seems a little less retouched than the first. But, once more, several versions will be circulated—the distance between Voroshilov and Beria varies, Beria's lock of hair is gone, and the clothing is redesigned, suggesting that this, too, is an example of superimposing several photographs on a single background.

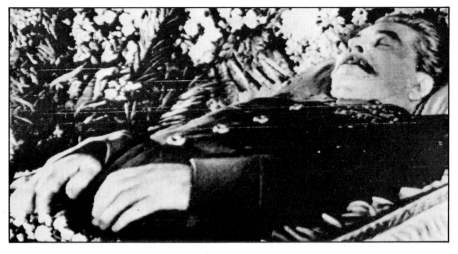

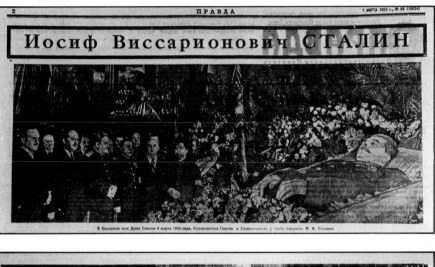

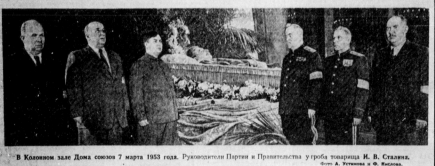

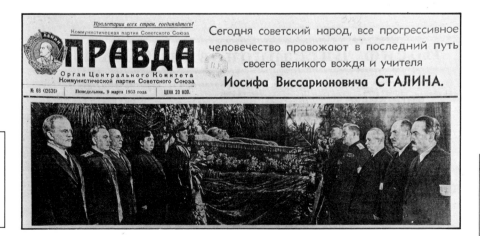

1. Photo released by Tass, *March 7, 1953.*
2. Photomontage, second page of the March 7, 1953 edition of Pravda.
3. Pravda, *March 8, 1953. Photo signed A. Ustinov and F. Kislov.*
4. Pravda, *March 9, 1953, and* Ogonyok, *March 15, 1953.*

■ A LITTLE KNOWN PHASE OF DESTALINIZATION

February 24, 1956. The XX Congress of the Soviet Communist Party is in progress. In the evening, Nikita Khrushchev, general secretary of the Party, presents a secret report about one hundred pages long. No mention of this report is made in *Pravda*. Only a few foreign Party leaders, Stalin's daughter, Svetlana, and Tito know about it. Through channels not yet identified but probably Polish, the U.S. State Department

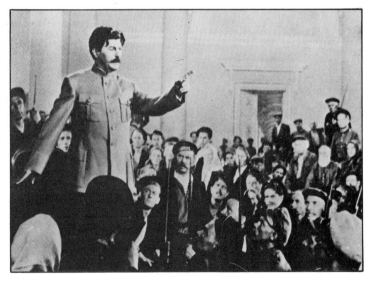

manages to get a copy and the *New York Times* prints it on June 4, followed immediately by all of the major Western newspapers.

In this report, prepared in the greatest secrecy, Khrushchev denounced Stalin's crimes and gave numerous examples of the fanatic "cult of personality." Between that date and the end of the Khrushchev era (1964), the Soviet authorities, who made no official mention of the secret report prior to

the XXII Congress (1961), became just as relentless in erasing all traces of Stalin as they had been during the twenty-five years they spent transforming him into a living god. His body was removed from the tomb in Red Square. His works, until then printed in tens of millions of copies, were destroyed or hidden away. Statues, pictures, and paintings were removed; the names of cities, dams, combines, and factories were changed; history books were withdrawn from circulation, rewritten, and republished. And, lastly, photographs were retouched so that the man whose image had once been everywhere simply vanished. In 1964, however, under Brezhnev, this complete effacement was relaxed: Stalin was again mentioned, but his strategy and his political philosophy were criticized, without, however, referring to the "cult of personality" or the purges and deportations. And his face could sometimes be found in history books in the midst of other Bolsheviks.

The cinema is where destalinization took the most curious forms. During the 1960s, all scenes showing Stalin were cut from films about him or Lenin. When this was impossible, he was simply blocked out. A scene from *Lénine en Octobre* showed Lenin and Stalin walking across a room toward a speaker's platform. In the sequence shown today, a sailor appears in Stalin's place. The original version of *Lénine en 1918* was 2 hours and 13 minutes long. The same film now runs 1 hour and 35 minutes; all of the scenes in which Stalin appeared and were not crucial to the dramatic action were cut. Similarly, in films from the thirties and forties, portraits of Stalin hung on the walls of apartments or offices were replaced with portraits of Marx or Lenin by overlaying a transparency, which, instead of being undetectable, actually attracts attention! The films stored in Western film libraries met the same fate. This was considerably facilitated by the fact that the Soviets had the original negatives: they offered to restore or renew the deteriorating copies free of charge and then sent back new, expurgated versions.

1. Stalin played by S. Goldshtab in Lénine en Octobre *(Mikhail Romm, 1937).*
2. M. Gelovani in L'inoubliable année 1919 *(M. Chiaoureli, 1951). These two scenes have been cut from modern versions.*

The Maoist Saga

With the history of Mao Zedong (Mao Tse-tung), intertwined for half a century with that of China, a phenomenon occurs that is nearly identical to the one observed with Stalin. Photographs play a primary role in the development of an exuberant "cult of personality": the reproduction of Mao's portrait *ad infinitum*, the isolation of his person, the removal of rivals, the juggling or recomposition of actual historic scenes, and even the invention of fictitious scenes. These retouched pictures are shown in museums, printed in newspapers and books, and sent abroad. Many are used to illustrate lies or to camouflage historic texts. And since Chinese history is written under the control of the Party, which deletes any episode not consistent with the political theory or philosophy, or, on the other hand, wildly exaggerates any symbolic event, all historic pictures have a meaning, demonstrate a specific point, and play an extremely precise role. They have their codes, their hierarchic order, their networks of allusions that everyone must learn to decipher. Chinese artists are past masters of the arts of retouching and photomontage. They have colored all the great photographs of the Maoist era. They have given prominence to certain individuals and have relegated others to obscurity. They have skillfully erased details and undesirable individuals.

But it is important to note that unlike the Soviet Union, where Trotsky's banishment has continued for more than half a century, pictures have been in constant evolution in China. Many who were eliminated have reappeared in the iconography, while others have vanished. Mao himself now occupies a much more modest position among the other leaders, and his pictures are less numerous in museums and books. The Chinese iconographic system has lost its precision, and it is not unusual to find different versions of the same picture in the same book.

■ FROM GROUP PORTRAIT TO SACRED IMAGE

Sometime after 1949, when Mao Zedong first became the revered object of a genuine cult, propaganda officials realized that the few existing pictures of his youth did not always accord with the legendary life then being written. Mao had been a young man from a good family, an average student, one Communist leader among many others. All of the portraits from that era displayed in Chinese museums or reproduced in books are enlargements, carefully cut out and retouched, from family photos or from pictures of students or political meetings. Thus, Mao's life, like that of Stalin or Kim Il Sung, becomes a succession of impassive, handsome, painted faces, more like sacred images than photographs.

In the photographs taken in the underground between 1930 and 1949, Mao is always wearing crumpled jackets with baggy pockets, twisted collars, and open shirts, some of which are even frayed. His hair is very long, with stray locks often falling across his forehead. After 1949, the Maoist iconographers erase all signs of this rather independent spirit. One photograph, given to Edgar Snow in 1936 and published by him, was taken in November 1931 during the Sixth Chinese Communist Party Congress. It shows several individuals, including Zhu De (Chu Teh), Deng Fa (Teng Fa), and Mao. When the "cult of personality" begins, this picture, cropped to show only a half-portrait of Mao, will be the one used to illustrate the revolutionary in the 1930s. But the protruding, open shirt collar is now tucked under the jacket, which is carefully buttoned and ironed. And

the outline of his bushy hair has been discreetly reshaped.

1. Minzu Huabao, no. 11, 1976. Mao "in his youth," in 1919, in 1924, in 1925, in 1927, and in 1931.
2. Photo by an unknown photographer given to Edgar Snow in 1936 and published by him in his book, Red Star over China (1937). Left to right: Fang Zhimin (Fang Chih-min), Zhu De, Deng Fa, Xiao Ke (Hsiao K'e), Mao Zedong, and Wang Jiaxiang (Wang Chia-hsiang).
3. Littérature chinoise, no. 11–12, 1976, and La Chine, no. 11, 1976.

蘇區中央局委員撮於第一次全蘇大會紀念日一九三一·十一金瑞色赤於之

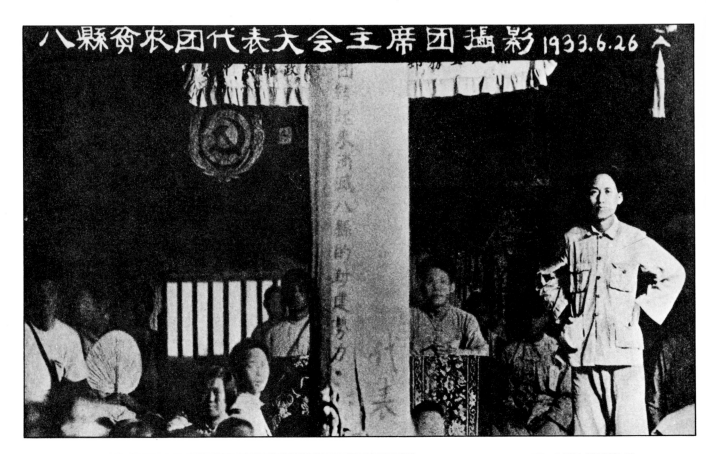

八縣貧農團代表大會主席團攝影 1933.6.26

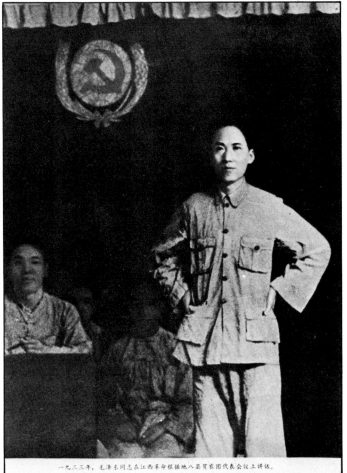

一九三三年，毛泽东同志在江西革命根据地八县贫农团代表会议上讲话。

■ THE HAMMER AND SICKLE

This photograph, taken in 1933, shows Mao standing on a platform with his hands on his hips, one of his favorite poses. Later, the Maoist iconography will include only the right side of this photograph. Mao's face is touched up, his jacket collar is ironed and buttoned, and the wrinkles in his clothes are erased. In several other versions the three large, unsightly wrinkles in his pants disappear, and his sagging right pocket is emptied and magically flattened. One last version of the picture is in color. The patterns in the rug covering the table are erased, and an object from the left side of the photo—the shield with the hammer and sickle—has been moved to the right.

1. *June 1933.* Histoire illustrée de l'armée populaire de libération, *volume 1, Beijing, 1980.*
2. Minzu Huabao, *no. 11, 1976. Caption:* "*Comrade Mao Zedong gives a speech to the conference of representatives of the poor peasant leagues from the eight districts of the Jiangxi revolutionary base in 1933.*"

■ THE REVOLUTION WITHOUT FOREIGNERS

In about 1938 a group of foreign visitors and friends poses with Chinese leaders for Edgar Snow. In the front row are Bo Gu (Po Ku), Zhou Enlai, and Wang Ming. This same photograph appears in Chinese history books and in the memoirs of Otto Braun (the military adviser sent by Stalin who led the Chinese army from mobile warfare to position warfare), but only the three Chinese leaders are shown. The trimming is rather crude: the portion of the photograph to be used was cut out with scissors and placed against a gray background. Ten people, including Agnes Smedley (rear center), Zhou Enlai's wife (far right, second row), and various other Western friends were cut out of the picture: the revolution is not a cosmopolitan picnic.

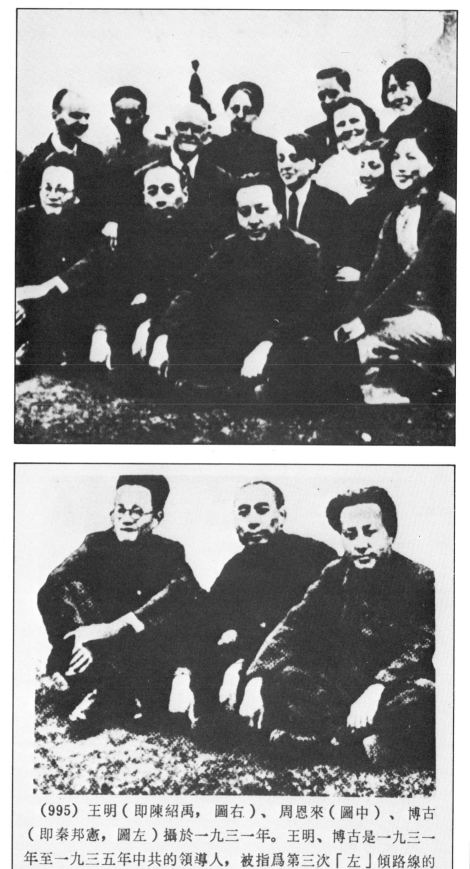

(995) 王明（即陳紹禹，圖右）、周恩來（圖中）、博古（即秦邦憲，圖左）攝於一九三一年。王明、博古是一九三一年至一九三五年中共的領導人，被指爲第三次「左」傾路線的執行者。

1. Photograph taken by Edgar Snow, probably in 1938.
2. Histoire illustrée de la Chine moderne, Tiandi Tushu, Beijing, 1980. Bo Gu was excluded from the Chinese iconography for a long time; pictures of him reappeared around 1980. But in this case, not all of the photograph has been restored. See also Otto Braun, Chinesische Aufzeichnungen 1932–1939, *Berlin, 1975.*

■ THE LONG MARCH REENACTED

In 1931 a Chinese Soviet Republic was proclaimed in the province of Jiangxi by Communist Party cadres who had escaped the quelling of the Canton rebellion (1927). Surrounded by Chiang Kai-shek's troops, the Red Army, 130,000 strong, begins a protracted retreat involving a year-long march of nearly 12,000 kilometers and the loss of three-fourths of its members before finding refuge in Shaanxi Province (October 1934 to October 1935). The "Long March," punctuated by bloody battles, complex military maneuvers, and legendary heroic episodes such as the crossing of the Luding bridge, became the great founding myth of the future Communist state. It is during this period that Mao, skillfully exploiting dissensions and allying himself with military leaders such as Zhu De, gradually gains power over his elders on the Central Committee. Elected president of the Central Committee at the Zunyi meeting (January 1935), he emerges from the Long March in a dominant position, which he will later strengthen by defeating the members of the "leftist" group and the Communists too closely aligned with Moscow.

No photographer was present for the whole epic, and only a few vague and very blurred photos, or those of secondary incidents, survived the Long March. After the 1949 victory, when the Chinese began writing the history of their revolution, they made frequent use of drawings by Huang Zhen, then a young soldier working in the propaganda section of the Red Army. The lack of photos was soon solved, however, by the cinema. Historic films showing immense crowds of well-disciplined soldiers provided Chinese illustrators with a wealth of images. And although it was common knowledge in China that there were no interesting photographs of this historic period, no one thought twice about publishing stills from these films and entitling them "Scenes of the Long March."

1 and 2. Drawings by Huang Zhen, Sketches of Travel to the West, Shanghai, October 1938. 3. Location photo from a Chinese revolutionary film, probably En franchissant mille monts et rivières, *by Yan Jizhou, 1977.*

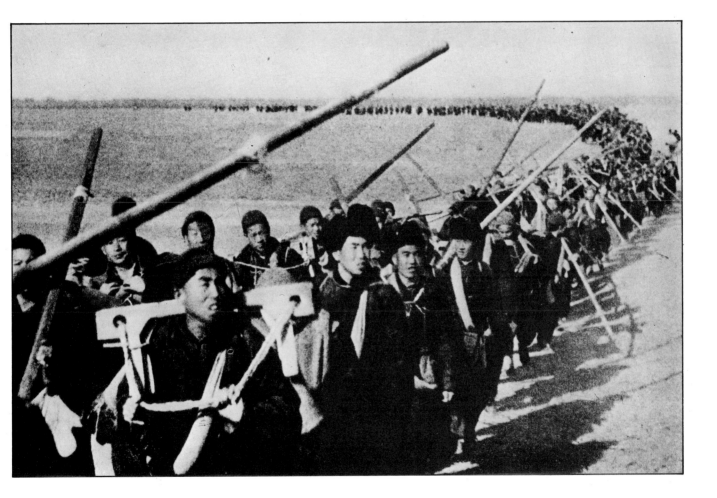

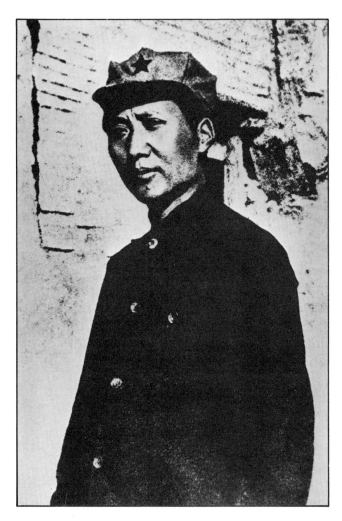

■ THE STORY OF A CAP

Before assuming power, Mao only rarely put on a uniform and even more rarely wore a military cap. In Bao'an in 1936, Edgar Snow insisted, and to photograph him in military guise, put his own cap with a red star on Mao's head. Mao, slightly annoyed, let him take the picture. The photo has had an enormous posterity. The original photograph, out of focus, shows a contorted face with harsh shadows and scowling eyebrows (Mao seems rather annoyed by the masquerade). The jacket collar is frayed. In the background behind Mao are a wall (no doubt one of the ones around the Bao'an grottoes) and the lintel of a door. Years later, illustrators will take this photograph (fake from the very start!) and turn it into one of the principal sacred images of the Maoist cult. The contours of the face and the cap were accentuated; the shadows lightened; the tip of the nose and the nostrils softened; the severity of the eyes and eyebrows diminished; the mouth, ears, collar buttons, and the red star touched up; the jacket collar straightened; officer insignia added (or perhaps emphasized); and the background considerably toned down to bring the subject into greater relief. All that was missing was color, which was soon added, thus creating one of the most famous pictures of the Chinese revolutionary era.

Many other photographs from this period underwent the same metamorphosis. And, with a little discreet retouching, the rebellious, shaggy, unkempt Mao was transformed into the stern general of the Chinese revolution.

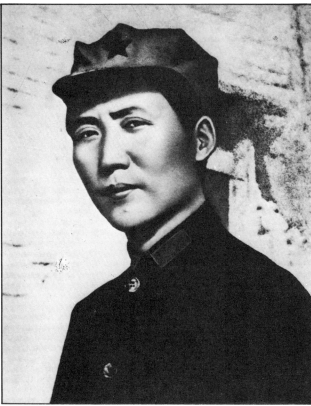

1. Photograph by Edgar Snow, taken in 1936 in Bao'an.
2. Museum of the Revolution, Beijing. And numerous publications such as La Chine, no. 7-8, 1971, and La Chine, no. 11, 1976.

■ A WALK IN THE COUNTRY

Mao has come to observe the work in the fields of Yan'an in 1942. Twenty-four years later the same picture reappears in a collection of photographs. But it is now in color and the peasants in the background have disappeared, as have the onlookers along the road. The photograph no longer has the same meaning: the isolation of the subject reinforces its now sacred character. In addition, Mao's face has been highlighted, the unattractive wrinkles in his collar have been removed, and his hair has been lightly trimmed.

1. *Photograph by Wu Yinxian, Yan'an, 1942.*
2. *La photographie chinoise, no. 3, 1976.*

■ THE XI'AN INCIDENT

December 1936. In Xi'an, the capital of Shaanxi, a large army of the Guomindang (Kuomintang) is preparing to march on Yan'an to destroy the Communist headquarters. Its leader is Zhang Xueliang (Chang Hsueh-Liang), son of the Manchu warlord assassinated by the Japanese in 1928. But, convinced that the fight against the Japanese and the retaking of Manchuria are far more important than destroying the Communist base, Zhang Xueliang has his own superior, Chiang Kai-shek, arrested on the night of December 11–12 and proposes an eight-point program to him, basically advocating an end to the civil war, more political freedom, and a united front against the Japanese. On December 13, Zhang Xueliang sends an airplane to take Zhou Enlai to Yan'an. But, in the meantime, a telegram arrives, allegedly written by Stalin himself: Chiang's arrest must be blamed on "Japanese agents." The national front against the Japanese must be maintained at all costs and, in Stalin's view, only Chiang Kai-shek can guarantee it; he must therefore be released. After several meetings with Zhou, Commander in Chief Chiang Kai-shek departs (taking his disloyal officer with him, who will remain his prisoner until 1962!). Despite various other deals (still fairly obscure since neither Communist nor Nationalist historians have shed any light on these meetings), the united front will actually be forged six months later by the breakthrough of the Japanese army into Chinese provinces and the ensuing massacres, bombings, and terror.

To illustrate the "Xi'an incident," Chinese iconographers selected a picture of Mao and Zhou Enlai standing beside each other in front of an airplane. Zhou is wearing an aviator suit, and the captions of this photograph usually read: "Mao welcomes Zhou at the Yan'an airfield after the resolution of the Xi'an incident." In reality, this photograph, which appears quite often in historical works, is only a small portion of a much larger photo of fifteen people posing in front of an airplane made available to Zhou by Zhang Xueliang. Mao is only one of the leaders on hand to welcome Zhou upon his arrival. Thus, an enlarged and recentered detail can take on an entirely different political tone.

But there is more: this same photo was used to create yet another version of the event. Zhou Enlai is standing alone in front of the airplane. His stance and the details of his suit show that this is exactly the same figure, cut from the original photograph. The missing part of his left arm has been added, and he has been moved closer to the front of the airplane so that he covers up the pilot who was standing there. Thus, depending on whether Chinese historians want to emphasize the role of Zhou Enlai or that of Mao, they use one or the other photo. Sometimes both versions are used simultaneously, and even the original version has appeared in Chinese publications!

1. Left to right: Bo Gu (Qin Bangxian), Zhang Wentian, Mao, Zhou, Peng Dehuai, Lin Boqu, and Xiao Jinhuang.
2. Luo Ruiqing, Lu Zhangcao, Wang Bingnan, Zhou Enlai and the Xi'an Incident, An Eyewitness Account, Beijing, 1983.
3. Israël Epstein, From Opium War to Liberation, Beijing, 1956, republished in Hong Kong, 1980. And, special issue in memory of Zhou, Minzu Huabao, no. 1, 1977. See also Hauts lieux de la Révolution chinoise, Beijing, 1985.

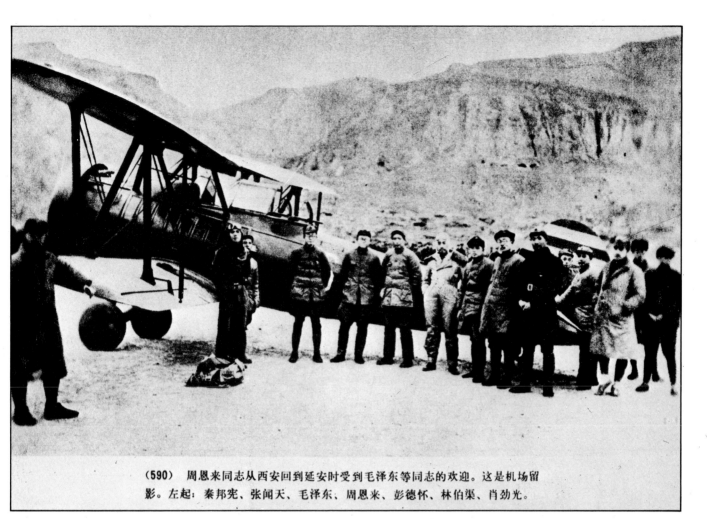

（590） 周恩来同志从西安回到延安时受到毛泽东等同志的欢迎。这是机场留
影。左起：秦邦宪、张闻天、毛泽东、周恩来、彭德怀、林伯渠、肖劲光。

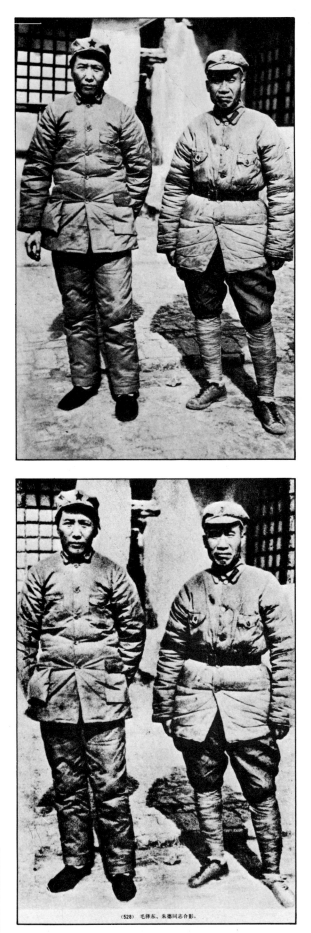

(528) 毛泽东、朱德同志合影。

■ THE CIGARETTE AND ITS SHADOW

In Yan'an in 1937 Mao poses with Zhu De, commander-in-chief of the Red Army. The version of this photo now in the Museum of the Revolution in Beijing and in the history books shows exactly the same individuals, but one detail has been changed. Mao now has his arm behind his back. Reason: the cigarette, which, in the censors' opinion, did not accord with the great man's dignity. The only sign of this discreet bit of fakery is that the retoucher forgot to erase the shadow of Mao's hand on the ground behind him.

<div style="border:1px solid">

1. *Yan'an, 1937.*
2. *Military Museum of the Revolution, Beijing.* Minzu Huabao, *no. 8, 1977. And,* Histoire illustrée de l'armée populaire de Libération, *vol. 1, Beijing, 1980.*

</div>

▪ FADED INTO THE BACKGROUND

In 1936 in Bao'an, in northern Shaanxi, not far from Yan'an, Helen Forster Snow, Edgar Snow's first wife, had four leaders of the Chinese revolution pose for her: Mao, Zhou Enlai, Zhu De, and Qin Bangxian (Chin Pang-Hsien).

Qin Bangxian, better known by his nom de guerre, Bo Gu, was a member of the famous group of 28 Bolsheviks trained in Moscow who, under the direction of the Comintern delegate, Pavel Mig, returned to China in 1930.

Bo Gu, a friend of Wang Ming, succeeded him as general secretary of the Party from 1931 to 1935. He opposed Mao at the Zunyi conference. He was then president of the northwest Soviet government. In this capacity he attended meetings and was party to agreements on the "united front" with Chiang Kai-shek following the commander in chief's capture. He then headed the Xinhua news agency as well as the Party newspaper. He died in an airplane accident in April 1946. In 1945 Mao had said that Bo Gu's policy had "cost the lives of more Communists than enemies."

Helen Snow's photographs appeared in the West not only in her own books (which she signed Nym Wales) but in her husband's as well. The photographs the Snows took appeared throughout the world and were reproduced after 1949 in Chinese history books, brochures, and the anniversary issues of magazines. They also appeared in museums in Beijing and Yan'an. Thus, this photograph, which can now be seen in the military museum in Beijing, shows Mao, Zhu De, and Zhou Enlai. But now, in the spot where Mao's old adversary, Bo Gu, was standing, nothing is visible but one of the wooden panels framing the window of a house in Bao'an. Bo Gu has faded into the background and the dark shade of his jacket, which contrasts sharply with those of his comrades, appears to have deepened the color of the panel.

1. Photograph by Helen Forster Snow (Nym Wales). Taken in Yan'an in 1937.
2. Military Museum of the Revolution, Beijing. And, Histoire illustrée de la Chine moderne, *Beijing, 1980. But the complete version has a tendency to reappear; see* Hauts lieux de la Révolution chinoise, *Beijing, 1985.*

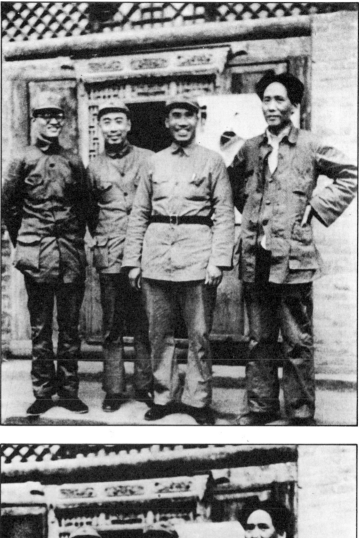

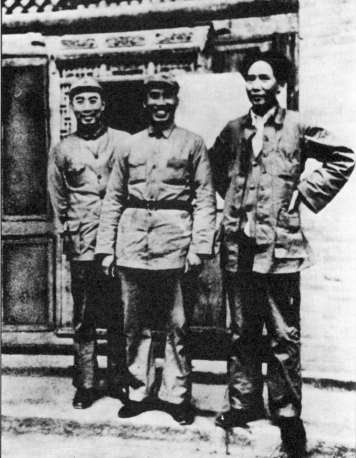

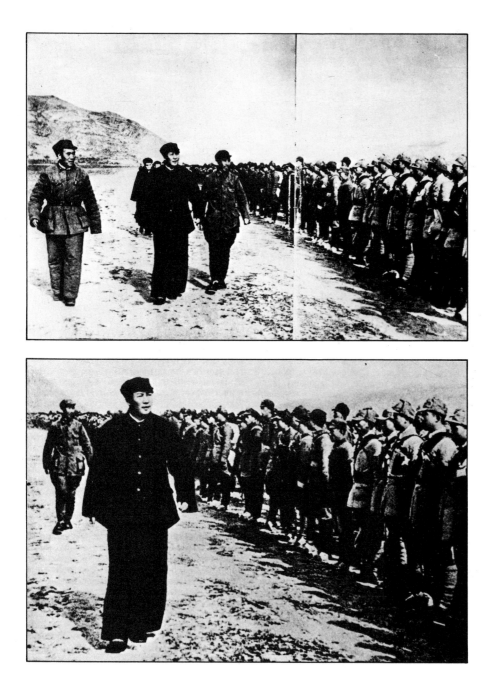

■ THE ORDERLY INSPECTION

October 1944. On the Yan'an airfield, Mao and Zhu De inspect their troops. Twenty-two years later, during the Cultural Revolution, when the Maoist cult was at its height, this photo reappeared and Mao was completely isolated by cutting out the part showing Zhu De and moving the person on Mao's right farther back. To avoid having to retouch the section where Zhu De had been and in order to recenter the composition, the figure of Mao was moved into his place. The opportunity was also taken to retouch his face and to highlight certain details such as the hands, the pockets, and the buttons on his jacket. The changes made in photographs to isolate the figure of Mao in a scene are among the subtlest elements of the cult of personality:

they reinforce the omnipresence and majesty of the hero, eliminate individuals of lesser importance, and place the principal figure squarely in the center of attention. Photographs, far more than the written word, shape the myth.

1. *Wu Yinxian,* Nan Ni Wan, *Shaanxi People's Press, 1975.*
2. *Xinhua News Agency, about 1965.*

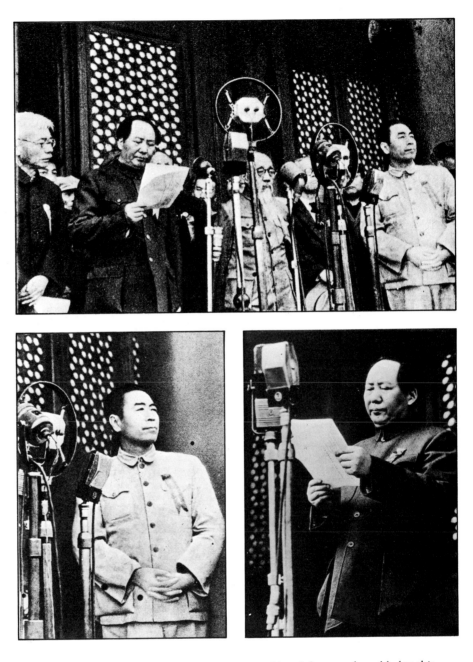

■ THE PROCLAMATION OF THE PEOPLE'S REPUBLIC

October 1, 1949. On the rostrum of the Tiananmen gate, Mao solemnly announces the founding of the People's Republic of China. Launched on June 30, 1947, the Communists' offensive enabled them to conquer the entire Chinese continent in less than two years. President of the Party since 1945, Mao has just been named president of the republic, a position he will hold until 1959. With him on the rostrum are all the historic leaders.

Years later, when a fanatic cult of personality develops around Mao, his figure is isolated—as though he had been the only one on the platform that day—by cropping the photo and erasing the people near him. Color was also added to this photograph. Only Zhou Enlai, the most prominent leader after Mao, will be entitled to this same treatment—background blocking and coloring—the day after his death (1976).

1. Xinhua News Agency.
2. La Chine, no. 11, 1976.
3. La Chine, no. 1, 1977.

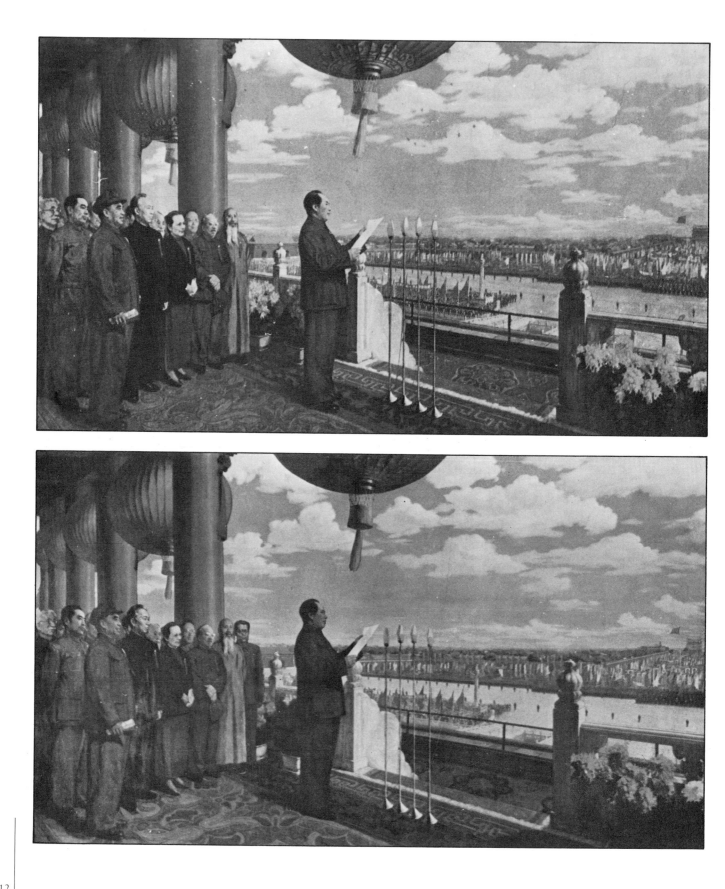

■ A PAINTING IN EVOLUTION

A famous painting by Dong Xiwen on view in Beijing in the Museum of the Revolution shows the ceremony of the founding of the People's Republic of China. Mao is standing a little to the left of center in the painting.

Behind Mao are the Party leaders: Zhou Enlai, Zhu De, and a number of others who were actually on the rostrum above the Gate of Heavenly Peace that day. Also depicted are Liu Shaoqi (Liu Shao-ch'i) and Song Qingling (Soong Ching Ling), who may have been present not far away, but who, in any case, do not appear in the press photos of the ceremony. When the Chinese artist painted this scene, probably on the occasion of the tenth anniversary of the proclamation, Song Qingling, who enjoyed great prestige as the widow of Sun Yat-sen, had just been named vice president of the People's Republic. Liu Shaoqi had just succeeded Mao Zedong as president of the Republic. Thus, in his painting, Dong Xiwen placed in the front row of the group the two greatest personalities in China after Mao, the one personifying continuity with the work of Sun Yat-sen and the other the state.

1968: The fall of Liu Shaoqi, one of the principal victims of the Cultural Revolution. His picture is removed from all publications and the color reproductions of Dong Xiwen's painting published in brochures, the propaganda press, and history books are cropped right after Soon Qingling.

July 1981: On the occasion of the celebration of the sixtieth anniversary of the founding of the Chinese Communist Party, Liu Shaoqi reappears in the historic photographs, still very close to Mao. He reappears in the reproductions of Dong Xiwen's painting too. But various details have been changed. Most noticeably, at the far right of the group, a new person has appeared, painted over the balustrade and the pink chrysanthemums. Stiff, square-jawed, high forehead, incipient jowls—Mao's successor, Hua Guofeng (Hua Kuo-feng), is easily recognized. He was only 28 years old in 1949 and was not at the ceremony. But, acceding to supreme power, he enters the legend of history and one of his first concerns is to be included in the group of "founding fathers," even if it means aging a bit.

1. *Xinhua News Agency, about 1950–1955.*
2. *La Chine, no. 7, 1981. And Museum of the Revolution, Beijing.*

■ MADAME MAO'S REVENGE

1958. It is the era of the "Great Leap Forward." Mao, president of the republic, and Peng Zhen, mayor of Beijing, set the example by being photographed, shovels in hand, at the huge work site of the Ming Tombs Reservoir near Beijing. A close friend of Liu Shaoqi, Peng Zhen found several opportunities to criticize and ridicule the absurd excesses of the "cult of personality." Moreover, in 1961 he began writing a report on the failure of the "Great Leap Forward" and Mao's errors. Following a series of intrigues, maneuvers, and strategic coups worthy of ancient China, Mao succeeds in upsetting the balance of political forces and regains absolute power in what is known as the "Cultural Revolution," which, as Simon Leys remarked, "was revolutionary in name only and cultural only because of the initial tactical pretext." In the spring of 1966 Peng Zhen will be one of its first victims. That year he is the target of violent attacks in the Party press. He is accused of having fomented a coup d'état against Mao and on December 4 is arrested by order of Jiang Qing (Chiang Ch'ing), Mao Zedong's wife. On December 18, in the Workers Stadium in Beijing, Peng and several others accused with him are subjected to six hours of humiliation by a meeting of 10,000 furious Red Guards, egged on by the leaders in the stands.

Peng Zhen's disgrace can be interpreted in a number of ways, depending on whether the Cultural Revolution is viewed in terms of political motivations (in reality, violent and sordid factional struggles for dictatorial power), cultural motivations (the theater as a pretext for settling accounts), or palace intrigues (Jiang Qing's revenge). Peng Zhen rebuffed Mao's wife several times when she asked him to present revolutionary operas on the stage of the prestigious Beijing Opera. According to one of Jiang Qing's biographers, Roxane Witke, Jiang Qing took Peng Zhen aside during a banquet and, with the opera program in her hand, asked him to turn over the Beijing Opera company to her so that she could "personally reform it." Furious, Peng Zhen ripped the program from her hands and threw it across the room, advising Jiang Qing to "fortify her position" before coming back to him with such a request. Ironically, less than a year after this scene that humiliated Mao's wife, Peng Zhen was on his knees in the stadium in Beijing at Jiang Qing's feet.

Was Peng Zhen—who was no better and no worse than many of his comrades (he was reponsible for a great many summary executions and trials during the revolutionary years)—sincerely defending the Beijing Opera or was he merely

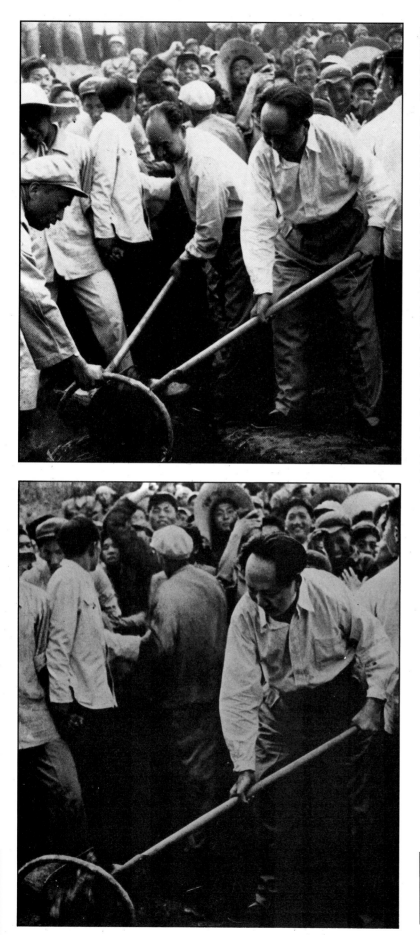

rebelling against the conniving Jiang Qing? No one knows, no more than anyone knows exactly why Jiang Qing was dead set against the Beijing Opera for so many years, to the point of eradicating almost all of its traditional repertoire.

Since the Cultural Revolution, all that remains of this uplifting scene of Mao and Peng together in the earthworks of the future giant dam is a touched up version, more consistent with Jiang Qing's spitefulness. Mao is now alone in the foreground. Peng has vanished into the crowd. His trousers and even some of the folds in his shirt were used to create the clothing of the person in the cap behind him. The frame of the photo has been slightly shifted to center on Mao, and the face and arm of the person holding the basket into which the two men were turning their symbolic shovelful of dirt have been erased in order to simplify the composition. Another interesting detail: the military cap worn by the person just behind Mao's head has been changed into an ordinary hat. Maybe it was a Soviet Army cap. As a matter of fact, a number of events transpired between the first and second versions of this photograph: the deterioration of relations with the Soviet Union, the withdrawal of the Russian experts, the Zhou Enlai controversy at the XXII Soviet Union Communist Party Congress, and the crisis of the summer of 1963.

1. *Xinhua News Agency, 1958.*
2. *La Chine, no. 11, 1976. Caption: "President Mao joins in the voluntary work at the construction site of the Thirteen Ming Tombs Reservoir in 1958."*

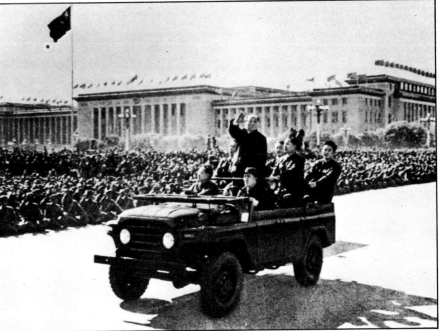

■ IN THE JEEP

In the summer of 1966 Mao inspects the Red Guards, who have come to Beijing from all over China. The photograph illustrating this event reappears in late 1976 in photo books and special magazine issues dedicated to Mao just after his death. Then, a year later, it is shown again. But this time there is another person in the jeep. Between late 1976 and mid-1977, the "Gang of Four" was removed and several of Jiang Qing's victims were rehabilitated. Such is the case with Peng Zhen, the former mayor of Beijing, who reappears in public and at the same time is restored to photographs from which he had been removed. He thus resumes his place next to Mao in this picture showing one of his last public appearances before his disgrace in the winter of 1966.

1. Littérature chinoise, no. 11–12, 1976. And, La Chine, no. 11, 1976.
2. La Chine, and Minzu Huabao, no. 8, 1977.

■ REMOVAL OF THE CHINESE KHRUSHCHEV

Liu Shaoqi, a member of the Central Committee since 1927, had succeeded Mao as president of the People's Republic of China. A theoretician of great repute, he is on good terms with the government of the Soviet Union. During the Cultural Revolution, however, he is violently attacked for his pragmatism. Denounced as the "Chinese Khrushchev" in 1968, he is stripped of all his duties and thrown into prison, where he is tortured and where he dies in November 1969. After Mao's death and the removal of the "Gang of Four," his name and his picture reappeared in Chinese newspapers and books. Among the dozens of photos from which Liu Shaoqi was removed during the Cultural

Revolution, this one stands out as a particularly absurd example of retouching. Liu, a blurred figure in the middle ground, is completely unrecognizable. Only those present in the room that day could possibly remember that Liu was beside Mao. But those with the power to efface must demonstrate their omnipotence to the very end by erasing even abstract details. The retoucher's message always finds its target.

1. *Yan'an, April 1945.* La Chine, no. 7, 1981.
2. La Chine, *no. 1, 1977.*

■ THE OFFICIAL PORTRAIT

In China between 1949 and 1976 there were several official portraits of Mao. The last portrait dates from the early sixties. The smooth, slightly fleshy face is impassive. A halo of well-groomed hair frames the high forehead. Over the years, depending on the publication, the background varies—white, dark gray, black—the shadows are more or less pronounced, a slight horizontal anamorphosis makes the face thinner or, on the contrary, enlarges it. But it is always the same face, the same shadows, the same jacket with the plain collar fastened by a round button with four holes sewn to the jacket with matching gray thread. This is undoubtedly a photograph, but over the years it was painted, enlarged, and reproduced, either by hand or mechanically by all sorts of processes. Often, it was even colored and then printed in the form of giant posters. The last clear indication of this incessant retouching: in the portrait published in late 1976 shortly after Mao's death—white background, thin face—the white edge of the shirt collar, one side of which looked slightly out of alignment, was corrected. Thus, upon the death of the subject and with the simple correction of this last, minute detail, the icon of the old dictator—ceaselessly reproduced, improved, and lovingly fussed over—achieves its final, symmetrical, perfect, and, to some extent, divine form.

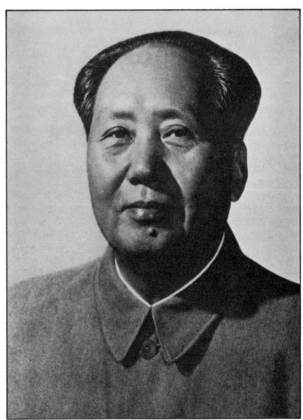

1. *Frontispiece of* Ecrits militaires de Mao Tse-tung, *Beijing, 1964.*
2. *Cover of* Minzu Huabao, *no. 11, 1976.*

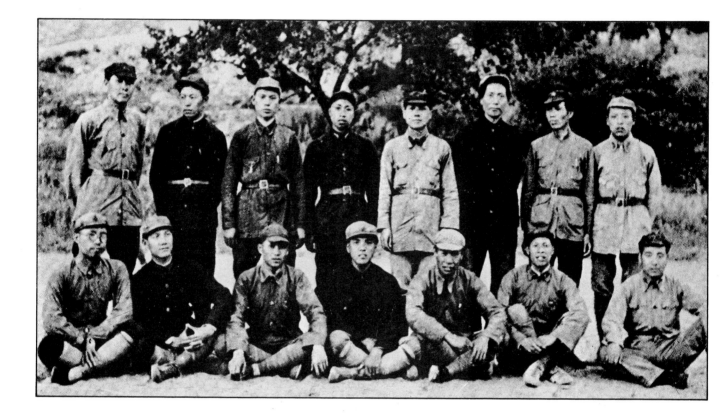

■ "THE CLOSEST COMRADE-IN-ARMS"

Several of the many photomontages of the Cultural Revolution show "Mao and Lin Biao in Yan'an." In actuality, there are no photographs from the Yan'an period showing the two men together. They appear only in a few group photos and even then are often far apart.

During the Cultural Revolution, Lin Biao, minister of war since 1959, who, after eliminating his chief rival, Peng Dehuai, transformed the army into a political weapon in Mao's hands, becomes "President Mao's closest comrade-in-arms and successor." Documents are then fabricated showing that this friendship, this closeness, this affiliation went all the way back to the years of fighting the Japanese.

For this montage, Mao's figure was borrowed from a photograph taken in 1936 in Bao'an (attributed to "Nym Wales"); that of Lin Biao was probably taken from a photo in the same series showing Lin Biao with his staff. A fairly neutral background of foliage—which changes with the different versions released to the press at the time—completes the composition.

During the Cultural Revolution, every official photograph of Mao also shows Lin Biao. Thus, when Mao welcomes Edgar Snow in 1970, Lin Biao is there beside him, holding the little red book in his hand. But that same year, Lin Biao, who had his eye on the presidency of the republic, is defeated in the Central Committee (August-September 1970). He disappears in September 1971 in circumstances that are more than mysterious: his airplane was either shot down or it crashed, although the official version was that he was trying to escape to the Soviet Union. His picture, which was still appearing in newspapers and magazines in August 1971, is immediately erased from every photograph, and when they reappear, they are either retouched or cropped. Such is the case with this meeting between Mao and Edgar Snow.

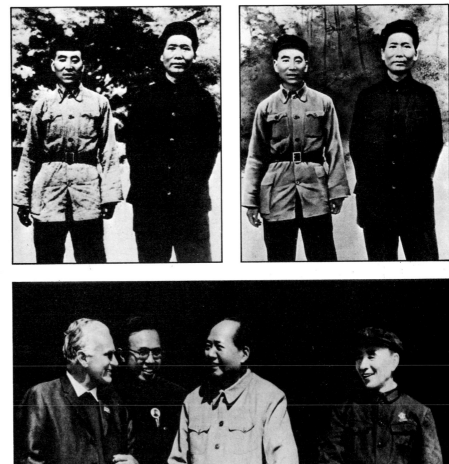

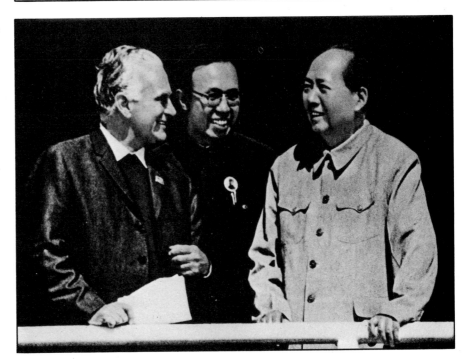

1. Photograph taken in Bao'an in 1936 by Helen Forster Snow (Nym Wales) and published for the first time in Red Star Over China, *London, 1937.*
2. Xinhua News Agency, about 1966–1968.
3. Xinhua News Agency, about 1968–1970.
4. La Chine, no. 7-8, 1971.
5. Histoire illustrée de la Chine moderne, Beijing, 1980.

119

■ "THE GANG OF FOUR"

Mao died on September 9, 1976. On September 18, in Tiananmen Square, Chinese leaders observe three minutes of silence in his memory before an enormous crowd. A photograph showing a row of about twenty individuals appears in all the media, both in China and abroad.

A few days after the ceremony the ultra-Maoists are defeated by China's new leader, Hua Guofeng. Mao's widow, Jiang Qing, and three members of the "Shanghai Group," Yao Wenyuan, Zhang Chunqiao (Chang Ch'un-ch'iao), and Wang Hungwen, are nicknamed the "Gang of Four" and become the hated enemies of the new regime and the symbol of everything devious and subversive.

In November 1976, Chinese and foreign observers note that the figures of the "Gang of Four" have been removed from official photographs. But, in the case of this photograph, no attempt was made to close the line of leaders, as was so often done in other Russian and Chinese photographs. The paint used to melt the four figures into the solid background is not supposed to conceal the faking. Instead, it leaves the spaces empty, gaping, as if to better emphasize the elimination (in the caption, *XXX* appears in place of their names!). A striking method of legitimizing the new government, of reinforcing its power and arrogance, of demonstrating its total control over images.

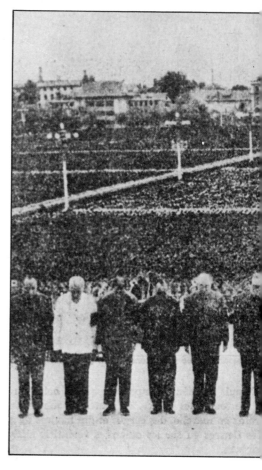

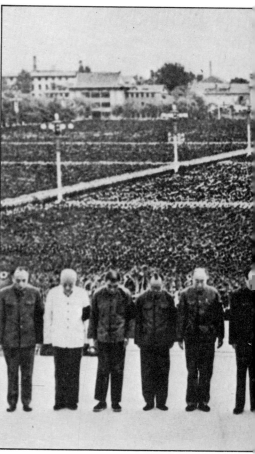

1. *Pékin information, no. 38, September 20, 1976.*
2. *La Chine, no. 11, 1976. Two other photos of the funeral are retouched.*

120

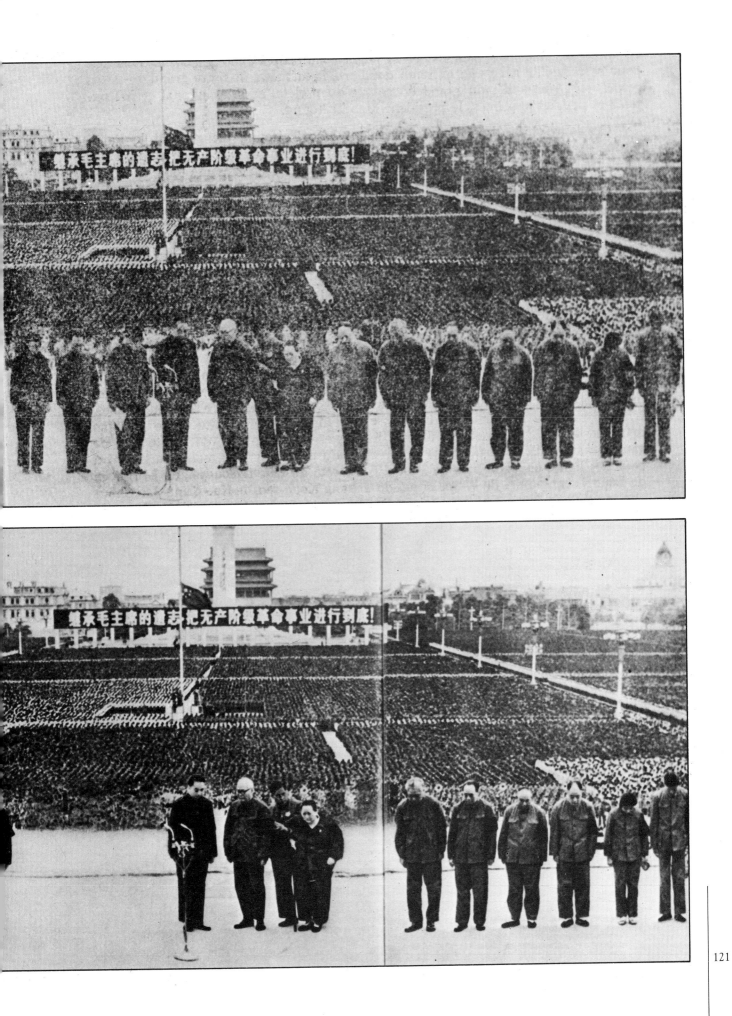

■ WITH HIS FRIENDS

"President Mao with his Asian, African and Latin American friends in 1959." This photograph, signed Heou Po and published several times between 1959 and 1976, shows a joyful, cosmopolitan group crowding around a jovial Mao. Although this Third World gaiety looks a bit forced, the photograph seems innocent enough at first glance. At the time, thousands of African and South American officials, ministers, representatives of political parties or unions, intellectuals, and students visiting

Beijing are invited to sumptuous receptions, huge banquets, and interminable tours. During this period, a souvenir photograph with the president is one of the ritual stages of these marathons, as is a visit to the Anshan steel mills, the model agricultural brigade of Dazhai or the Red Flag Canal. Mao dies on September 9, 1976. In the English edition of the special issue of the magazine *China*, which appears a few weeks later, this photograph, no doubt one of hundreds like it, is chosen to illustrate that period. A few days later, the French edition of the same magazine

appears. In the interval, the Gang of Four is removed and several photographs in this special issue are altered. This picture, which, as far as we know, has no apparent connection with the Gang of Four, is nevertheless very oddly retouched. It has been cropped, eliminating eleven people at a stroke. A twelfth person, who was standing to Mao's right and just a little behind him, has been painted out. Various other details have also been painted out: the edge of the man's face at the bottom left of the photo, the cigarette in the hand resting on the shoulder of the man on the right in the dark suit. The patterns in the dress of the woman on the left have been painted in. And, perhaps to show that certain individuals were deliberately removed, the man at the bottom right of the photo, who would have been cut in half by the cropping, was cut out and moved to the left in order to include him in the narrower frame. A photograph that started out with twenty-three people has been transformed into another with only eleven. It is impossible to tell why this photograph was cropped and retouched, or to link anyone in it to a plot or to one of the intrigues of the Gang of Four, or even to blame these people for some past action that might, for example, reflect negatively on the president's memory. There is undoubtedly a whole network of esoteric allusions which, when the photograph was published, must have found their targets. Purely esthetic alterations cannot be ruled out either.

1. *Photograph by Heou Po. A larger, early version in* Photo de Chine, Beijing, 1963. *A second, cropped version (shown here) in* China, *no. 11, 1976.*
2. Minzu Huabao, *no. 11, 1976, and* La Chine, *no. 11, 1976.*

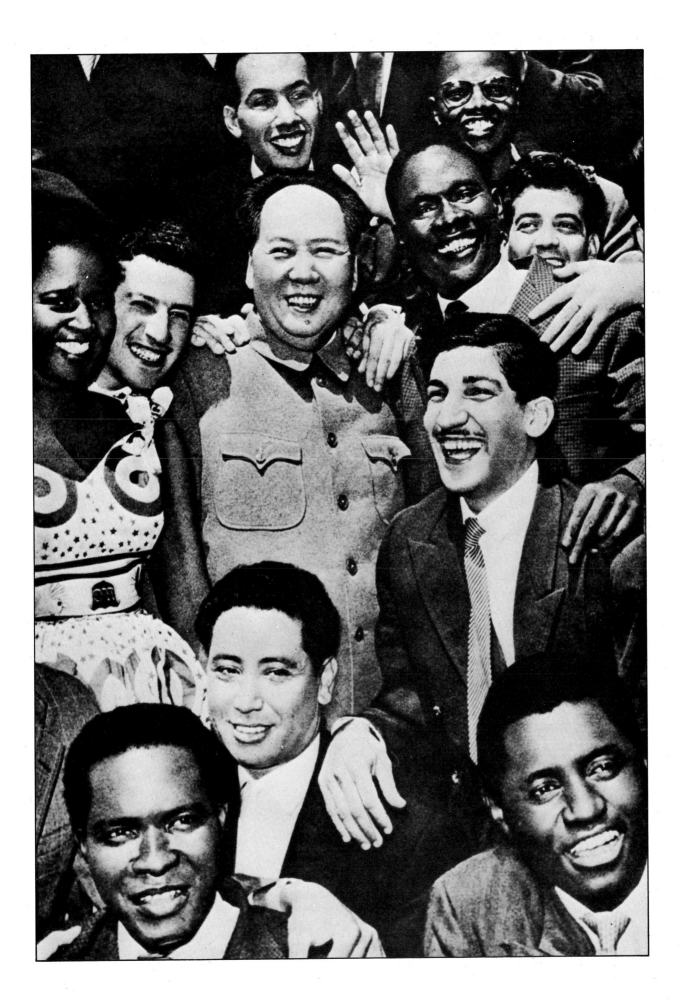

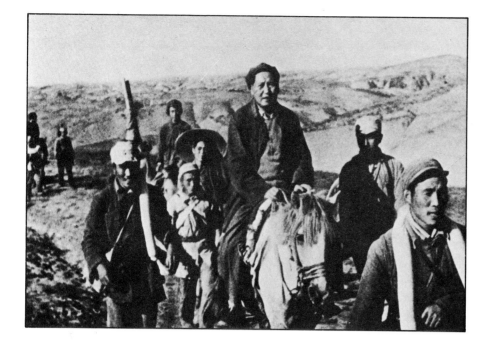

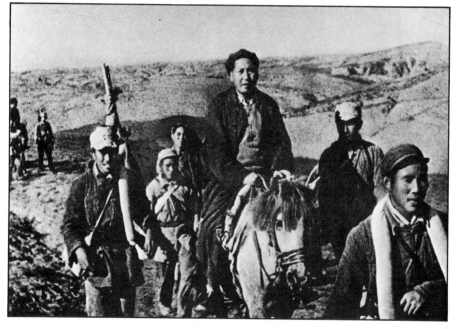

■ THE RIDE INTO OBLIVION

It has been said that Mao's wife was intent on having various individuals removed from historic photographs. One of the new regime's first gestures was to remove her. Such is the case with this famous photograph: Mao, in the center of a small detachment of foot soldiers, is riding his white pony across northern Shoanxi in 1947. Behind him is the slim figure of his wife, Jiang Qing, also on horseback. In November 1976, only a few days after the old dictator's death and the fall of the Gang of Four, the photograph appears with a bit of retouching: Jiang Qing has been made to vanish into the mountains in the background. Mao's little white horse is now

stuffed and in a glass case in the Yan'an Museum, where this retouched photograph—which, in China today, generally symbolizes the revolutionary war—can also be seen. Sometimes, however, it is incorrectly dated twelve years earlier and is given the caption: "Mao during the Long March."

1. Anonymous. Yan'an Museum. Numerous publications.
2. Minzu Huabao, *no. 11, 1976.* Littérature chinoise, *no. 11–12, 1976.* Histoire illustrée de la Chine moderne, *Beijing, 1980.*

From the Prague "Coup" to the Prague "Spring"

February 1948. Riding the wave of a political crisis, the Czech Communist Party seizes power. In the West this incident will be called the "Prague Coup," the immediate cause of the "cold war." A few days later, all other parties, whether Czech or Slovak, are excluded from the government and soon outlawed. The borders are closed. Under the leadership of Klement Gottwald, Czechoslovakia becomes a people's democracy tied to the Soviet bloc. Newspapers are brought to heel, censorship imposed. Thousands of opponents are imprisoned. Before long, waves of trials begin and camps are opened. First, the political opposition is eliminated, then the clergy. The army is purged. But, very quickly, the hunt for "traitors," "Titoists," "American agents," and "Zionists" spreads to the ranks of government and the Communist Party. In the end, a few individuals are singled out. Tortured, put on display in endless trials before fanaticized mobs, forced to make incredible rote confessions, most of the victims of these strange, ritualistic exercises are sentenced to death. Their faces disappear from historic photographs immediately, while those of Gottwald and the leaders close to him are retouched, painted, enhanced, and separated from unsuitable surroundings.

1968. It is the "Prague Spring," a wave of liberalization without precedent in any people's democracy. But "order" is restored by the arrival of Soviet tanks on Czech territory: in the following months, "normalization" is imposed in every field, including that of photographic images. During the exciting weeks of the "Prague Spring," when the press enjoyed relative freedom, one of the first things Czech journalists did was to publish a large number of well-known photographs, in both their original and their retouched versions. That spring, something unique occurred in the eventful annals of the Eastern-bloc countries: the Czechs were astonished to discover the falsification of their own history!

■ CLEMENTIS RELENTLESSLY PURSUED

Prague, Old City Square, February 21, 1948. The political crisis has begun: the day after the resignation of the eleven non-Communist ministers, Prime Minister Klement Gottwald calls for the formation of Action Committees. The ministers who resigned were hoping to hold early elections. But, taking advantage of the situation and with Prague firmly in hand as a result of infiltrating the police several months earlier, Gottwald and the Czech Communist Party mobilize the country, control the press, and wipe out all opposition. In four days, after enormous demonstrations, power is seized. On February 25 a new government is appointed, composed entirely of Communists or their allies. Only one non-Communist, Jan Masaryk, remains in office as minister of foreign affairs. He is the son of Thomas G. Masaryk, the architect of Czech independence and the first president of the Czechoslovak Republic. Masaryk has occasionally violent altercations with his colleagues in the government. During the next two weeks he becomes increasingly dismayed by what he sees around him. On March 10 he is found dead on the sidewalk outside the Cernin Palace. A symbolic suicide evoking the famous defenestration of Prague (1618) or a police crime? The truth was never discovered, and there are fairly convincing arguments supporting both theories. Masaryk was only the first in a long line of suicides and executions. The sweeping purges of 1948 (elimination of the "bourgeois" parties) were to be followed by waves of political "coups" and highly publicized trials (General Pika and military leaders, January 1949; trial of the Horáková group, June 1950; trial of Catholic prelates, December 1950; "discovery" of the network headed by Sling, February 1951; removal, arrest, torture, trial, and execution of Slansky and his "group," from September 1951 to December 1952; trial of other "accomplices" of Slansky, May-December 1953; trial of "bourgeois" Slovak nationalists, April 1954).

Beside Gottwald in the photographs of the historic appeal of February 21 was Vladimir Clementis (the man in the hat, partially hidden by the microphones, photo 1). Clementis—a Slovak intellectual, a member of the Central Committee of the Czech Communist Party, and secretary of state for foreign affairs in the previous government—holds the post of minister of foreign affairs in the new government. In February 1952 he is accused of "conspiring with the enemy" in the Slansky affair, sentenced to death and hanged on December 3, 1952, along with eleven other prisoners. Clementis was then erased from

photographs—with a relentlessness evinced by these photographs taken at the same moment: the background behind Gottwald is painted over to erase the photographer, and the cluster of microphones is moved closer to him to cover up Clementis' face (3); or, in a photo taken from another angle, only Gottwald remains (4); or else the photo is reversed and the face of the person beside him is made unrecognizable by engulfing it in a gray fog (2).

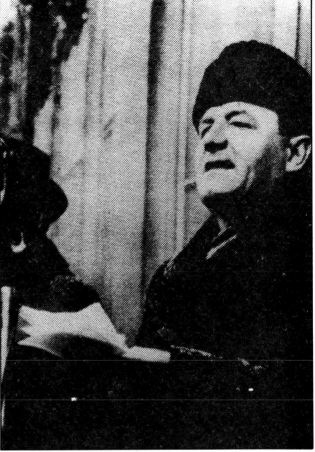

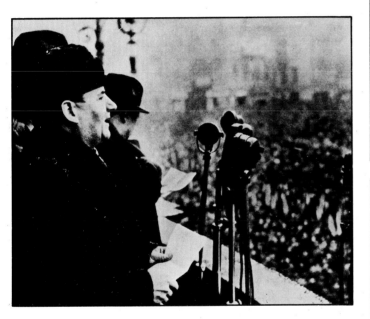

1. Czech press and Walter Storm, The Crisis, *Prague, 1948. A very similar version is found in the brochure,* Les événements de février 1948, *Prague, May 1948.*
2. Vaclav Husa, Dejiny Ceskoslovenska, *Prague, 1961.*
3. Retouched version, 1953. Klement Gottwald Museum, Prague.
4. Karel Kral, La Tchécoslovaquie pays du travail et de la paix, *Prague, 1953. Same photograph in Jaroslav Dvoracek and Antonin Novak,* Ten Years of the New Czechoslovakia, *Prague, 1955. And Gottwald Museum, Prague. This is the same perspective as photo 3, but the photo was printed backwards in Czech books.*

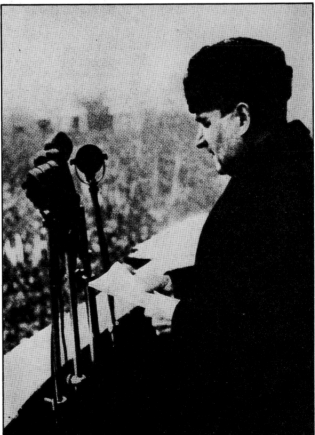

127

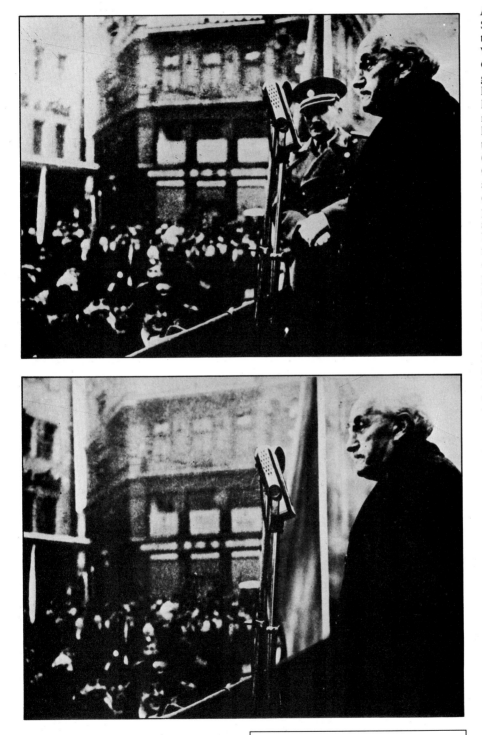

VANISHED FROM THE ROSTRUM

A rostrum in Prague, February 25, 1948. Several leaders close to Gottwald speak in turn to the crowd gathered in Saint Wenceslas Square. They are waiting for Gottwald, who had gone to Hradschin to give Eduard Beneš a list of the ministers in his new government. Among the speakers, left to right, are Vaclav Kopecky (named minister of information later that same day, he will institute censorship of the press and the faking of photographs), Josef Krosnar (president of the Central Committee of the Communist Party for the city of Prague), and Professor Zdenek Nejedly (minister of education, who, the next day, savagely purges the university; one of his first actions will be to order that Stalin's portrait be hung on the wall of every classroom in the country). Four years later the Ministry of Information will release a version of this photograph more in keeping with the fate of the various participants. Cropping eliminates the five hats in the foreground. Not only are the half-hidden faces and hats visible here and there behind the four main speakers made to disappear into the awning in the background, but so are two completely visible faces, including that of Marie Svermova, who was between Krosnar and Nejedly. A deputy from Prague and the widow of a leader killed in the Resistance, Svermova will be arrested just three years later and accused of participating in a "plot" organized by Otto Sling to oust Gottwald. Imprisoned and tortured, she will be released in 1956 and rehabilitated in 1963, only to be expelled from the Party again two years after the events of 1968.

In another photograph taken on the same occasion, only the profile of Nejedly is visible in front of the microphone. Opposite the photographer is an officer. It may be General Bocek, chief of staff of Defense Minister Ludvik Svoboda. Something of a Russophile like Svoboda and therefore fairly close to the Communists, Bocek remains faithful throughout the "Coup." But, shortly afterward, he is removed, arrested, and dies in prison. A great many other Army officers will also be executed following the staged trials that will take place between 1948 and 1952 and, like Bocek, they will be erased from the most important historical photographs. Thus, the retouched version of this photograph shows Nejedly on the platform alone. The officer, his coat, cap, buttons, and leather gloves are all subtly dissolved into the folds of the red flag at the edge of the platform.

1 and 3. Czech press, February 1948.
2 and 4. The retouched versions are in the K. Gottwald Museum, Prague. Other retouched pictures of the February speeches are found in the Miroslav Bocek book, Praha v'únoru 1948 *(Prague in February 1948), Prague, 1963.*

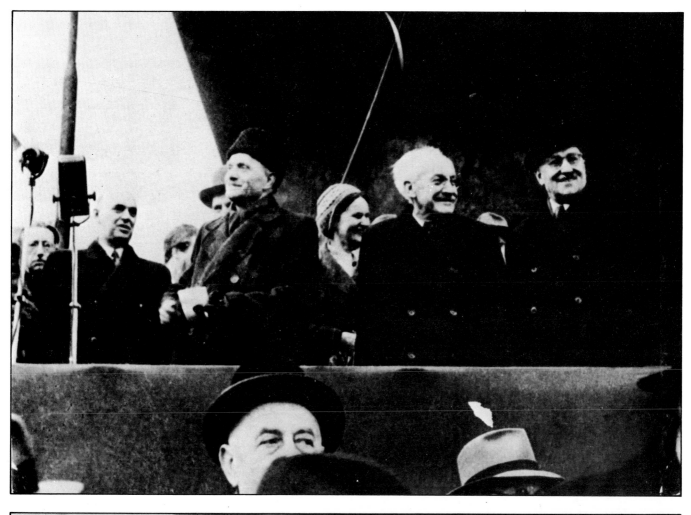

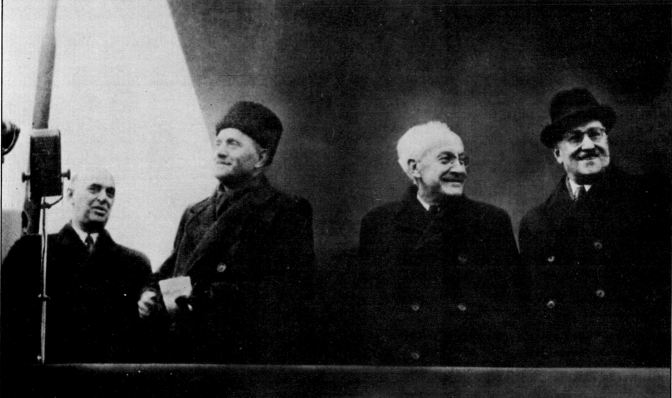

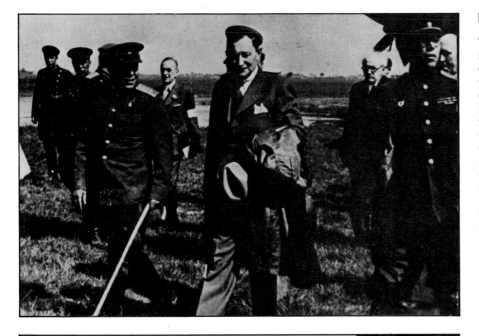

■ GOTTWALD SIGNS

This scene was recorded on July 27, 1948. A month earlier, President Eduard Beneš, who did not approve the new constitution proposed by the Communists, resigned (he died less than three months later). He was immediately replaced by Klement Gottwald, who had presided over the council since the "Prague Coup." The photograph shows Gottwald signing the law on cooperatives in the presence of the president of the Central Council of Cooperatives, A. Zmerhal (left), and the official in charge of the Two-Year Plan, E. Utrata (left, wearing glasses). There were six men with Gottwald; the censors will leave only two. In this case, it does not appear that the retouching was done for any reasons other than esthetic. The photograph was undoubtedly too crowded and did not give the ceremony a sufficiently solemn atmosphere. Those who were not absolutely necessary were therefore painted out. There is, however, something prophetic about this effacement since Dr. E. Utrata will be eliminated during the wave of trials and executions in 1952.

The artist assigned to retouch this photograph recreated the background details hidden by the four men who were erased: the gilding on the palace wall, the sconces, the polished mahogany pedestal table with its reflections, the rococo frame of the mirror, and even the enigmatic and cloudy depth of the reflection in the mirror.

■ THE RETURN OF THE SOCIAL-DEMOCRAT

In Czechoslovakia, as in the Soviet Union in earlier years, retouching was not confined to altering pictures of the new regime, but extended back in time as far as necessary to give history a perspective consistent with the current line. Thus, a seemingly ordinary press photo shows the return to Prague in May 1945 of a group from Kosice, in Slovakia, then a Soviet zone where the Czech government was in exile. In the middle is Zdenek Fierlinger, until then ambassador to the USSR. Certain individuals and incongruous details such as the military cap atop Fierlinger's head have been erased.

President of the Social Democratic Party,

but widely believed to be a secret Communist, Fierlinger was president of the council in 1945 and 1946. He was the official responsible for the dissolution of the Social Democratic Party and its merger with the Communist Party. His dual role enabled him not only to continue holding important positions until 1964, but also to survive the implacable gray paint used to remove so many other Czech historical figures from photographs.

1. Published by Czech journalists in 1968.
2. In the Zdenek Fierlinger book, Od Mnichova po Kosice, 1939–1945 *(From Munich to Kosice), Prague, 1946, there are several other photographs that will also be expurgated, one of which shows this same return from another angle.*

1. The original version was published in 1968 by Czech journalists.
2. The retouched version is in the K. Gottwald Museum in Prague and in the files of the Institute of Marxism-Leninism.

■ LEAVING THE TRAIN

The purges and summary executions begin quietly in Czechoslovakia just a few days after the Prague Coup. But, in May, more spectacular trials begin. Blaring headlines in the newspapers announce: "The Conviction of a Traitor to the Country," "A Vast Spy Ring in Slovakia," "A Band of Terrorists behind Bars," "They Wanted War so that the Capitalists Could Exploit Our People Again," "Sold Out to Western Imperialism, They Wanted to Destroy the Republic," "The People Rule High Treason," etc.

Thousands of people are arrested, hundreds of trials staged. The prisons are overcrowded. Execution follows execution. Among the first to be eliminated are the military personnel who fought the Nazis, such as Commander Zingor and General Pika. In fact, in just a few months the new Communist regime eliminates almost every army officer with even a remotely forceful personality who might one day oppose the dictatorship.

One photograph, out of a hundred like it, attests to this fact. It was taken in 1948 when Klement Gottwald was touring Slovakia. The prime minister has just gotten off the train and is standing on the carpet rolled out for the occasion. Behind him are various individuals, including Otto John (right), president of Parliament. And perhaps one of those high-ranking officers who, later that same year, so swiftly became suspect in the eyes of the regime. The censors will block out the overcrowded background and will elevate Gottwald to the sacred solitude of power, but not without also fixing his right coat sleeve, which had rolled up unattractively.

1. Original version published by Czech journalists in 1968.
2. K. Gottwald Museum, Prague. And CTK Agency.

■ RECEPTION AT THE CERNIN PALACE

This photograph was taken during a reception in Prague for a Soviet delegation headed by Marshal Bulganin, then minister of defense in the Soviet Union. President Klement Gottwald is entering a room with the imposing Mrs. Gottwald. The marshal follows behind. But a Soviet minister and marshal can never appear *in the background*, not even in the press of a satellite country. It will therefore be preferable to have him disappear behind the black curtain of a painted background. A recentered version of the photograph will appear, but without a woman who, if she were left hovering at the edge of the new picture, would tend to detract from the isolation of the central figures because of her nearness to Mrs. Gottwald.

This is a very ordinary picture, to be sure. It is merely a moment in an official gathering at the Cernin Palace in 1950. Who could doubt it? Although it is retouched, this is not a case of censorship. The point is not simply to erase the Soviet minister but, rather, to show him (possibly in another photograph) only in the position and in the surroundings that his rank demands.

1. *Original version made public by Czech journalists in 1968.*
2. *K. Gottwald Museum, Prague. CTK Agency.*

133

■ PARADE AND PROTOCOL

In Prague in 1951, Czech President Klement Gottwald receives Soviet Marshal Konev, the conqueror of the Dnieper. Both appear on a platform during a military parade. But the great marshal has unconsciously allowed his little finger to stray! The retouchers promptly erase his hand and his forearm, and are therefore forced to erase Gottwald's as well. This also affords the opportunity to open Konev's eye a bit, which had been caught in an unfortunate blink. This imperceptibly retouched picture then appears in the press, its irrefutability reinforced by its complete banality.

1. Original version made public by Czech journalists in 1968.
2. CTK Agency and Tass News Agency, 1951.

■ THE PRAGUE SPRING

Prague, March 30, 1968. An official ceremony in Hradschin in front of the Saint Vitus Church. There, side by side, are Josef Smrkovsky, who will soon be president of the National Assembly; Alexander Dubcek, general secretary of the Communist Party since January 5; and Ludvik Svoboda, who was named president of the republic earlier in the day. In a few weeks these three men become the most popular political figures in Czechoslovakia: they represent the liberal currents that had recently caused the downfall of Antonin Novotny. Gottwald's successor as leader of the Party in 1953 and then Zapotocky's successor as president of the republic, Novotny, one of the toughest leaders of the people's democracies, severely reprimanded the students in 1967, attacked Czech writers, and opposed all economic reforms to such an extent that for the first time in any Eastern bloc country the regime fell of its own accord. Under Dubcek there is a partial return to democracy. Freedom of conscience, of assembly, of association, of travel, the right to strike, and the independence of the judiciary are guaranteed by the new government. This is the "Prague Spring," which is accompanied by extraordinary political creativity and an intense intellectual outpouring: newspapers, magazines, debates in public, and on the radio. But there are also violent attacks in the Soviet press, which accuses the new regime of playing the "enemies of socialism" game. In May and June, the tension mounts. In July, Leonid Brezhnev and the "brother parties" issue warnings. On July 23, Soviet reserves are called up and the attacks in the Soviet press increase. On August 20, columns of tanks cross the border. At dawn on August 21, parachutists capture Dubcek, Smrkovsky, and Cernik and fly them to a secret prison in the USSR, while Svoboda is held prisoner in Hradschin. Svoboda immediately negotiates the release of Dubcek, and on August 26 the Moscow accords are signed, followed by "normalization." Which is to say restoration of the Socialist order under Soviet occupation. Thousands of people leave the country, thousands of officials are dismissed. Many will be prosecuted and imprisoned. 500,000 people are expelled from the Party! Censorship is reinstated. The most popular leaders are eliminated by Gustav Husak, the man who, one year earlier, had defended the "Prague Spring" and who will be Czechoslovakia's first "normalizer." Expelled from the presidium of the Party and the Parliament, Dubcek is sent as ambassador to Turkey. But even in this position he continues to attract too much attention. He is recalled and packed off to the country, where he is forced to do menial work (chauffeur, gardener, etc.).

Normalization was to have an effect on pictures as well. Thus, in 1969, the new censors will create a skillfully retouched version of this meeting of the three men in Prague in the spring of 1968. Dubcek is gone. Svoboda is closer to Smrkovsky. This was accomplished by carefully cutting the photograph between the buildings and sliding the two parts together like the movable scenery in the theater. The house in the background covers part of the façade of the Saint Vitus Church, throwing the perspective off only slightly (it is noticeable, however, that the tiles of the square are no longer correctly aligned and that Smrkovsky is now standing far behind Svoboda). Dubcek disappears behind Svoboda into that secret place, into that trapdoor of history opened with a skillful snip of the retoucher's scissors. Only the tip of his right shoe, at the edge of the cut, was forgotten.

1. Czech press, first week of April 1968.
2. The retouched version appeared in the fall of 1969. CTK Agency.

Asian Lives and Battles

Dien Bien Phu, far more than a major battle, is a turning point in the history of relations between colonial powers and Third World countries. With the founding of a people's democracy in North Vietnam came the absolute control of information by the Party. But, without even waiting for this subjugation of texts and pictures to be universally established, it is in the middle of the war, on the very day after Dien Bien Phu, that photographers and cinematographers begin fabricating pictures of the historic battle.

Examples of photographic manipulation abound, not only in the second war in Vietnam, where the Americans and the North Vietnamese try to outdo each other in propaganda, but also in the maneuvers of other war-torn countries such as Cambodia, where the Khmer Rouge employ wholesale slaughter as a means of establishing a new form of people's democracy.

In the North Korea of Kim Il Sung, retouching and the faking of photographs are raised to the level of a state institution. The production of texts and pictures glorifying the head of state, a veritable living god, exceeds the worst excesses of the Stalinist or Maoist cults.

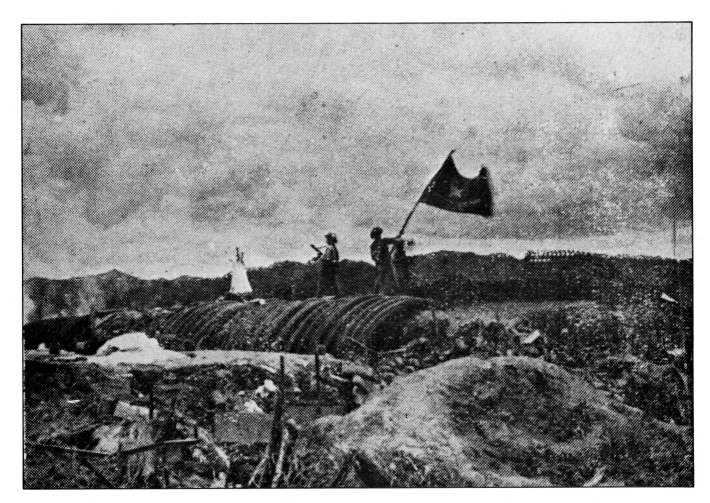

■ DIEN BIEN PHU: EXTRAS FOR THE BATTLE

Spring 1954, the battle of Dien Bien Phu. The war in Indochina has continued since 1946. The French troops are fighting elusive guerrilla forces. Despite rallies by Generals De Lattre and Salan, which halt the Vietminh offensives for a time, the war continues. General Navarre, who succeeds Salan, decides in November 1953 to create a vast entrenched camp at Dien Bien Phu, in upper Tonkin. General Giap mobilizes tens of thousands of porters, who carry supplies by night on bicycles. With the help of 35,000 men and heavy artillery, he manages to surround the entrenched camp. The surprise attack—declared impossible by experts—begins March 13, 1954. After 57 days of resistance, the French camp is taken. Giap's victory was not decisive, but it had an enormous psychological impact, both in France, where it caused the fall of the government and accelerated peace negotiations, and in Vietnam, where it was viewed as a symbol of all struggles for liberation.

The Vietnamese published many photographs of this historic battle and the May 8 surrender. Almost all of them are reenactments. Whether they show the movement of supplies (3) or attacks by Vietminh soldiers (4), which were photographed in broad daylight despite the fact that all of these operations took place at night, or whether they are supposed to show the final assault on the main redoubt (soldiers play the dead and smoke bombs provide a combat atmosphere) (5), all of these scenes were photographed and filmed well after the battle. Similarly, a photograph with the caption "General Castries and his entire staff surrender" was in fact taken days later, while the officers were in captivity. The photograph of a column of French prisoners ("All of the survivors of the garrison surrendered") was taken during a reenactment on May 14 (2). Soviet director Roman Karmen had arrived in the area. The Vietnamese military leaders had the prisoners line up and march in separate units past a platform where the camera was located, several times in succession in order to film several sequences. At this same time, in mid-May, more than a week after the surrender of the entrenched camp, Karmen filmed the scene showing the Vietminh flag being planted on the roof of General Castries' command post (1). Other scenes were filmed by Karmen and by Vietnamese directors to recreate various phases of the battle. Only a few French prisoners, mostly Algerian auxiliaries, agreed to play the French soldiers in these reenactments.

1, 2, 3. Photos published in the book by General Vo Nguyen Giap, Dien Bien Phu, *1st edition, Hanoi 1959, 2nd, 1964. And in* Guerre du peuple armée du peuple, *Hanoi 1961.*
4, 5. Published by the North Vietnamese Embassy in France, about 1980. Film commentary by General Bigeard on French television May 8, 1964. Several of these fake scenes filmed by Karmen or the Vietnamese reappeared in a series by Henri de Turenne broadcast on French television in March and April 1984, touching off a heated controversy.

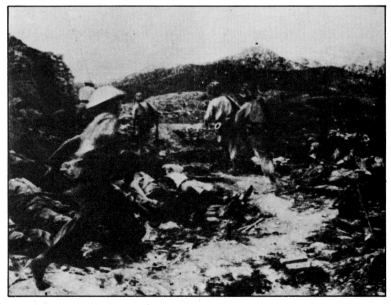

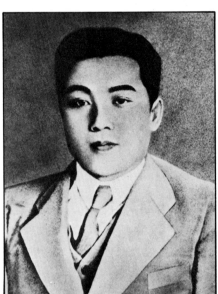

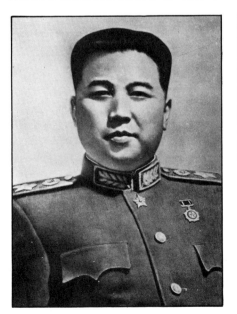

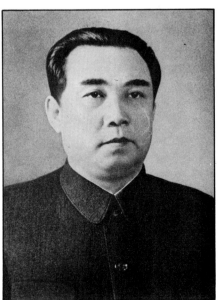

■ THE UPLIFTING PHOTOGRAPHIC LIFE OF THE SUN OF HUMANITY

Kim Il Sung is one of the world's most mysterious political figures. Despite the thousands of pages of his dithyrambic biography, very little is known about him. A child of middle class parents, he fled to the Soviet Union, where he trained the Korean troops with whom he would later fight in Stalingrad. Sent by Stalin to Korea in 1945 to thwart the plans of the Chinese Communists, he eventually, with Soviet assistance, became the head of the North Korean government. His invasion of South Korea in 1950 started a war that would involve the United States and would last until 1953. Keeping well out of the Sino-Soviet quarrel but borrowing from both the Chinese and the Soviet models, Kim Il Sung developed one of most fanatic forms of the "cult of personality" ever witnessed. Museums overflow with exhibits in his honor. All sorts of objects once belonging to the "Sun of Humanity" are displayed in glass cases. The lack of photographs illustrating his life is compensated by enormous superrealist frescoes showing the glorious episodes—most of them no doubt imaginary—of his inexorable rise to power. The pictures represented as photographs look more like paintings in black and white. Some may have started out as actual portraits, but others were probably entirely faked.

1 and 2. Livre illustré de l'activité révolution-naire du camarade Kim Il Sung, *Pyongyang, 1970.*
3. Histoire abrégée de l'activité révolution-naire du camarade Kim Il Sung, *Paris, 1973.*
4. Livre illustré . . . , *1970.*
5. Museo de la guerra de liberación de la pa-tria, *Pyongyang, 1969.*
6. Livre illustré . . . , *1970.*

■ THE GREAT LEADER IN THE FIELDS

The caption of a picture of Kim Il Sung in a North Korean brochure reads: "Comrade Kim Il Sung, Great Leader, rejoicing with peasants on the Unjŏn plain, which yields a bounteous harvest each year" (1). The great leader is seen smiling and walking through a field of grain. His entire entourage must have been behind him—bodyguards, aides, secretaries, valets—and perhaps even the peasants mentioned in the caption. But the entourage has been erased. Not completely, however, since there is a vague, halo-like silhouette around Kim and even a hand sticking out behind him, apparently belonging to no one. Kim, unreal and smiling, hovers over a promising harvest that dissolves into an already melted horizon. Photography in North Korea and the superrealist painting that sometimes substitutes for it have acquired a dimension unique in the world because of a highly perfected art of legend-making (2). A few of the many examples: "Comrade Kim Il Sung, Great Leader, receiving from his mother pistols imbued with the high ideals of his father, Kim Hyung Jik, concerning the restoration of the motherland"; "Comrade Kim Il Sung, great military strategist and renowned, invincible commander with a will of iron, leading the maneuver of retrooping into large formations"; "Comrade Kim Il Sung, respected and beloved Leader, worrying about the fate of the people of South Korea"; "Comrade Kim Il Sung, respected and beloved Leader, personally managing the Kangsŏn steelworks in order to call all Party members and other workers to a heroic struggle aimed at implementing the decisions of the December 1956 plenary session of the CC of the Korean Labor Party"; "Workers exerting greater efforts in the production of refrigerators in wholehearted support of the Great Ten-Point Political Program proposed by the Leader."

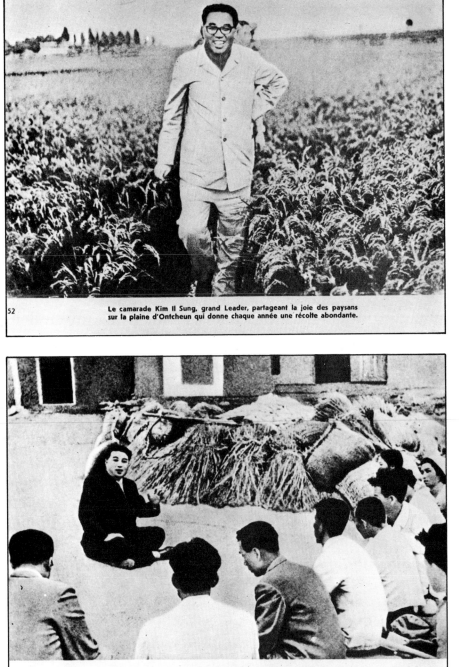

52 Le camarade Kim Il Sung, grand Leader, partageant la joie des paysans sur la plaine d'Ontcheun qui donne chaque année une récolte abondante.

A Tcheungsan-ri, assis sans façon dans une aire de battage couverte d'une natte, le camarade Kim Il Sung, Leader et père affectueux, a discuté avec les paysans des travaux agricoles et de leur ménage.

1 and 2. Le musée de la révolution coréenne, Pyongyang, 1978. An unretouched version of photo 1 is also found in the Biographie *in 3 volumes, vol. III, Beirut, 1973; and in* Histoire abrégée . . . , *1973.*

In Ch'ŏngsani, seated informally on a mat-covered threshing floor, Comrade Kim Il Sung, leader and loving father, talked with peasants about agricultural work and their homes (2).

■ WORLDWIDE DIFFUSION

In both the Museum of the Founding of the Party and the Museum of the Korean Revolution in Pyongyang, several rooms are devoted to the worldwide diffusion of the thoughts of the "Respected and Beloved Leader, Great Thinker, and Theorist." There, Korean visitors can see thousands of books—the numerous literary works and the voluminous biography (2,200 pages) of Kim Il Sung, translated into all of the world's languages—and thousands of clippings or whole pages from newspapers all over the world, where the face of the "Sun of the Nation" appears above flattering articles, entire speeches, and glowing interviews. Also on display in these museum cases are *Le Monde* and the *New York Times*, the *Asahi Shimbun* and the *Gazette de Lausanne*, *L'Express* and the *Times of Ceylon*. "The newspapers of many countries of the world express their wholehearted support for the inspired works of Comrade Kim Il Sung . . ." says the caption. Kim Il Sung's son, Kim Jong Il, "an eminent thinker blessed with rare insight," began to receive the same attention in newspapers throughout the world toward the end of the 1970s. And even Kim Il Sung's father, Kim Hyung Jik, "the implacable anti-Japanese revolutionary militant," was showered with whole pages

of praise in Indian, British, and African newspapers. Are North Korean visitors to the Pyongyang museums surprised to see newspapers and magazines, half a century later, recounting the life of a man who died in 1926? Are they surprised that so many newspapers mention their Great Leader? Do they understand the word "advertisement" which sometimes appears at the top of these full-page articles? Because the truth is that these thousands of articles are advertisements purchased at high prices in all of the world's capitals, and these thousands of books were indeed published in every language, but at the author's expense. Newspapers and publishing companies cannot afford to refuse the precious manna generously distributed by North Korean diplomats in exchange for ready-made interviews and long speeches. When this practice culminated, between 1968 and 1978, these worldwide advertising expenses accounted for a significant percentage of the national budget. With an enthusiasm equaled only by their naiveté, the diplomats had to resort to selling drugs, tobacco, and alcohol to feed this advertising mill with foreign currency, hence the dozen or so diplomatic scandals in 1976. The results of this teeming activity: displays in the museum cases of pages from *France-Soir*, the *Times*, and the *International Herald Tribune*, which the

North Koreans cannot read but where they immediately recognize the portrait of their "Great Leader."

The Museum of the Korean Revolution, Pyongyang, 1978.

■ NGUYEN VAN BE, THE MAN WHO WAS DEAD

During the second Vietnam war (1957–1975), the two sides tried to outdo each other in propaganda. Rumors, false reports, faked photos, and false documents were distributed freely by both the North Vietnamese government and the U.S. Army. The unwitting hero of one of the strangest propaganda stories was a 20 year-old Vietnamese, Nguyen Van Be. His story appeared one day in the fall of 1966 in the Hanoi newspaper, *Thien Phong*. From a poor peasant family in the Mekong Delta, he had joined the Vietcong and was to become a model of "revolutionary zeal." Taken prisoner near the city of My An on May 30, 1966, while loaded down with mines, grenades, and other ammunition, he was questioned by an American officer. He suddenly grabbed a mine: "Raising the mine above his head, his eyes shining with a terrible brightness, he cried: 'Long live the National Liberation Front! Down with the American imperialists!' (. . .) Thus were 69 of the enemy killed, including 12 Americans (one captain), and 20 puppet officers." In North Vietnam the "martyr" was celebrated in brochures, newspaper articles covering the whole front page, poems, plays, radio broadcasts, and an opera. No

less than two statues were erected in his memory.

In February 1967 a South Vietnamese prison guard noticed the close resemblance of one of his young prisoners to the photographs published in the Communist newspapers and brochures. He pointed this out to the authorities. The prisoner was none other than Nguyen Van Be and the circumstances of his capture were among the most commonplace: a South Vietnamese soldier had caught him by the hair while he was trying to escape by swimming underwater in a canal. Nguyen Van Be was presented to the public in a press conference. American propaganda took advantage of this incident and exploited it in its own way: in July 1967, 30 million tracts, 7 million brochures, 465,000 posters, 175,000 copies of a special newspaper issue, 167,000 photographs, a number of films, and several radio and television broadcasts had already spread the features of Nguyen Van Be, his family, and friends in both the South and the North. Communist propaganda responded with the same fervor. On May 30, the anniversary date of the "death" of the hero, several million young North Vietnamese gathered in gigantic stadiums. A third statue was erected. A huge book recounting his

exemplary life was published. The press and the radio in Hanoi accused the Americans of falsification and even claimed that the so-called Nguyen Van Be was only a creation of Hollywood-style plastic surgery. In July 1967 the Communists offered a reward of 2 million piastres (about 80,000 francs) to anyone who would reveal the exact circumstances of the hoax. Around the village where Nguyen Van Be was born several people who knew him were executed by the Vietcong. His family was pressured. And each year, the anniversary of the hero's death continued to be celebrated. No one knows what happened to him after the "liberation" of South Vietnam and the fall of Saigon (April 30, 1975).

> *The tract distributed by the Americans shows Nguyen Van Be reading the* Tien Phong *of December 7, 1966, where his photo appears on the front page followed by a long report of his heroic deeds. The text tells the whole story and explains: "The Communists say that Be chose a hero's death. Be says that he never fired a shot and that he never even knew how a mine was detonated." (Source: U.S., JUSPAO, tract no. 66).*

■ THE KHMER ROUGE PUT ON A SHOW

1972. The National United Front of Cambodia headed by Khieu Samphan wants to prove its legitimacy in the eyes of the world. It also wants to prove that by leading the fight against American imperialism it recognizes the legitimate authority of Prince Sihanouk, then in exile in Beijing. And, lastly, it wants to prove that its leaders really are in the jungle on Cambodian territory and that they have not, as the Americans claim, cautiously withdrawn to bases along the Thai border. A series of photographs is therefore fabricated and sent to Sihanouk. The photos show ministerial councils being held in jungle huts and operations led by five Khmer Rouge leaders in various "liberated" zones. However, the same trees, the same scarcely changed huts, the same landscapes, and the same clothing details appear in every photo. The whole series of photographs is obviously an enormous show staged in a safe, comfortable location, always with the same actors. Thus, the same soldiers who, a few photos back, were shown on exercises, are shown in exactly the same costumes and with the same weapons, "ready to swoop down on the enemy."

Three years later the Khmer Rouge entered Phnom Penh (April 17, 1975), cleared the city of all its residents, including the sick, finished off the wounded, and transported the population to rural areas where a great many people were slaughtered. The reign of the Khmer Rouge lasted until 1979, when the Vietnamese invaded the country. The type of rural Communism imposed on the country by the Pol Pot government included forced labor, the near-total destruction of traditional society, and the planned, systematic extermination of a large segment of the population. The figures suggested by the most reliable experts range from about 500,000 to 2,000,000 deaths.

The leaders of the Khmer resistance and members of the Royal Government of National Union in the interior of Cambodia, National United Front of Cambodia, brochure, 1972.

Balkan Revolutions

The system of censorship and the control of pictures developed and perfected by the Soviets in the 1930s served as the model for all of the people's democracies founded in Europe after the Second World War. In many cases, Soviet advisers even helped the new governments set up special offices within the Ministries of Information or Propaganda.

Hungary, Poland, East Germany, Czechoslovakia, Bulgaria, Romania, Yugoslavia, and Albania were thus provided with solid bureaucratic structures in charge of controlling thought and information. Even if several of these countries were to break away from the Soviet Union or enter into conflict with it, the political system would not be seriously threatened. In each country the same mechanism exists for the centralization of information and publishing, censorship and propaganda, and is usually linked to more or less pronounced forms of the "cult of personality." The head of state, that providential individual, becomes the one around whom everything revolves: history, politics, cultural life. Pictures are rearranged to ensure historic continuity between the legendary life of yesterday's hero and the destiny of the nation with which he is identified. Rivals eliminated one after another, incomprehensible political expedients, failures, or contradictions—photography plays a large part in the permanent reshaping of history, which is one of the principal cultural activities of these countries.

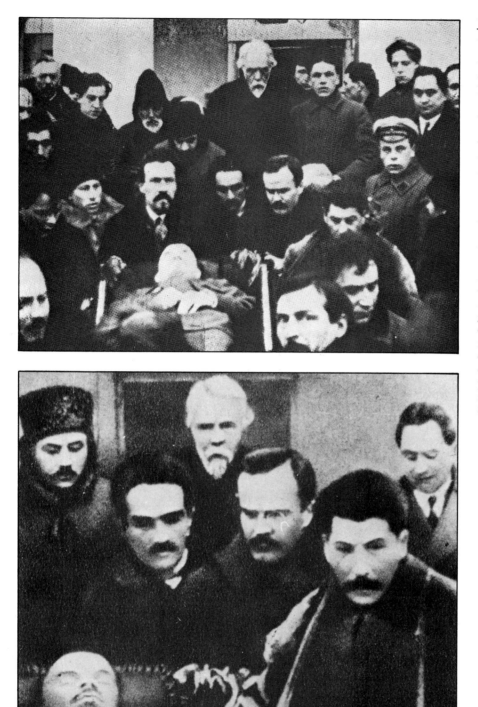

Димитров на погребението на В. И. Ленин заедно ръководители на ВКП(б) и Съветската държава.

January 1924. Lenin is dead. During the funeral, family, friends, Bolsheviks, and revolutionaries crowd around the casket. In the crowd is a Bulgarian, Georgi Dimitrov (1882–1949). A young deputy in the Bulgarian National Assembly, he is imprisoned for pacifism from 1915 to 1917. Organizer of the Bulgarian Communist Party, he meets Lenin in 1920. Following the worker strikes of 1923 he is sentenced to death: he spends twenty-two years in exile, most of the time in Moscow. In Berlin in 1933, he is accused by the Nazis of instigating the burning of the Reichstag. He is acquitted at the end of a celebrated trial that reverberates throughout Europe. Back in Moscow, he will not return to Bulgaria until 1945 with the Red Army.

In the eulogistic books published after his death, Dimitrov is shown at Lenin's funeral. Part of the crowd was erased in order to give Dimitrov the same standing as the other revolutionaries, and he has been moved a little closer to Stalin. However, in editions of the same works published during the destalinization period the photograph disappears altogether, as do the many other photos showing Dimitrov with Stalin.

1. *Still from "Lenin's Funeral," a special newsreel sequence filmed by Kinokhronika in early February 1924.*
2. Georgi Dimitrov 1882–1949, *Sofia, 1958.*

■ IN FRONT OF THE FOUNTAIN

Moscow, September 1944. Georgi Dimitrov,
still in exile in the Soviet Union, poses in
front of a fountain in a Moscow garden.
With him is his "staff," Vassil Komarov
(seated, left), Dimitri Ganev (seated, right),
Georgi Damianov (standing, left), and Vilko
Chervenkov (standing, right). Having
returned to Sofia after the war and named
president of the council, Dimitrov dies on a
trip to Moscow in 1949. His brother-in-law,
Chervenkov, succeeds him. The Party is
savagely purged by the new leader (Kostov
trial, December 1949). After involving
Bulgaria in a type of development much
too Chinese or Albanian for Soviet tastes,
he is expelled from the Party in late
November 1961, following a report read by
Todor Zhivkov. Chervenkov's picture
disappears from publications. The foliage in
the garden replaced him in this
photograph, which had to be recentered in
order to rebalance the composition, thus
eliminating the loyal Ganev as well.

1. *Georgi Dimitrov 1882–1949, Sofia, 1958.*
2. *Luka Zulamski and Georgi Stoichev,* Toi,
moi et Dimitrov, *Sofia, 1968.*

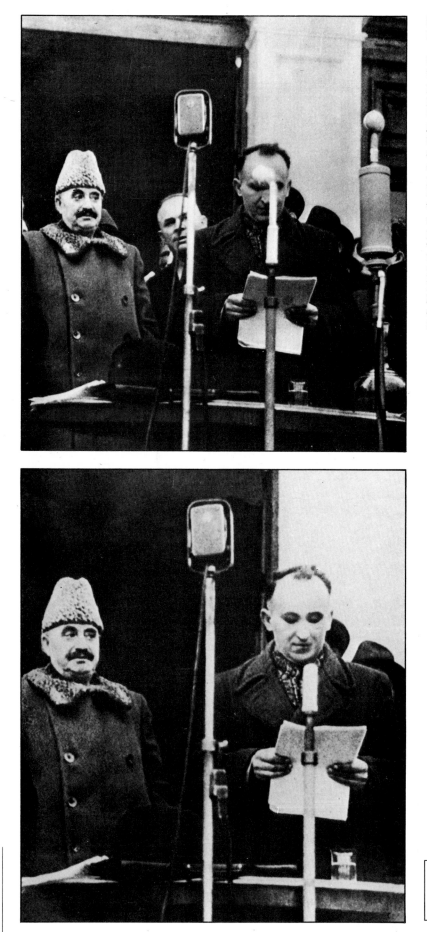

■ AN AWKWARDLY-POSITIONED MICROPHONE

Sofia, January 31, 1946. During a meeting in the square in front of the national theater, passage of the law on the confiscation of property illegally acquired during the war is announced. Georgi Dimitrov, head of the government, listens to a young member of the Party's Central Committee read a speech. Years later, Todor Zhivkov, secretary of the Bulgarian Communist Party, assumes power at Moscow's urging; dismisses the head of state, Vilko Chervenkov (1961); and, with Khrushchev's support, has himself named prime minister (1962). The photograph showing the future leader, which must of course appear in his biography, is retouched. The microphone hiding Zhivkov is shortened and the people between him and Dimitrov are removed. Zhivkov's face is reconstructed and the continuity between the two historic leaders is thenceforth assured.

1. Luka Zulamski and Georgi Stoichev, Toi, moi et Dimitrov, *Sofia, 1968.*
2. Todor Zhivkov, A Biographical Sketch, *Sofia, 1981.*

148

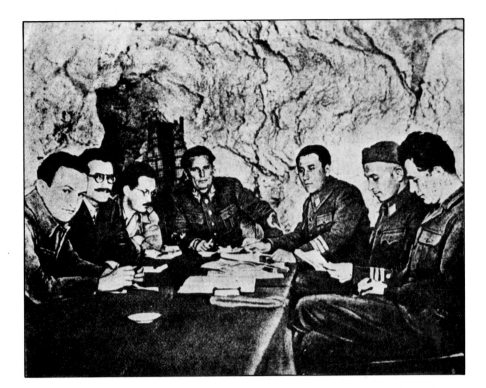

■ TITO TRIMS HIS STAFF

A photograph taken in 1944 in the underground shows Josip Broz Tito surrounded by the Yugoslav Liberation Army staff during a secret meeting in a cave on the island of Vis. Tito is in the center of the photo. On his right are Vladimir Bokaric, Ivan Milutinovic, and Edvard Kardelj; on his left are Eleksander Rankovic, Svetozar Vukmanovic-Tempo, and Milovan Djilas. After the expulsion of Djilas (1954), faked versions appear. Since Djilas is on the far right in the photograph, all it took to obtain a perfectly acceptable group was to shift the frame to include only the five central figures. But Rankovic is dismissed in 1966. He is the man on Tito's immediate left. This time, the entire photograph is compromised: Yugoslavian books in the late 1960s show only the leader's face.

1. Svetozar Vukmanovic-Tempo, Revolucija Koja tece, Memoari *(The revolution in progress, memoirs), Belgrade, 1971.*
2. Pero Moraca and Viktor Kucan, La guerre et la révolution des peuples yougoslaves, 1941–1945, *20th anniversary of the insurrection, Belgrade, 1961.*

■ THE CAFÉ OWNER'S CIGARETTE

Enver Hoxha (1908–1985), son of an Albanian merchant, studied in Montpellier and Paris. Secretary of the Albanian Consul in Brussels (1933), he then returned to his own country (1936). A teacher at the Tirana high school and then the French school in Korçë, his political activity attracts attention: he is fired. He then opens a café and tobacco store, the Flora, in Tirana, which becomes the meeting place of intellectuals and anti-fascist agitators. In 1941, after the Italian invasion (1939), when the Yugoslavian representatives of the Comintern attempt to unify the various factions, Hoxha is named secretary of the Albanian Communist Party. He then helps to organize the armed Resistance. In the postwar years, Hoxha becomes the absolute master of Socialist Albania. The only photograph taken in what historians now prudishly refer to as "the Flora shop" is retouched. The cigarette Hoxha had in his mouth is gone, his quizzical smile is broadened, his coat is ironed a little. In short, the café owner has been transformed into the future head of state.

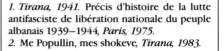

1. *Tirana, 1941.* Précis d'histoire de la lutte antifasciste de libération nationale du peuple albanais 1939–1944, *Paris, 1975.*
2. Me Popullin, mes shokeve, *Tirana, 1983.*

Profesorë e nxënës të Liceut të Gjirokastrës. Nga e majta në të djathtë.

■ TOO MANY FEET IN A GROUP PORTRAIT

Hoxha, now the leader of Socialist Albania, must deal simultaneously with the annexationist tendencies of Yugoslavia and various internal conflicts. The interior minister, Koci Xoxe, favors an economic alliance. Nako Spiru, one of the leaders of the Resistance, opposes it: he is forced to commit suicide. A little later, the break between Stalin and Tito reverses the situation: Xoxe is tried, sentenced to death, and immediately executed (1949). In 1956, Hoxha, still the object of Tito's attacks, takes advantage of the Communist world crisis (Budapest) to eliminate all of his opponents, including the Communist leader, Liri Gega (shot while pregnant). He then turns to China and resists attacks from the Soviet Union. After the Sino-Yugoslav rapprochement, he gradually breaks with the Chinese and dismisses his defense minister, Beqir Balluqu (1975); then his chief of staff, Petrit Dume (1976); and all of the "pro-Chinese" ministers.

Finally, one of his oldest comrades in arms, his prime minister, Mehmet Shehu, commits suicide (December 1981). The following year, Hoxha explains in one of his books that Shehu had always been a spy for the Yugoslavians and the Soviets and that he had organized a plot to assassinate him.

These waves of executions were followed by harsh purges of historic texts and pictures. For example, between 1975 and 1983, illustrated books on the history of Albania had to be republished four or five times to eliminate pictures of Balluqu, Dume, and Shehu and to spotlight the new heir apparent, Ramiz Alia.

Pictures of the life of Enver Hoxha were also revised and corrected. And in museums and books alike, the photographs are full of holes. An example is this already ancient group photograph showing the young Enver while he was still in high school in his native city of Gjinokaster. Several students are standing behind a group of teachers.

Two holes were obviously made in the group. Two people were removed by carefully painting in the wall in the background, but the retoucher forgot to erase their feet as well (bottom center and under the chair on the far right).

Enver Hoxha, Vite të vegjëkusë, Tirana, 1983.

151

■ PHOTOGRAPHIC MARRIAGE

When illustrating the life of great leaders, expert retouchers do not forget feelings. An example is this beautiful montage reuniting Hoxha and his wife, Nexhmije. The figure of Hoxha, borrowed from a group photograph taken during the 1st Congress of Antifascist Youth in Helmes in August 1944, was painted, cut out, and pasted onto another photograph. An attempt was made to unify the two backgrounds, but the vertical splice is still clearly visible.

Me popullin, mes shokeve, *Tirana, 1983*.

■ FROM MAKEUP TO EFFACEMENT

Several leaders of the Albanian Resistance pose with Enver Hoxha during the Labinot Conference (March 17-22, 1943). During this meeting the Communist Party organized the struggle, created a national liberation army, and elected Hoxha general secretary. The photograph was famous in Albania, where it appeared in various museums. The same photo reappeared in a historical work published in 1976. But just as distribution of the book was about to begin, it was noticed that an undesirable was in the group. It may have been Petrit Dume, chief of staff of the Albanian army, who had just been eliminated. His face was therefore covered with black ink, and the book was sold and exported in that form. The photograph is still published in historical works, but now a background detail has been painted over the unwanted individual.

1. Ndreçi Plasari and Shyqri Ballvora, Histoire de la lutte antifasciste de libération nationale du peuple albanais, *vol. 1, Tirana, 1976.*
3. Me popullin, mes shokeve, *Tirana, 1983.*

153

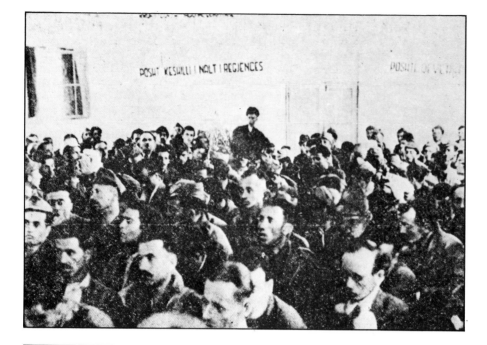

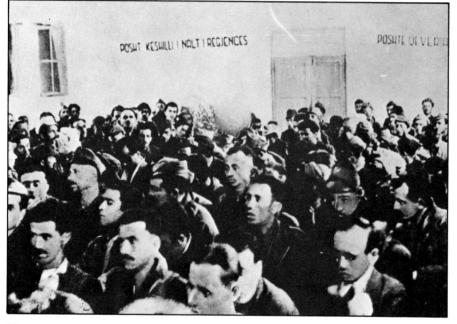

■ A SLIGHT SILHOUETTE AT THE CONGRESS

Përmet, May 24, 1944. A congress elects an Antifascist Council of National Liberation to carry on the fight for freedom. This is in fact the birth of the people's democracy in Albania. In 1983, this photo of the congressional hall appears in a book of historic photographs. The person in black standing at the back of the hall was erased. It was undoubtedly Mehmet Shehu, Hoxha's prime minister, who committed suicide in December 1981 after a remarkably strange conspiracy. The usefulness of erasing a tiny, barely recognizable silhouette may well be questioned. But retouching has its own laws: it is a coded message that must find its targets, one way or another.

1. Précis d'histoire de la lutte antifasciste de la libération nationale du peuple albanais, 1939–1944, Paris, 1975. Attentive readers will have noticed that the original version was itself retouched: a person near the man standing up has been erased, no doubt someone eliminated in the years 1945–1975.
2. Me popullin, mes shokeve, Tirana, 1983.

■ "THE DAWN THAT BROKE . . ."

November 29, 1944. Albania is completely liberated; Hoxha speaks in Tirana. The historic photo showing him in front of a microphone reading a speech with other leaders of the Resistance beside him (1), will go through various transformations: it is carefully touched up and recentered (2) and will eventually be retouched to remove everyone else and leave Hoxha as the sole liberator of Albania (3). This last picture is labeled with the following caption: "The dawn that broke in November heralded the morn of a new era."

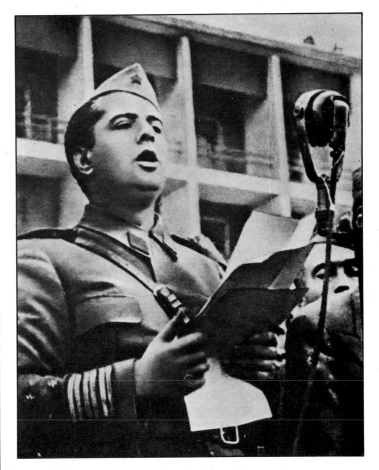

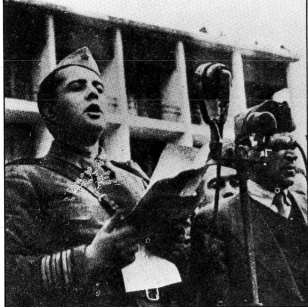

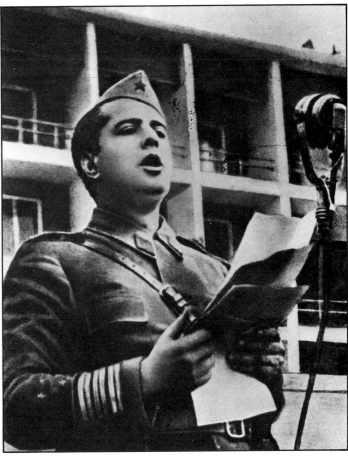

1. Précis d'histoire de la lutte antifasciste de libération nationale du peuple albanais 1939–1944, *Paris, 1975.*
2. Me popullin, mes shokeve, *Tirana, 1983.*
3. 40 vjet shqiperi socialiste *(40 years in Socialist Albania), Tirana, 1984.*

■ A VISIT TO THE TOMB

To express his admiration for Stalin, Hoxha
wrote a book. Next to authentic photos that
were retouched to eliminate certain
individuals are photographs that have, over
the years, undergone innocuous and
apparently absurd modifications. Such is
the case with this photograph of Hoxha
placing a floral tribute on Lenin's grave. In
the new version, superfluous details are
eliminated. The retouching is obvious and
unnecessary, demonstrating to what
treatment photographs in totalitarian
countries are constantly subjected (in this
case, however, the person eliminated may
have been Mehmet Shehu).

1. Me popullin, mes shokeve, *Tirana, 1983.*
2. Enver Hoxha, Avec Staline, Souvenirs,
Tirana, 1984.

The Optical Illusions
of Cuban History

On January 2, 1959, when Fidel Castro triumphantly enters Havana, he enjoys immense national prestige and international sympathy mixed with curiosity. The Cuban press, one of the richest and most varied of Latin America, generally supports the new regime and its essential reforms. But the euphoria is short-lived. In less than two years, dailies, weeklies, and monthlies, until then prolific and representing a wide spectrum of groups and currents of thought, will be nationalized, reorganized, and finally reduced to three or four titles.

The founding of a single party, initially the "United Party of the Socialist Revolution" and then, more prosaically, the "Cuban Communist Party," is accompanied by the elimination of opponents and then non-Marxist revolutionary tendencies. At the same time, the hardening of the American position in reaction to nationalization (agrarian reform, June 1959; sugar refineries, August 1959; oil, October 1959) and the blockade force Castro to turn to the USSR.

After the failure of the Bay of Pigs landing (April 16, 1961) and, more particularly, after the Cuban missile crisis (October 1962), Soviet advisers help the Cuban government take control of the press, historic records, and information. All of the revolutionary records are placed under the supervision of the Institute of History of the Communist Party and the Interior Ministry. And the Cubans learn from Soviet experts how to retouch photographs. Photograph censorship is thus exercised against the various other currents of the Cuban revolution, against Castro's former comrades in arms who eventually disagreed with him and were shot, thrown into prison, or who chose exile; against members of the dictator's family who became estranged from him; and against everyone who stayed in Cuba and chose suicide to protest the oppression in which they had unwittingly participated.

And, as in many other totalitarian countries, the settling of scores, sordid family histories, and the elimination of rivals or opponents were covered up, just as several historic events were either completely distorted or transformed into revolutionary myths.

157

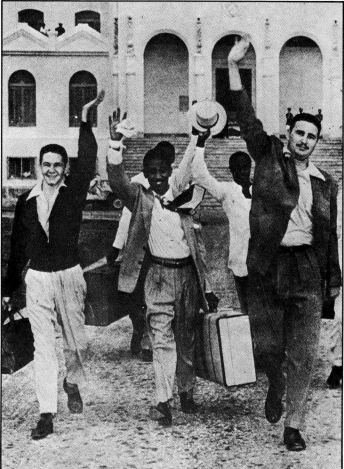

■ "TRAITORS TO THE REVOLUTION"

Havana, October 13, 1953. Mr. Ramon Hermida, Interior Minister, yesterday decided to send to the Isle of Pines national penitentiary twenty-seven individuals convicted by the court of Santiago de Cuba following events at the Moncada barracks.

The press release is short but exact: twenty-seven guerrillas survived the attack on a barracks soon to become a symbol of guerrilla warfare (there are also two women, Haydée Santamaria and Melba Hernandez, who will be sent to another prison). Twenty months in the penitentiary. Amnesty on May 15, 1955, departure of Fidel Castro for Mexico, founding of the July 26 Movement, return of a group aboard the *Granma*, difficult landing on December 2, 1956. Castro goes underground, his movement expands, the regime topples, the dictator Batista flees, and Castro enters Havana triumphantly (January 2, 1959). The regime, which enters into an alliance with the Soviet Union, very quickly becomes a dictatorship, and many of Castro's former friends turn against him. They are generally erased from historic photographs. But this is not always the case. For example, in this photograph taken in a courtyard of the Isle of Pines penitentiary (3), the Moncada twenty-seven are all clearly visible, but the caption names only 25. Eduardo Montano and Mario Chanes, the two men with no number, have been declared "traitors to the revolution." Montano was exiled and Chanes, beaten and tortured, was still in a Cuban prison in 1986. Similarly, photographs of the prisoners leaving the prison on the day of the general amnesty were recentered on Fidel Castro and his brother Raúl in order to eliminate the undesirables (1 and 2).

1. All of the original versions of photographs of the departure from the Isle of Pines penitentiary are in Bohemia, *no. 21, May 22, 1955. This photograph appears again, unrecentered, in* Cuba, *special issue, "Los cien años de lucha," October 1968.*
2. The recentered version also appears in La prison féconde *and in several other works:* Fidel Castro, La historia me absolverá, *Havana, 1973;* Moncada, *1973.*
3. A series of articles by Mario Mencia published in Bohemia *in May and June 1980, on the occasion of the twenty-fifth anniversary of the release of Castro and his comrades. Reproduced in the book,* La prison féconde, *Havana, 1982. The photograph appears with the correct captions in books and magazines published before 1968, for example,* Bohemia, *no. 5, February 1, 1959.*

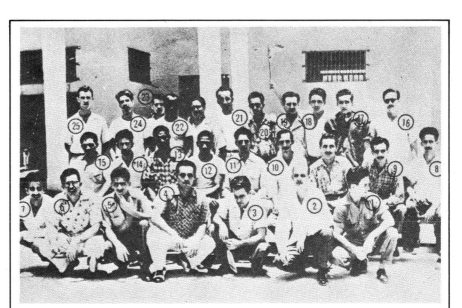

The "Moncadists" in the courtyard outside the room where they were imprisoned.

1. Julio Díaz 2. Eduardo Rodríguez Alemán
3. José Suárez Blanco 4. Reinaldo Benítez
5. Ramiro Valdés 6. Jesús Montané
7. José Ponce 8. Gabriel Gil 9. Israel Tápanes
10. Orlando Cortés 11. Rosendo Menéndez
12. Juan Almeida 13. Agustín Díaz Cartaya
14. René Bedia 15. Enrique Cámara 16. Fidel Labrador
17. Ciro Redondo 18. Raúl Castro
19. Abelardo Crespo 20. Andrés García
21. Pedro Miret 22. Armando Mestre
23. Francisco González 24. Oscar Alcalde
and 25. Ernesto Tizol.

◼ EFFACED IN BLACK OR WHITE

January 1, 1959, Palma Soriano. Fidel Castro, at the gates of Santiago de Cuba, reads a solemn appeal into the microphone of "Radio Rebelde" (Rebel Radio) inviting the forces of Camilo Cienfuegos and Che Guevara to march on Havana. Opposite him is Jorge Enrique Mendoza, Radio Rebelde announcer, and on his right, Carlos Franqui, station manager and one of the five members of the executive bureau of the July 26 Movement. In the morning, Franqui, who had learned of Batista's flight, called for a strike and urged the rebels to cut the lines of communication, take cities, occupy police stations, and maintain order.

After the takeover, Franqui is manager of the newspaper *Revolución* until 1963. In 1967 he organizes the May exhibition and in 1968 the Havana Cultural Congress. In the summer of 1968, when Fidel Castro applauds the Soviet invasion of Czechoslovakia, Franqui breaks with the regime and goes into exile in Italy. His picture disappears from publications. And he is even erased from this very famous historic photograph. He is sometimes painted out with white and sometimes with black. On view at the Museum of the Underground in Santiago de Cuba is a facsimile of a page from a contemporaneous revolutionary newspaper showing this same photo, but with Franqui dissolved into a black background!

"I learn of my photographic death," writes Carlos Franqui in a poem. Of all those in history who have been "erased," he is, so far, the only one to have reacted literarily and to have attempted to convey the anguish of photographic disappearance:

> *Do I exist?*
> *I'm a little white,*
> *I'm a little black,*
> *I'm a little crap,*
> *On Comrade Fidel's coat.*

1. *Numerous publications prior to the fall of 1968. For example, roneograph of* Revolución, *December 1962.*
2. *Effacement "in black":* Cuba, *special issue,* "Los cien años de lucha," *October 1968.*
3. *Effacement "in white":* Gamma, *weekly selection in French, March 18, 1973.*

■ THE CIENFUEGOS MYSTERY

January 8, 1959, Havana. Fidel Castro addresses the nation before an enthusiastic crowd. Beside him, one of the Cuban people's most beloved "barbudos," Camilo Cienfuegos. At one point Fidel stops, turns to Camilo, and asks:

Voy bien, Camilo? *(How am I doing, Camilo?)*
Vas bien, Fidel! *Cienfuegos answers (You are doing fine, Fidel!).*

This exchange will become the most famous of the Castro era. An idolized hero, Cienfuegos, head of the rebel army, disappears swiftly, under extremely bizarre circumstances.

In October 1959, Hubert Matos, former teacher and another hero of the Cuban revolution who became military chief of Camaguey province, warned Castro against Communist infiltration of the army and the government and especially about the methods of implementing agrarian reform. He eventually submits a letter of resignation (October 19). Castro instructs Cienfuegos to arrest Matos at once. At this point one of the most obscure episodes in Cuban history begins. Matos is actually arrested. He will be convicted of "treason" and thrown into prison, not to emerge until twenty years later. But what Cienfuegos was doing at that time cannot be precisely reconstructed, even though Cuban "historians" sometimes give minute-by-minute details.

It has been said that Cienfuegos, opposed to Matos's arrest, returned to Havana and had a violent argument with Fidel Castro: soldiers later saw his body, riddled with bullets, in a military hospital. It has been said that Cienfuegos was personally liquidated by Raúl Castro, Fidel's brother, on a small airfield where his airplane was making a stopover. It has been said that his airplane was sabotaged. A great many things have been said, but the fact remains that Cienfuegos never reappeared. His aide-de-camp was killed shortly afterward by a sentry. The Camaguey control tower official fled to the United States. The day after Cienfuegos's disappearance, Castro puts the entire country on alert. Rumors. Someone thinks he saw him on a small island. False report. Press conference with the "Líder máximo" who points out the route of the airplane on a map (the reverse of the one indicated by the Camaguey control tower). Public speeches linking the two incidents: Matos is responible for Cienfuegos's disappearance. During the demonstrations in the winter of 1959–1960, placards are seen everywhere: "Fidel no olvides que por el traidor perdimos a Camilo" (Fidel, do not forget that because of the traitor we lost Camilo). With his chief rival in terms of popularity dead and one of his most intelligent potential political adversaries safely locked up, Castro's path to absolute power was unobstructed.

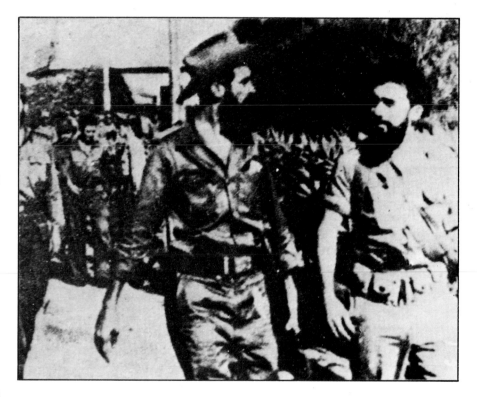

Photograph published in Cuba, *special issue, "Los cien años de lucha," October 1968, with this caption: "In October, Camilo, after arresting the traitor, Hubert Matos, disappeared aboard an airplane that was bringing him back to Havana" The photograph also appears in the book by Antonio Nuñez Jimenez,* En Marcha con Fidel, *Havana, 1982, with the same type of commentary.*

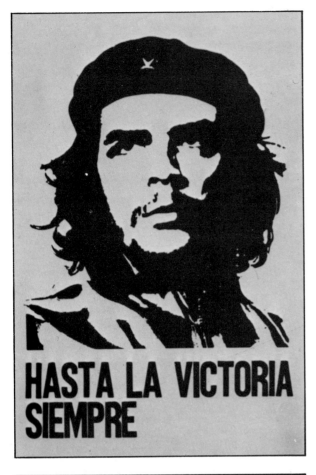

HASTA LA VICTORIA SIEMPRE

EN MI ISLA

INSPIRADOS EN SU
EJEMPLO
FORMAREMOS
NUESTRA CONCIENCIA
Y CONSTRUIREMOS
EL COMUNISMO

■ CHE'S FACE

Born in Argentina, Ernesto Guevara, known as "Che," joined Castro's forces in Mexico and landed with him in Cuba in December 1956. A famous commander during the revolutionary war, he became minister of the economy after 1959. Somewhat suspicious of Soviet aims and in profound disagreement with Fidel Castro, he disappeared from Cuba in 1965. He went to Bolivia where, convinced that the revolution should be extended to the entire continent, he headed a small band of guerrillas. In early October 1967, surrounded by Bolivian soldiers, Che was killed. No sooner was his death confirmed than the Italian publisher, Feltrinelli, arrived in Havana and began a search for documents on the legendary guerrilla. Juan Vivès, then director of information at the Foreign Affairs Ministry, was summoned by Fidel Castro, who ordered him to assist Feltrinelli. The two men rummaged through various records before falling back on those of Vivès. By chance, they found a photograph taken during the memorial ceremony for the sailors of the French freighter, *La Coubre*, which had exploded in March 1960 while carrying a load of weapons to Cuba, no doubt sabotaged by the CIA.

"It was a photo I had taken from a great distance," Juan Vivès remembers,

while I was in the crowd. There were at least fifty people lined up on the platform on either side of Fidel Castro. It would never have been published in any case: there were several people in it who were in exile, others who were in prison, and still others who, in the meantime, had been shot. But Che was clearly recognizable in the group. It was this minute detail that was chosen. It was greatly enlarged and printed on high contrast paper. Feltrinelli took the picture and sold it all over the world. Millions of copies were made in the form of buttons, tee-shirts and, most of all, posters. Of course I never collected a cent in royalties!

1. "Ever onward to victory," poster of the Justice for Cuba Committee, Canada, 1967. The original photograph was destroyed. Similar versions are found in the photo essay on the ceremony in Bohemia, No. 11, March 13, 1960.
2. "On my island, inspired by his example, we will chart our own course and we will build Communism." Poster of the Organization for Solidarity with the People of Asia, Africa, and Latin America (OSPAAL), 1968.
3. Day of the Heroic Guerrilla, October 8, OSPAAL poster for the first anniversary of Guevara's death, 1968.

■ A DANGEROUS PHOTO

November 1971. Fidel Castro pays a triumphal visit to Chile. He was invited by Salvador Allende, president of the Popular Unity government since October 1970. His visit, which lasts three weeks, is hailed in the Cuban press as "the symbolic meeting of two historic processes." On November 10 he lays a floral tribute at the base of the statue of Bernardo O'Higgins, the general who asserted Chile's independence in the battle of Maipú (April 5, 1818). With Castro are representatives of the military hierarchy. In a large bound book with illustrations, *Cuba-Chile*, published by the Cuban Communist Party a few weeks later, there are several photographs of Fidel Castro with a then-unknown general.

Twenty-two months after Castro's visit, a military junta seizes power in Chile, killing Allende and thousands of men and women. The figure of General Augusto Pinochet, soon named "supreme ruler of the nation," quickly emerges from the junta. And in the eyes of the whole world, Pinochet becomes the new symbol of Latin American "right-wing" dictatorships. This photograph of the meeting between the "left-wing" dictator and the future "right-wing" dictator is obviously an extraordinary document. It is easy to imagine the retrospective terror of the officials in charge of censorship in Cuba when they remembered that book. In any case, they did their work well: the book was quickly withdrawn from sale and absolutely cannot be found in any Cuban bookstore or public library.

November 10, 1971: published in Cuba-Chile, *Havana, 1972.*

164

The Soviet Tradition

Neither the death of Stalin nor the subsequent "destalinization" put an end to the system of pictorial censorship that had ground on for more than thirty years. Khrushchev himself benefited from it by having several rivals erased after arranging for a spring cleaning of the Stalin iconography. Once removed from power, he, too, disappeared rather abruptly from books and magazines. His successor, Leonid Brezhnev, was handed an exemplary life in retouched pictures. And these same pictures were used to illustrate his own works, which won him the Lenin prize for literature.

As it did under Stalin, the Party continues to invent its "men of marble"—labor heroes, pioneers of virgin territories, explorers, engineers, researchers—whose faces, gestures, and achievements are restored to us in a rich and systematically embellished iconography. What if some of these people never really existed or the facts presented are often pure inventions? Such details are beside the point since the source is always the same and verification is impossible. In any case, the average Soviet has his own way of knowing whether to believe what he is told and when to distrust the pictures shown to him. The youthfulness that the official portraits of Soviet leaders have displayed for a long time, when they were clearly known to have been aged, ill, or dying, has been the source of many a funny, whispered story. Less well known is the heavy retouching of the photographs of those superheroes, the cosmonauts. And what is done for the cosmonauts— retouching, recentering, the effacement of undesirable individuals—is done in many other fields as well, such as sports, the army, national minority cultures, scientific research, and the development of Siberia.

Similarly, pictures of the lives of several writers—Mayakovski, Esenin, Pasternak— have been retouched, and those of famous dissidents—Alexander Solzhenitsyn, Mstislav Rostropovitch—completely eliminated.

■ THE LIFE OF A HERO

April 12, 1961. The world is shocked to learn that for the first time a man has traveled into space and has orbited the earth. The pleasant, smiling face of the pilot, Yuri Gagarin, 27 years of age and the father of two, soon appears.

In the newspaper articles, brochures, and books published about him there are a great many retouched photographs. The past life of the new Soviet hero was carefully revised, expurgated, and corrected (photos 1, 2, 3). Similarly, each of his gestures was carefully studied. Thus, a more suitable version of a photo taken upon his triumphal welcome in Moscow (4) was printed: the eyes lost in shadow are retouched and highlighted, the slightly open mouth is closed (5). Another example of these embellishments is the photo of Gagarin's wife, taken, say the captions, during the flight. Details change from one version to another (collar, shadows, background). Finally, in every photograph of Gagarin, Khrushchev was all too visible. In books today, Khrushchev is gone and only Leonid Brezhnev is seen embracing and decorating the first cosmonaut.

1, 2 and 3. Yuri Gagarin, Doroga v kosmos (The road to space, translated into French as Le chemin des étoiles), Moscow, undated (about 1962) and Un Soviétique dans l'espace, Moscow, undated.
4. K zvyezdam (To the stars), Moscow, 1982.
5. Y. Gagarin, op. cit.
6. K zvezdam, 1982.
7. Y. Gagarin, op. cit.

A few weeks after Gagarin's feat, nine Soviet astronauts gather around the head of the space program, Sergei Korolev (1906–1966), to pose for a highly official and very ordinary "family" photograph. The most famous of the cosmonauts is there, Yuri Gagarin (seated, second from left). He has already traveled in space, all of the the others will have their turn.

In 1968, shortly after Gagarin is killed in an airplane crash, a Soviet book, *Vers les étoiles*, recounts in pictures the first stages of the Soviet conquest of space. The same photograph reappears. Same group, same smiles, but one person is missing, dissolved into the wall in the background. It is Vladimir Komarov, who, four years earlier, was the pilot of Voskhod 1, the seventh manned Soviet spacecraft. Having left under Khrushchev with the physician, Egorov, and the engineer, Feoktistov—the so-called "space troika"—Komarov returned two days later under Brezhnev (October 12–14, 1964). According to officials, he was killed three years later, on April 24, 1967, during a Soyuz 1 return flight. Why was he erased from this photo? German and British experts commenting on this disappearance have offered several possible explanations: Komarov may not have measured up to Russian purity standards because his mother was of German descent; he may have criticized the regime or, more specifically, the Soviet space program; he may have been executed a year before the book was published, etc. These explanations are romantic and no doubt excessive. There is a much simpler one (which, however, does not exclude certain others): when the 1968 version of *Vers les étoiles* appeared, Yuri Gagarin had just died in an airplane accident. Komarov himself had disappeared just a year before. Two deaths in this small group of the most celebrated "heroes of the Soviet Union" would have had a truly awful effect! Moreover, the flight official, S. Korolev, also died in 1966.

1. Unsigned photo taken in May or June 1961 in Sochi. First publication unknown. Reproduced in Evgeny Ryabchikov, Les Russes dans l'espace, *Moscow, 1971, and Paris, 1972. We assume that the individuals shown are the following: seated, Andrian Nikolaev, Yuri Gagarin, Sergei Korolev, Boris Yegorov, Vladimir Shatalov; standing, Pavel Popovich, Vladimir Komarov, German Titov, and Valery Bykovsky.*
2. Vers les étoiles, *Moscow, 1968.*

■ THE SECRET HISTORY OF THE SPACE PROGRAM

March 18, 1965. Pavel Belyaev and Alexei Leonov, the two cosmonauts of the Voskhod 2 crew, are taken by bus to their spacecraft. Their superior, Vladimir Komarov, accompanies them to the launch pad. Behind him is one of his colleagues wearing the same uniform. In a subsequent version of this photograph, this person is missing. Years later (1978), the man was identified as a certain "Dimitri," who had been a member of the support crew for the Voskhod 2 flight and who, in 1969, had had "serious medical problems." The Soviet space program has an official, heroic history and a more tragic, secret history: catastrophe at the Baikonur launch site in October 1960 (forty program leaders killed); other disasters in April 1967 (the death of Komarov and possibly other crew members) and in June 1971 (asphyxiation of the Soyuz 11 crew); failed launches and maneuvers; loss of control (November 1967, April 1968, June 1969, November 1969, April 1971, June 1971, July 1972, April 1973, May 1973, August 1974, April 1975, October 1976, August 1977, October 1977, April 1978, April 1979, etc.). And as Soviet leaders themselves admit, six to eight men were killed in training.

Numerous Soviet spacecraft were launched without anyone ever learning the identity of the crew members or seeing any photograph of the launch or of the interior of the spacecraft (especially the Salyut series). Finally, several cosmonauts were dismissed from the programs without any explanation of the reasons or of their fate.

1. March 18, 1965. Published by Tass News Agency.
2. Republished in this form in the series Vers les étoiles, *1968 and thereafter. Another very similar photograph appears in* K zvezdam *(1982).*

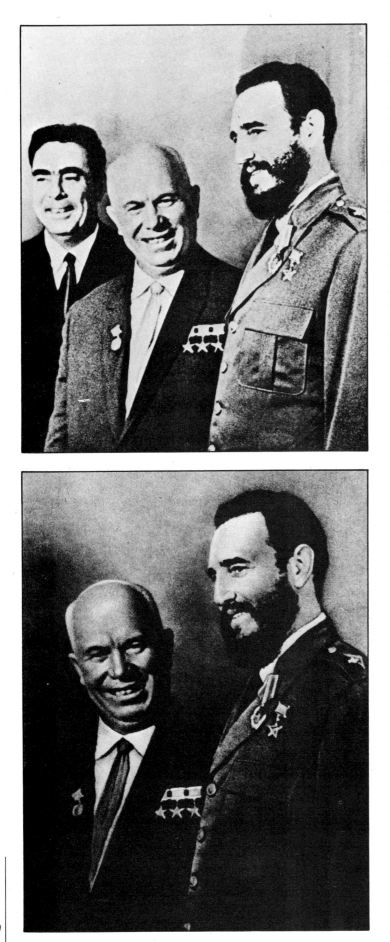

■ K VERSUS B

In May 1963, Fidel Castro is welcomed in the USSR, where he is decorated with several medals, including the one given to Soviet heroes, or the Order of Lenin. One of the photographs taken by the Soviet press agency and given to the Cubans (already slightly retouched) shows Fidel Castro with Nikita Khrushchev, general secretary of the Communist Party (i.e., the actual head of the Soviet government), and Leonid Brezhnev, then president of the Supreme Soviet Presidium. However, in the version that appeared that same year in the Soviet Union, Khrushchev is alone with Castro. It may be that Brezhnev, an ambitious politician, was removed at the order of a suspicious Khrushchev. This was a premonition, for, one year later, "Mr. K" was ousted by Brezhnev, who was to reign as absolute master of the USSR for 18 years and would be responsible for the invasion of Czechoslovakia (1968) and Afghanistan (1979).

1. *Dated May 23, 1963, Moscow.* Viva Cuba!, *Havana, 1963.*
2. Piat let koubinskoy Revolutsii *(The Cuban revolution is five years old), Moscow, 1963.*

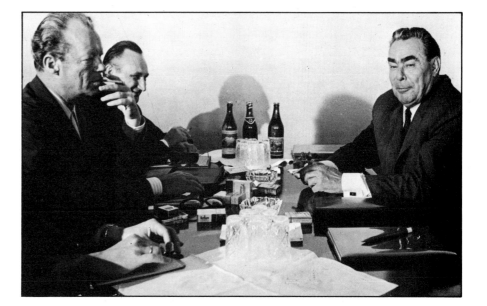

Беседа Л. И. Брежнева с В. Брандтом

ЯЛТА, 17. (ТАСС). Сегодня в районе Ореанды состоялась продолжительная беседа между Генеральным секретарем ЦК КПСС Л. И. Брежневым и Федеральным канцлером ФРГ В. Брандтом. В ходе беседы были затронуты актуальные вопросы развития отношений между Советским Союзом и Федеративной Республикой Германии и международные проблемы, представляющие взаимный интерес, в особенности вопросы укрепления европейской безопасности. Беседа будет продолжена во второй половине дня.

■ IN PRAISE OF SOBRIETY

Oreanda, near Yalta in the Crimea, September 1971. Willy Brandt, chancellor of West Germany, meets with Leonid Brezhnev, first secretary of the Communist Party. There is a lot of smoking; the ashtrays are full. There is a lot of drinking, too; the bottles of Crimean champagne are piling up. A cordial atmosphere, although a little messy. At a certain point, photographers are admitted. In the German press, the bottles, cigarette packages, overflowing ashtrays, Brezhnev's protruding cuff, and the hands of other participants are visible. In the *Pravda* photo, everything has been cleaned up, the table has been cleared of its conspicuous bottles and cigarette butts, other trivial details have been eliminated, and the meeting has been transformed into a dignified and pleasant conversation.

1. September 18, 1971, Oreanda. Süddeutscher Verlag.
2. Pravda, September 19, 1971.

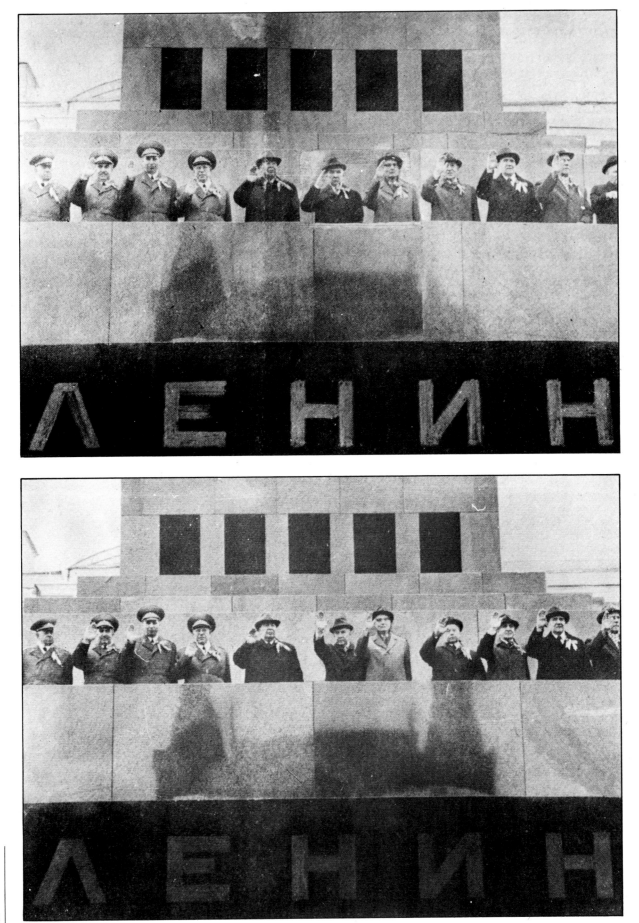

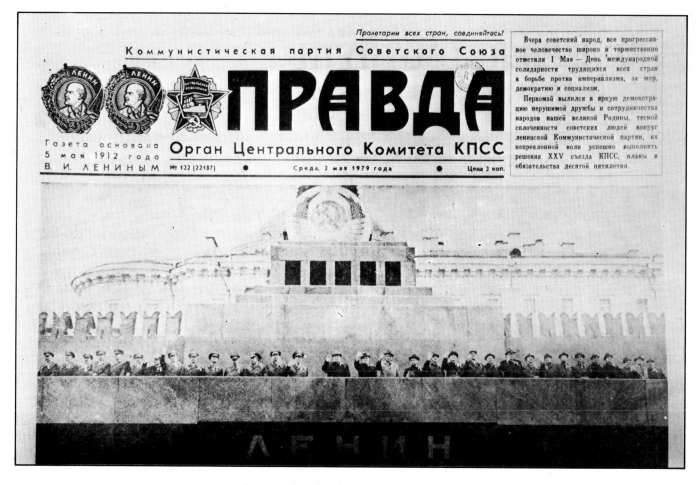

Пролетарии всех стран, соединяйтесь!

Коммунистическая партия Советского Союза

ПРАВДА

Орган Центрального Комитета КПСС

Газета основана
5 мая 1912 года
В. И. ЛЕНИНЫМ № 122 (22187) ● Среда, 2 мая 1979 года ● Цена 3 коп.

Вчера советский народ, все прогрессив-
ное человечество широко и торжественно
отметили 1 Мая — День международной
солидарности трудящихся всех стран
в борьбе против империализма, за мир,
демократию и социализм.

Первомай вылился в яркую демонстра-
цию нерушимой дружбы и сотрудничества
народов нашей великой Родины, тесной
сплоченности советских людей вокруг
ленинской Коммунистической партии, их
непреклонной воли успешно выполнить
решения XXV съезда КПСС, планы и
обязательства десятой пятилетки.

■ THE SECRET RUMBLINGS OF MAY 1

The fact that official photographs of Soviet ceremonies are usually line-ups of individuals who have been touched up, painted and pasted in place, or else reshuffled scenes is demonstrated in reverse by the following incident that occurred in 1979. On the day of the May 1 parade, everyone had seen Soviet government and Party leaders lined up on the gallery of the tomb in a certain order.

In the evening paper *Vechernaya Moskva* (Moscow News) published that day the photograph of the rostrum indeed shows the proper line-up—Brezhnev, Kosygin, Suslov, Grishin, Gromyko—but, wonder of wonders, Andrei Kirilenko, Politburo member and one of Brezhnev's so-called "heirs apparent," whom everyone saw standing between Suslov and Grishin, is missing. Secret meetings in waiting rooms, excitement at the embassies, rumors at press agencies: this astonishing signal is already being interpreted as the reflection of a power struggle, or some secret quarrel between the leaders, or even the brutal elimination of the alleged heir apparent (Beria and a number of others have not been forgotten). Recent incidents and the struggle between "the two factions" (there

always are two factions ready to devour each other) are recalled. Some note that the retouching has brought Viktor Grishin, head of the Party organization for the city of Moscow, closer to Brezhnev: there are speculations about the future of this new heir apparent.

The mystery is short-lived: The May 2 *Moskovskaya Pravda* (Moscow Pravda) republishes the official photograph with Andrei Kirilenko in his proper place. The individuals at the far ends of the group, Brezhnev and Gromyko, are exactly the same, frozen in the same gestures (which would be highly improbable if two photographs were taken at different times), but Kirilenko has been restored to his place between Suslov and Grishin. It appears, however, that the retoucher was unable to reuse the entire original photograph, perhaps because the negative was damaged. He therefore chose another photo of Grishin taken at the same time (he is wearing the traditional May 1 red ribbon in his lapel) and another photo of the Kosygin-Suslov duo, but the latter was no doubt taken at the beginning of the ceremony (they are not wearing the traditional red ribbon in their lapels yet): the retouching is imperfect and even Brezhnev's shoulder suffered in the operation.

On the same day, May 2, the national *Pravda* simply published another photo of the ceremony.

1. Vechernaya Moskva, *May 1, 1979.*
2. Moskovskaya Pravda, *May 2, 1979.*
3. Pravda, *May 2, 1979.*

■ THE ETERNAL YOUTHFULNESS OF OFFICIAL PORTRAITS

Photographs taken in January 1980 in Moscow by French journalists accompanying Jacques Chaban-Delmas, then president of the French National Assembly, show Leonid Brezhnev's face during the official meeting. (At this same time, KGB agents arrest Sakharov and take him to exile in Gorky). Brezhnev is an old, sick man in a soft rubber mask, with a flabby, blemished, swollen neck, sunken into his shoulders, just as a wax figure, snatched from a fire, would have begun to blister, boil, and run all over itself. The mouth is open as if to breathe the rarified air, the small bright eyes are barely able to see through the soft folds of the eyelids, the cheeks are melting.

The official portraits from that same year, 1980, released by Tass News Agency and printed in *Pravda* or on the cover of brochures and Brezhnev's "literary" works, show a sort of composite face, which, by dint of retouching, painting, and alterations, takes us back to a man frozen in the eternal vigor of his fifties. The crowsfeet are there, as a mark of manly nobility, but the rest of the face is smooth, taut, stern. A photograph taken twenty or thirty years earlier may have been used. However, this is supposed to be the Brezhnev of 1980, since the photograph is precisely dated. Care has even been taken to place the gold Joliot-Curie peace medal he was awarded in 1975 and the medal of the Lenin Prize for Literature given to him in March 1979 on the right side of his coat.

1. Official portrait in 1980.
2. Photo by Arnaud de Wildenberg, Granma Agency, Paris.

When Methods Are Exported

It would be naive to think that the vigilant denunciation of historic distortions in totalitarian countries could ever protect democratic countries from these same evils or that it guarantees "cold" photographic information, totally devoid of afterthought. Deception, propaganda, and disinformation recognize no borders and often flourish far from their sources. War propaganda is a good example, but, excepting such extraordinary periods, the faking and falsification of history are encountered, in particular, anywhere a serious effort is made to copy the methods of totalitarian propaganda (characterized by its three major styles: Fascist, Nazi, and Communist), and, in general, anywhere pictures are distorted for political purposes or blackmail. Sometimes, even for journalists and historians whose main concern is not politics, the temptation may be strong to "fix" a picture in order to obtain the exact illustration wanted. Tampering with pictures poses just as many ethical problems as tampering with the written or spoken word: a little recentering by the press can change the meaning of a photograph altogether.

We have therefore tried to give a few examples of these various types of distortion. Obviously, many other examples of the faking of pictures, erroneous or misleading captions, retouching, cutouts, and photomontages could be found in the press or in the historical works of free countries. But, except for war propaganda, which is used at a time when the normal functioning of democracy is in every way disturbed, what distinguishes these pictures from those published by totalitarian regimes is their status and their purpose. First, they were not released by a solitary regime in total control of information sources and distribution systems. And, once in circulation, they were open to comparison, analysis, and criticism. They were denounced by journalists, historians, political opponents, and, in the long run, were sometimes even refuted by their own creators. If this has not yet happened, it can happen at any moment because of a few simple principles—plurality of information, freedom of access to sources, freedom of expression, freedom of travel—which are the very foundations of democracy.

June 21, 1940, Compiègne. Hitler, ready to receive the surrender of the French army, takes his seat in the railroad car where the Germans surrendered in 1918. Afterward, a beaming führer walks up to a group of Nazi officers. In British and American newsreels a few days later millions of spectators witness this incredible scene: Hitler executing a joyful little dance step. The truth did not come out until after the war. John Grierson was the director of the Canadian information and propaganda departments during the war. When he received the newsreel sequence showing the French surrender, he noticed that at a certain moment in the scene Hitler raised

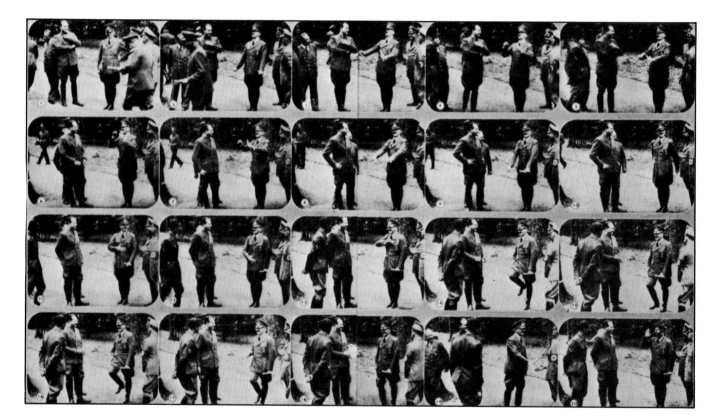

his leg rather high up. It was a very quick movement, but Grierson had the idea of repeating this very short sequence a sufficient number of times to give the impression that Hitler, who was smiling broadly anyway, was jumping for joy. This short jig had the extraordinary propaganda effect of arousing the fury of the public in every Allied country where it was shown.

German newsreel sequence re-released in this faked form in the series, World in Action *(National Film Board, Ottawa, 1940).*

■ THE ARTISTS OF THE WAR PHOTO

Several very famous photos of the Second World War have only very distant ties with historic reality. This is the case, for example, with "the taking of Tobruk," a gripping scene staged several days after the battle with the help of smoke bombs (October 1942). The photo is signed by Sergeant Chetwyn, one of the most dynamic members of Britain's famous Army Film and Photographic Unit. Chetwyn's crew of photographers, nicknamed "Chet's circus," produced many spectacular photographs that never failed to please the War Ministry and the British propaganda office, but other photographers were somewhat scandalized by them.

On other occasions, the Allies did not hesitate to create outright fakes or to stage misleading scenes to counteract German propaganda campaigns. The British illustrated magazine, *Parade*, for example, was launched to compete with the German magazine, *Signal*. In 1943, when the German army was beginning a general retreat, the first page of *Parade* showed a rather dishevelled German soldier with the caption: The Master Race. Derek Knight, who was an assistant of John Grierson and then of Alberto Cavalcanti and who worked at the time in the Army Film and Photographic Unit, recalls that the German soldier on the cover of *Parade* was in fact "the ugliest Arab they could find in the streets of Cairo and whom they dressed up in a sort of uniform."

What distinguishes these two photographs from the ones published by totalitarian countries, however, is that their history is not secret. After the war, the British Propaganda Office revealed some of their ruses, and any historian can, with little trouble, examine the records.

1. *"The attack on Tobruk," AFPU photograph, November 1942.*
2. *Parade, no. 143, vol. 11, May 8, 1943.*

■ THE ELIMINATION OF A TRAITOR

Between the 1937 and 1949 editions of *Fils du peuple* by Maurice Thorez there are a number of remarkable differences. First, the text. Stalin, to whom Thorez had devoted only a few admittedly flattering paragraphs, suddenly assumed extraordinary importance, whereas Thorez's account of his encounters with the individuals eliminated in the Moscow trials vanished. Next, the pictures. A group photograph in the 1937 edition showed a visit by members of the Communist Party political bureau to the French art exhibit at the 1937 World's Fair. Twelve men in a row. In the 1949 version, there are only eleven. The man who was standing between Jacques Duclos and Raymond Guyot has disappeared. Someone cut the photo, shoved the outcast through the trap door, and, unseen and unknown, closed the ranks by bringing the two edges together. In subsequent editions this inspiring picture will be perfected by moving Duclos closer to Thorez: the group is now compact, with no breaks, all of one piece.

The small, stout man who so closely resembled his neighbor, Duclos, was none other than Marcel Gitton, and his photographic fate was exactly the same as his fate in real life. Secretary of the Central Committee and a deputy, he is one of the Party's most prominent leaders until 1939. He breaks with the Party after the German-Soviet pact and, according to a tried and true method in the French as well as the Russian Communist Party, is immediately denounced as a police infiltrator. Labeled a collaborator in the wake of Doriot, he is killed in September 1941 by the Party's "special organization," which, according to Auguste Lecoeur, was in charge of "fund raising, supplies, protecting militants, and executing 'traitors.'"

VISITE DE MEMBRES DU BUREAU POLITIQUE ET DE MILITANTS COMMUNISTES AU MUSÉE D'ART FRANÇAIS, A L'EXPOSITION

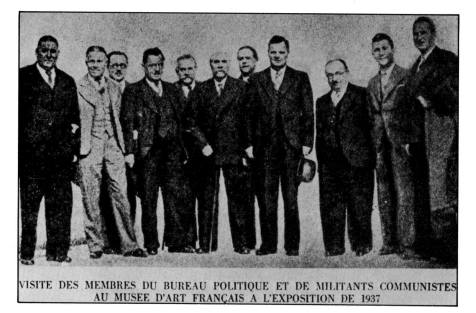

VISITE DES MEMBRES DU BUREAU POLITIQUE ET DE MILITANTS COMMUNISTES AU MUSEE D'ART FRANÇAIS A L'EXPOSITION DE 1937

1. Maurice Thorez, Fils du Peuple, *Paris, 1937. 2.* Fils du peuple, *1949 edition. Other versions:* Fils du peuple, *1970 edition. And V. Sedykh,* Trois vies, Marcel Cachin, Maurice Thorez, Jacques Duclos, *Moscow, 1981.*

■ "I WILL NOT KILL MYSELF"

In July 1929, Maurice Thorez, who had just been arrested by the police on a charge of "inciting soldiers to rebellion for anarchistic propaganda purposes," poses in a courtyard of the Santé prison. With him are Pierre Lacan, Gabriel Péri, Paul Vaillant-Couturier, André Marty, and several others. The photograph, published in the 1949 edition of *Fils du peuple*, survives in the 1954 edition. But it has undergone various changes: cut out, recentered, and placed against a blank background, there are now only three people with Thorez. André Marty, the man formerly on Thorez's left, is gone.

Between the two versions of this photograph, the Marty affair had erupted (1952). André Marty, a former participant in the Black Sea mutiny of 1917, then a deputy and a member of the Central Committee in 1925, became inspector general of the International Brigades at the time of the Spanish Civil War. His role in Spain was highly controversial. Nicknamed "the butcher of Albacete" by the anarchists and portrayed by Hemingway in *For Whom the Bell Tolls* as a dull-witted slaughterer, Marty appears, more than anything else, to have been a compliant agent of Stalin's secret service. After the Liberation, he is No. 3 in the French Communist Party, after Thorez and Duclos. His relations with the general secretary are poor: after an expulsion attempt in 1947, the great offensive begins in 1952. The entire affair, spearheaded in Paris by Duclos, is undoubtedly organized from Moscow by Thorez, who is there for treatment. Accused along with former FTP chief Charles Tillon, subjected to inquisition-like trials, expelled from the political bureau, the Central Committee, and his own cell, Marty collapses. His records are stolen, his wife is harrassed for hours on end, she is illegally confined and forced to ask for a divorce. In particular, he is publicly accused of being a police infiltrator. Marty appeals to Stalin, who of course does not respond. To finish him off, an article by Etienne Fajon appears in early January 1953 on the front page of *L'Humanité* entitled "Marty's Police Connections." "I will not kill myself," Marty had written to Duclos when the affair was at its height. But the "indomitable" Marty was already morally and politically dead: three years later he died after trying to solidify his political defense.

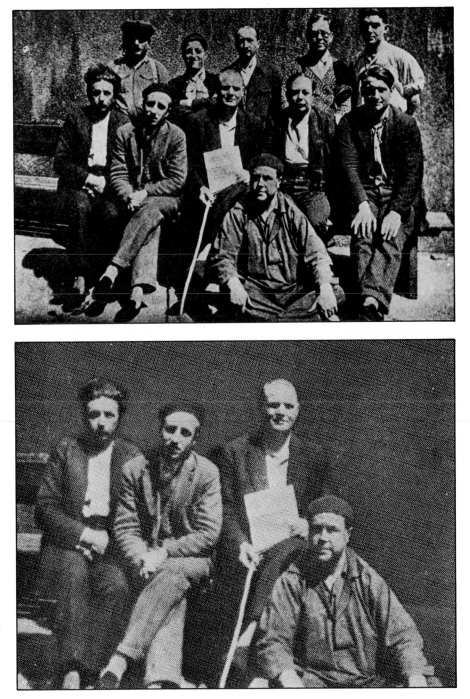

1. Maurice Thorez, Fils du peuple, *1949 edition.*
2. Fils du peuple, *1954 edition. The photograph is not included in subsequent editions (1960, 1970).*

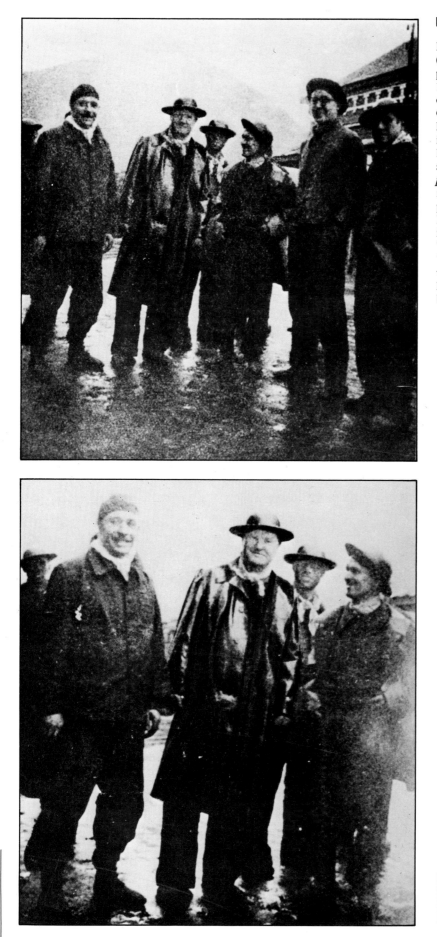

■ A VISIT TO THE MINE

In the second edition of *Fils du peuple* (1949), several chapters are changed, some pictures are added. In particular, that of a 1946 visit by Thorez—then vice president of the council in the first presidency of General de Gaulle—to the northern mines. He poses with several Communists, including Auguste Lecoeur, the deputy from Pas-de-Calais and the undersecretary of state for coal. In the 1960 edition of *Fils du peuple*, the same photograph appears, recentered on Thorez. The right part of the photo, containing two other men, is gone. In the interval, Auguste Lecoeur, the Party's favorite son, was denounced as an "opportunist," "authoritarian," and "dogmatic" and, in 1954, was expelled. "He wanted to bury me alive," Thorez said. LeCoeur was therefore eliminated simply by recentering the photo on Thorez.

1. Maurice Thorez, Fils du peuple, *1949 edition.*
2. Fils du peuple, *1954 and 1960 editions.*

■ PRAGUE FROM ONE YEAR TO ANOTHER

Under the heading "Death Sentence in Prague," the weekly, *Paris-Match*, published two photographs on November 12, 1949. They were supposed to have been taken at the moment when a court announced the death sentence against six people accused of conspiracy. This was when the purges were at their worst in Czechoslovakia, as they were in other people's democracies (the Rajik trial in Budapest, the Kostov trial in Sofia). "When the loudspeaker of the 'people's court' announced the death sentence, women fell to their knees in the streets of Prague. Soldiers brought in to control the crowds also knelt." That was the caption printed in the magazine. In fact, this photograph was rather improbable: in 1949, the police were in full control and any street demonstration was impossible. Nevertheless, it went unquestioned and appeared in most of the world's major illustrated magazines. Until the Communist daily, *Ce soir*, pointed out that this photo strangely resembled another, taken a year earlier during the funeral of Czech president Eduard Beneš (September 3, 1948). Following an investigation, *Paris-Match* admitted that it had been deceived. But the reason for the deception is unclear. The international agency, *News Photos*, had asked a Czech agency for photos illustrating the impact of the 1949 trials and had received this photo in reply. After a request for explanations, the caption had been confirmed. A deception on the part of the Czech government or an act of protest by one of the agency's journalists? "What we find most disturbing," the management of *Paris-Match* commented,

is that no one, not even Ce Soir, *denies that the picture of a woman weeping in the front row of a grief-stricken crowd is the very picture of Czechoslovakia today.*

Paris-Match, *no. 27, September 24, 1949. Attacks in* Ce Soir, *October 22, 1949. Reply in* Paris-Match, *no. 34, November 12, 1949.*

■ TALES OF BLACKJACKS

February 8, 1962. A large demonstration protesting OAS outrages is held in Paris, organized by the leftist parties. Police repression is terribly brutal. At the Charonne metro entrance nine bodies are found, including two women and a young boy. Most of the dead were members of the Communist Party. In *Au rythme des jours*, a collection of documents and remembrances of Benoît Frachon, who headed the CGT from 1945 to 1975, first as secretary and then as president, is a photograph no doubt taken the evening of the massacre. Near the Charonne metro entrance are shoes and other articles of clothing. But this photograph, eloquent in and of itself, was not good enough: the figure of a person stretched out on the sidewalk and a helmeted policeman with a blackjack were added. The retouching is of rather poor quality, however, and is quite obvious.

A Latin Quarter demonstration in 1963. The police scuffle with students. A photo appears in the Communist weekly, *La Terre*, but it is slightly different from the one released by a news agency: a blackjack has been placed in the hand of one policeman and the blackjack hanging from the belt of another has of course been erased.

la réponse du pouvoir : la matraque

Au cours de la manifestation du 29 novembre à Paris, un étudiant cherche à se protéger la tête contre les matraquages de la police

1. Benoît Frachon, Au rythme des jours, T2, Paris, 1973.
2. Agence diffusion presse photo, November 29, 1963.
3. La Terre, no. 998, December 1963.

La France attise le feu dans cette sale guerre...

Le massacre des indiens Mosquitos, farouchement anticastristes,
par les « barbudos » socialo-marxistes du Nicaragua,
au mois de décembre. Deux cents indiens
furent hachés par les grenades et les armes automatiques.
Ni les femmes ni les enfants ne furent épargnés.
Forte de 7 000 hommes à l'époque de Somoza,
l'armée du Nicaragua en compte aujourd'hui 80 000.
Le gouvernement de Managua veut y ajouter 200 000 miliciens.

A la fin du mois de décembre dernier, des unités de l'armée marxiste nicaraguayenne ont effectué, au mépris des lois internationales, une incursion sur le territoire du pays voisin, le Honduras. Objectif de ce raid : attaquer, de l'autre côté du rio Coco, des tribus d'indiens Mosquitos, citoyens honduréens vivant sur cette partie de la côte des caraïbes qui porte leur nom.

Esquisse d'un génocide, doublé d'un règlement de compte : ces indiens Mosquitos sont farouchement anticastristes, et ont toujours déjoué les tentatives d'infiltration des agitateurs venus de La Havane. Mais maintenant, les « barbudos » sont les « conseillers » et les instructeurs de l'armée socialo-marxiste du Nicaragua, dont ils sont en train de faire la force la plus redoutable d'Amérique centrale : « une super-puissance à l'échelle de l'Amérique centrale ».

C'est à ce pays que la France vient de vendre des vedettes, des hélicoptères, des roquettes qualifiées de « non-réexportables ».

Le gouvernement français a également qualifié ces armes de « défensives » mais cet armement conviendra parfaitement à des opérations offensives contre des tribus indiennes pratiquement désarmées.

**En pages suivantes :
La dame de fer
de la diplomatie américaine
accuse les socialistes**

■ A POLITICAL BLAZE

In February 1982, *Figaro Magazine* published a shocking, two-page color photograph of human bodies engulfed in flames. Under the lurid headline, "France Fans the Flames," which was an allusion to the political and economic agreements between the French Socialist government and the Nicaraguan government, the following caption appeared:

The massacre, in December, of the fiercely anti-Castro Mosquito Indians by the Socialist-Marxist "barbudos" of Nicaragua. Two hundred Indians were cut to pieces by grenades and automatic weapons. Neither women nor children were spared.

The photographer who took this photo, Matthews Naythons, immediately recognized it and protested the deception: the photograph had been recentered and falsely dated two years later. This was in fact a picture of the burning of dead Nicaraguan soldiers from both sides, carried out in 1978 for health reasons by doctors and nurses of the International Red Cross. In the original photo the white uniforms and flag of the Red Cross were plainly visible. In their zeal to denounce the terrible massacres of the Miskito Indians (not "Mosquito"), the journalists committed an error in judgment, at the risk of casting doubt on the reality of a truly appalling tragedy. The photographer filed suit against the magazine and won.

Photographic Credits

All the photos in this book are from the author's collections and were photographed by him, with the following exceptions:

BDIC, Nanterre: 71 (1 and 2)—94 (1 and 2)—95 (2, 3 and 4)—158 (1)—171 (2)—172 (1 and 2)—173.

Bibliothèque nationale, Paris: 16–18 (1 and 2)—30 (2)—56 (1)—57 (6)—63 (3 and 4)—72 (1)—88 (2)—149 (1 and 2)—170 (1 and 2).

Bibliothèque nationale, Versailles: 78 (6)—160 (2)—161.

Bundesarchiv, Koblenz: 75.

Jean-Louis Cohen, Paris: 79 (2)—80 (1).

René Dazy, Paris: 53 (1)—93 (1).

Direction des statuts de l'information historique, ministère de la Guerre, Paris: 66 (1)—76 (1 and 2).

Euprapress, Munich: 128—129—130—131—132—134—136.

Patrice Fava, Paris: 100 (2)—104 (2)—115 (1 and 2)—116 (1 and 2)—119 (3).

Agence Gamma, Paris: 174 (2).

Zeitgeschichtliches Bildarchiv Heinrich R. Hoffmann: 65 (1).

Imperial War Museum, London: 73 (1)—177 (1 and 2).

Index of Censorship, London: 127 (3).

Institut Luce, Rome: 54—55 (2).

Agence Keystone, Paris: 93 (4).

Archives David King, London: 24—26 (1)—28 (1)—34—37 (4)—83 (1 and 2)—146.

Editori Laterza, Milan: 8.

Roger Pic, Paris: 103.

Archives Ringart, Palaiseau: 62 (1)—66 (4).

Editions Philippe Sers, Paris: 49 (1).

Editions du Seuil, Paris: 29 (2).

Edgar Snow Collection, New York: 99 (2)—101 (1)—104.

Helen Foster-Snow Collection, Magnum, New York: 109 (1)—118.

Time-Life: 176.

Süddeutscher Verlag, Munich: 70 (1 and 2)—171 (1).

Roger Viollet, Paris: 52—79 (1).

Juan Vivès, Marseille: 164.

Westview Press Inc.: 143.

Select Bibliography

The History and Philosophy of Photography

Beaumont Newhall, *L'histoire de la photographie*, Paris, 1967. Helmut Gernsheim, *The History of Photography*, London, 1969. Raymond Lécuyer, *Histoire de la photographie*, Paris, 1945. Gisèle Freund, *Photographie et société*, Paris, 1974. Walter Benjamin: "L'oeuvre d'art à l'ère de sa reproductibilité technique" and "Petite histoire de la photographie" in *Poésie et révolution*, Paris, 1971. Roland Barthes, "Rhétorique de l'image," reprinted in *L'aventure sémiologique*, Paris, 1985; *La chambre claire*, Paris, 1980; *L'obvie et l'obtus*, Paris, 1982. Susan Sontag, *La photographie*, Paris, 1979. Albert Plécy, *La photo, art et langage*; Verviers, 1971. Volker-Kahmen, *La photographie est-elle un art?*, Paris, 1974. Pierre Bourdieu et al., *Un art moyen, essai sur les usages sociaux de la photographie*, Paris, 1965. Enrico Fulchignoni, *La civilisation de l'image*, Paris, 1975. John Berger, *Voir le voir*, Paris, 1976. Guy Gauthier, *Vingt leçons sur l'image et le sens*, Paris, 1982. Erich Gombrich, *L'art et l'illusion*, Paris, 1972. Pierre-Fresnault-Deruelle, *L'image manipulée*, Paris, 1983.

The Newsphoto

Tom Hopkinson, *Picture Post 1938–1950*, London, 1970. *Instants d'années, 25 ans de World Press photo*, Paris, 1981. Harold Evans, *Front Page History*, London, 1984; *Picture on a Page*, London, 1974. Associated Press, *Instant It Happened*, New York, 1972. Ken Baynes, *Scoop, Scandal and Strife*, London, 1971. John Faber, *Great Moments in News Photography*, London, 1960. Arthur Rothstein, *Photojournalism*, New York, 1965. Gerald D. Hurley and Angus McDougall, *Visual Impact in Print*, Chicago, 1971. Wilson Hicks, *Words and Pictures*, New York, 1952. *Photo-journalisme*, Pierre de Fenoyl presentation, Paris, 1977. Tim N. Gidal, *Modern Photojournalism, Origin and Evolution, 1910–1933*, New York, 1972. *Life, The First Decade, 1936–1945*, Boston, 1979.

Propaganda and Its Images

Jean-Marie Domenach, *La propagande politique*, Paris, 1950. Jacques Ellul, *Histoire de la propagande*, Paris, 1967; *Propagandes*, Paris, 1962. Monica Charlot, *La persuasion politique*, Paris, 1970. Anthony Rhodes, *Histoire mondiale de la propagande de 1933 à 1945*, Brussels, 1980. *Guerres et propagande ou comment armer les esprits*, exhibition catalogue, Brussels, 1983. *Revue d'histoire de la Seconde Guerre mondiale*, "Propagande, presse, radio, film," no. 101, January 1976. Stanley Baker, *Visual Persuasion. The Effect of Pictures on the Subconscious*, New York, 1961. Vance Packard, *La persuasion clandestine*, Paris, 1975. Jean-Paul Gourévitch, *La propagande dans tous ses états*, Paris, 1981; *La politique et ses images*, Paris, 1986.

Alain Gesgon, *Sur les murs de France*, Paris, 1979. Stephane Marchetti, *Affiches 1939–1945, Images d'une certaine France*, Lausanne, 1982. Gary Yanker, *Prop art*, Paris, 1972. Max Gallo, *L'affiche, miroir de l'histoire, miroir de la vie*, Paris, 1973. Zbynek Zeman, *Selling the War, Art and Propaganda in World War II*, London, 1978. *L'imagerie politique*, Centre Pompidou exhibition catalogue, 1977. Jean-Paul Gourévitch, *L'imagerie politique*, Paris, 1980. *Propaganda und gegenpropaganda im film 1933–1945*, slide presentation cataglogue; Ostereischisches Film Museum, Vienna, 1972. Lief Furhammar and Folke Isaksson, *Politics and Film*, Stockholm, 1968, London, 1971. "Cinéma et propagande," *Revue belge du cinéma*, no. 8, Summer 1984. Marc Ferro, *Cinéma et histoire*, Paris, 1977; *Analyse de films, analyse de sociétés*, Paris, 1975. R. Taylor, *Film Propaganda: Soviet Russia and Nazi Germany*, London, 1979. Jean-Pierre Jeancolas and Daniel-Jean Jay, "Cinéma d'un monde en guerre," *La documentation française*, Paris, no. 6024, August 1976.

Deception, Disinformation, Falsification of History

A. Cave-Brown, *La guerre secrète*, Paris. Léon Poliakov, *De Moscou à Beyrouth, essai sur la désinformation*, Paris, 1983. Sefton Delmer, *Opération Radio noire*, Paris, 1965. Pierre Nord, *L'intoxication*, Lausanne, 1971. Ladislas Bittman, *The Deception Game*, New York, 1972. Anthony Buzek, *How the Communist Press Works*, London, 1964. Paul Lendvai, *Les fonctionnaires de la vérité*, Paris, 1980. *Soviet Covert Action (The Forgery Offensive)*, U.S. Congressional hearings, 96th Cong., 2nd sess., February 6 and 19, 1980, Washington, D.C. John Barron, *KGB*, Paris, 1974; *Enquête sur le KGB*, Paris, 1984. Brian Freemantle, *KGB*, London, 1983. Thierry Wolton, *Le KGB en France*, Paris, 1985. *Les complots de la CIA*, Paris, 1976. Brian Freemantle, *La CIA, les secrets de l'honorable compagnie*, Paris, 1986. Philip Agee, *Journal d'un agent secret, dix ans dans la CIA*, Paris, 1976. Ernest W. Lefever and Roy Godson, *The CIA and the American Ethic: An Unfinished Debate*, Washington, 1979. Richard H. Shultz, Roy Godson, *Dezinformatsia, mesures actives de*

la stratégie soviétique, Paris, 1984. *La désinformation, arme de guerre*, texts presented by Vladimir Volkoff, Paris, 1986. Jean-François Revel, *Comment les démocraties finissent*, Paris, 1983. Normahn Cohn, *L'histoire d'un mythe*, Paris, 1967. Léon Poliakov, *La causalité diabolique*, 2 vols., Paris, 1981 and 1985. Christian Jelen, *L'aveuglement*, Paris, 1984. Marc Ferro, *L'Occident devant la révolution soviétique*, Brussels, 1980. Jean-Noël Darde, *Le ministère de la vérité*, Paris, 1984. Marc Ferro, *Comment on raconte l'histoire aux enfants à travers le monde entier*, Paris, 1981. *History in Communist China*, edited by Albert Feuerwerker, Cambridge (USA), 1968. *Rewriting Russian History*, edited by C.E. Black, New York, 1956. *Contemporary History in the Soviet Mirror*, edited by John Keep, London, 1964.

Publications: *Le genre humain* (in particular, issues on "La rumeur," no. 5, 1982; "La vérité," no. 7-8, 1983; "1984?," no. 9, 1984). *Index of Censorship* (in particular, vol. 15, no. 2, February 1986 *"False History?"*). *L'Alternative* and *La Nouvelle alternative* (in particular, no. 1, April 1986, "Les historiens dans l'histoire" by Karel Bartosek).

The Photomontage

Dawn Ades, *Photomontage*, Paris, 1976. Irène Charlotte Lusk, *Montagen ins Blaue: Laszlo Moholy-Nagy, Fotomontagen und collagen 1922–1943*, Berlin, 1980. Eckhard Siefmann, *Montage: John Heartfield*, Berlin, 1977. John Heartfield, *Photomontages antinazis*, preface by Denis Roche, Paris, 1978. Reiner Diederich and Richard Grübling, *Unter die shere mit den Geiern!, Politische fotomontage in der Bundesrepublik und West Berlin*, Berlin, 1977. Claude Leclanche-Boulé, *Typographies et photomontages constructivistes en URSS*, Paris, 1984. Giuliano Patti, Licinio Sacconi, Giovanni Zilani, *Fotomontaggio*, Milan, 1979.

The Faking of Photographs

"Usines de faux," *Témoignages de notre temps*, no. 8, August 1934. "Images secrètes de la guerre," *Témoignages de notre temps*, no. 1, May 1933. "Images secrètes allemandes de la guerre," *Témoignages de notre temps*, no. 3, October 1933. "Le bourrage de crânes," *Crapouillot*, July 1937. Donald E. English, *Political Uses of Photography in the Third French Republic 1871–1914*, Ann Arbor, 1984. *Le reportage photographique*, chapter entitled "Les techniques de persuasion," Life la photographie, Paris, 1982. Guy Durandin, *Les mensonges en propagande et en publicité*, Paris, 1982.

"Photographic documentation on the bacteriological warfare waged by American forces in China and Korea," packet of photos, International Union of Students, 1952. "Les photos bactériologiques sont des faux, voici pourquoi," special issue *Défendre la vérité*, April 19, 1952. "Photos interdites," *Objectif* 50, 1945.

"Bildfälschungen-Fotomontagen," *Der Journalist*, December 1957. Yves Bourde, "Les faussaires de la photo," *Photo*, no. 34, July 1970. Rainer Fabian, *Die Fotografie als Dokument und Fälschung*, Munich, 1976. Christopher Hitchens, "Mutilating Russia's photographic history," *New Statesman*, September 1, 1978. Claudie and Jacques Broyelle, *Le bonheur des pierres*, Paris, 1978. "The acceptable faces of Russia—and the real ones," *The Sunday Times*, March 10, 1981. Alain Jaubert, "Le pouvoir contre les images," *L'Echo des Savanes*, no. 15, October 1983; "La photo a toujours raison," *L'Ane*, no. 6, Autumn 1982. Claude Roy, "Eloge de la retouche," *Le Nouvel Observateur*, September 25, 1982. Andrei Siniavski "Meeting in Naples" and "Artistes at the service of the revolution," *A-Ya*, no. 5, 1983. Isaac Deutscher and David King, *The Great Purges*, Oxford, 1984. "Falsified photographs," *Index of Censorship*, vol. 14, no. 6, December 1985. And *Svedectvi*, no. 77, 1st quarter 1986.

Bibliography by Chapter

In most cases, works already cited in the boxes are not mentioned again here.

The Legendary Life of Lenin

Edward Hallet Carr, *The Bolshevik Revolution*, 3 vols., London, 1950–1953. Pierre Broué, *Le parti bolchevique*, Paris, 1963. Gérard Walter, *Lénine*, Paris, 1950. Leon Trotsky, *Ma vie*, Paris, 1953. Louis Fischer, *Lénine*, Paris, 1966. Henri Guilbeaux, *Le portrait authentique de Lénine*, Paris, 1924. Pierre Broué, David King, *Trotsky*, Paris, 1979. *Lénine*, Coll. "Génies et réalités," Paris, 1972. Jean Bruhat, *Lénine*, Paris, 1960. Maxim Gorky, *Pensées intempestives*, Lausanne, 1975 and Paris, 1977.

Chagi sovietov, 1917–1936, Moscow, 1977; *1937–1957*, Moscow, 1981. *Sovjetische fotografen, 1917–1940*, Berlin, 1980. *Pionniers de la photographie russe soviétique*, Paris, 1983. *Dix ans de photographie soviétique*, Moscow, 1928. *Exposition d'oeuvres de maîtres de l'art soviétique*, Moscow, 1935. *Première exposition d'art photographique d'URSS*, Moscow, 1937. Sergei Morozov, *Sovietskaya boudozhestvennaya fotografiya 1917–1957*, Moscow, 1958; *Tvorcheskaya fotografiya*, Moscow, 1985.

Publications consulted: *L'Illustration* (1905–1924), *Pravda, Ogonyok, Sovietskoe foto, Proletarskoe foto, Sovietsky fotografichesky al'manak, Fotograf, Novy lef*.

Films: *Lénine par Lénine*, by Jacques Aujubault, Marc Ferro, and Pierre Samson, 1970 (INA).

Scenes of the Revolution

S.M. Eisenstein, *Oeuvres*, 7 vols., Paris, 1975–1985; *Octobre*, entire script, Paris, 1971. *Le cinéma russe et soviétique*, under the direction of Jean-Loup Passek, Centre Pompidou, Paris, 1981. Jay Leda, *Kino, Histoire du cinéma russe et soviétique*, Lausanne, 1976. Luda and Jean Schnitzer, *Histoire du cinéma soviétique*, Paris, 1979.

The attack: the spectacle was described in *Vestnik Teatra*, no. 75, November 30, 1920, and by Evreinov himself in *Krasny militsioner* (The red militiaman, no. 14, 1920) and then in *Le théâtre en Russie soviétique* (Paris, 1946). Another account is

given in *Istoriya sovietskogo teatra* (History of the Soviet theater), Leningrad, 1933. Other photographs of the spectacle and of Annenkov's preliminary sketches are found in *Agitatsionno-massovoye isskoustvo, oformlenie prazdrestv*, Moscow, 1984. Of course, the photograph does not appear in the first edition of John Reed's book (New York, 1919).

Mussolini, Master of Images

L'Italie fasciste, Instituto Luce, Rome, 1932. *Exposition de la révolution fasciste*, Rome, 1933. *Enciclopedia italiana. Giorgi Pini and D. Susmel, Mussolini, l'uomo e l'opera*, 4 vols., Florence, 1953–1958. Renzo de Felice, *Mussolini*, 3 vols., Turin, 1965–1967. Renzo de Felice, Luigi Goglia, *Storia fotografica del fascismo*, Milan, 1981; *Mussolini, il mito*, Milan, 1983. Umberto Silva, *Ideologia e arte del fascismo*, Milan, 1973. Massimo Cardillo, *Il Duce in moviola*, Bari, 1983. André Brissaud, *Mussolini*, 3 vols., Paris, 1983. Dino Biondi, *La fabrica del Duce*, Florence, 1967. Max Gallo, *L'Italie de Mussolini*, Paris, 1964. Pascal Gallo, *Mussolini en images*, Brussels, 1978. Pierre Milza, *Le fascisme*, Paris, 1986. *Elements pour une analyse du fascisme*, seminar by Maria-Antonietta Macciocchi, Paris, 1976. *Le cinéma italien, 1905–1945*, under the direction of Aldo Bernardini and Jean A. Gili, Centre Pompidou, Paris, 1986.

Magazines and newspapers consulted: *L'Europeo, Epoca, Storia illustrata, Il lavoro fascista, La Stampa, La difesa della Razza. Revue d'histoire de la Deuxième Guerre mondiale*, no. 26, April 1957, "L'Italie mussolinienne."

Films: *Fascista*, by Nico Naldini (1974). *Le fascisme en Italie* (Cinémathèque de l'enseignement public). *Histoire du fascisme* (Musée pédagogique). *La montée du fascisme*, by G. Bruley (1956).

The Third Reich and Its Images

Heinrich Hoffmann, *Hitler Wie ihn Keiner Kennt*, Munich, 1932, 1934; *Jugend und Hitler*, 1935; *Hitler in Seiner Heimat*, 1938; *Mit Hitler im Western*, 1940; *Mussolini erlebt Deutschland*, 1937; *Hitler Was My Friend*, London, 1955. Zbynek Zeman, *Nazi Propaganda*, Oxford, 1973. *Nazi Propaganda*, edited by David Welch, London, 1983. Joachim C. Fest, *Hitler*, 2 vols., Paris, 1973. John Toland, *Hitler*, 2 vols., Paris, 1978. Curt Riess, *Joseph Goebbels, A Biography*, London, 1949. Albert Speer, *Au coeur du troisième Reich*, Paris, 1971. Werner Maser, *Hitler inédit*, Paris, 1975. Alfred Grosser, *10 leçons sur le nazisme*, Paris, 1976; *Hitler, la presse et la naissance d'une dictature*, Paris, 1972 and 1986.

Berthold Hinz, *Art in the Third Reich*, New York, 1979. Adelin Guyot and Patrick Restellini, *L'art nazi*, Brussels, 1983. Francis Courtade and Pierre Cadars, *Histoire du cinéma nazi*, Paris, 1972. Siegfried Kracauer, *De Caligari à Hitler*, Lausanne, 1973. Veit Harlan, *Le cinéma selon Goebbels*, Paris, 1975.

Icons of the Stalinist Cult

Boris Souvarine, *Staline*, Paris, 1935, republished 1977. Robert C. Tucker, *Staline révolutionnaire*, Paris, 1975. Lily Marcou, *Les staline*, Paris, 1979. Emmanuel d'Astier de la Vigerie, *Sur Staline*, Lausanne, 1967. Georges Bortoli, *Mort de Staline*, Paris, 1973. Hélène Carrère d'Encausse, *Staline, l'ordre par la terreur*, Paris, 1979. Jean-Jacques Marie, *Staline*, Paris 1967. Boris Bajanov, *Bajanov révèle Staline*, Paris, 1977. Isaac Deutscher, *Stalin, A Political Biography*, London, 1967. Isaac Deutscher and David King, *The Great Purges*, Oxford, 1984. Branko Lazitch, *Le rapport Khrouchtchev et son histoire*, Paris, 1976. Leon Trotsky, *Staline*, 1948. Pierre and Irène Sorlin, *Lénine, Trotsky, Staline, 1921–1927*, Paris, 1961. A.B. Ulam, *Staline, l'homme et son temps*, 2 vols., Paris, 1977. *Les procès de Moscou, presented by Pierre Broué*, Paris, 1964.

Au pays des Soviets, presented by Fred Kupferman, Paris, 1979. Alexander Solzhenitsyn, *L'archipel du goulag*, 3 vols., Paris, 1974–1976.

Branko Lazitch and Milorad Drachkovitch, *Biographical Dictionary of the Comintern*, Stanford, 1973. *Paris-Moscou*, Centre Pompidou exhibition catalog, Paris, 1979. "Le cinéma stalinien," *Cinématographe*, no. 55, 1982. "La guerre froide," *La documentation photographique*, no. 6045, February 1980. "L'URSS depuis 1945," *La documentation photographique*, no. 6076, April 1985. André Bazin, "Le mythe de Staline dans le cinéma soviétique," reprinted in the collection *Le cinéma français de la libération à la nouvelle vague*, Paris, 1983.

Films: *The Red Tsar*, series by Paul Neuburg (TWT, 1978). *Staline*, by Jean Aurel (1985).

Publications consulted: *L'URSS en construction, L'Union soviétique, Pravda, Ogonyok, Izvestia*.

The Maoist Saga

Edgar Snow, *Living China*, London, 1938; *Red Star Over China*, London, 1937, New York, 1971. Nym Wales, *Inside Red China*, New York, 1939; *Red Dust: Autobiographies of Chinese Communists*, Stanford, 1952.

Harold R. Isaacs, *La tragédie de la révolution chinoise*, Paris, 1967. Stuart R. Schramm, *Mao Tse-tung*, London, 1966 and Paris, 1972. Agnes Smedley, *Battle Hymn for China*, New York, 1943; *The Great Road: The Life and Times of Chu Teh*, London, 1958 and Paris, 1969. Jacques Guillermaz, *Histoire du parti communiste chinois*, 2 vols., Paris, 1968 and 1975; *Le parti communiste chinois au pouvoir 1949–1972*, Paris, 1972. Simon Leys, *Les habits neufs du président Mao*, Paris, 1971; *Ombres chinoises*, Paris, 1974; *Images brisées*, Paris, 1976. Claude Hudelot, *La longue marche*, Paris, 1971. Roxane Witke, *Comrade Chiang Ch'ing*, Boston, 1977. Ross Terrill, *Madame Mao*, Paris, 1984. *Pékin, un procès peut en cacher un autre*, Paris, 1982. Patrice and Chantal Fava, Jean Leclerc du Sablon, *Chine*, Paris, 1977. Emile Guikovaty, *Mao, réalités d'une légende*, Paris, 1977.

Lois Wheeler Snow, *Edgar Snow's China*, London, 1981 (hommage to Snow, but most of its photos are from China and are retouched!). *Le cinéma chinois*, under the direction of Marie-Claire Quiquemelle and Jean-Loup Passek, Paris, 1985. Régis Bergeron, *Le cinéma chinois*, Paris, 1983. Donald W. Klein, Anne B. Clark, *Biographic Dictionary of Chinese Communism 1921–1965*, Cambridge (USA), 1971.

Publications consulted: *La Chine, Littérature chinoise, Pékin information, La Chine en construction, La photographie chinoise*.

From the Prague "Coup" to the Prague "Spring"

André Fontaine, *Histoire de la guerre froide*, Paris, 1965. Hubert Ripka, *Le coup de Prague*, Paris, 1949. François Fejtö, *Le coup de Prague 1948*, Paris, 1976; *Histoire des démocraties populaires*, Paris, 1969. Karel Kaplan, *Procès politiques à Prague*, Brussels, 1980. Jean-Pierre Rageau, *Prague 48, Le rideau de fer s'est abattu*, Brussels, 1981. Artur London, *L'aveu*, Paris, 1969. Milan Kundera, *Le livre du rire et de l'oubli*, Paris, 1979. Lili Marcou, *Le Kominform*, Paris, 1977. Pavel Tigrid, "The Prague Coup of 1948, The Elegant Takeover," in *The Anatomy of Communist Takeovers*, Munich, 1971. Karel Kaplan, *Der Kurze Marsch, Kommunistiche Machtübernahme in des Tchechoslovakia 1945–1948*, Munich, 1981; *Dans les archives du Comité Central*, Paris, 1978. Edward Taborsky, *Communism in Czechoslovakia 1948–1960*, Princeton, 1961. H. Kuhn, O. Böss, *Biographisches Handbuch der Tchechoslowakei*, Munich, 1961.

Newspapers and magazines: *Reporter* (1968–1969). *Literarni listy* (1968–1969). *Student* (1968). *Photo*, Paris, no. 34, July 1970 (Yves Bourde, "Les faussaires de la

photo"). *Index of Censorship*, vol. 14, no. 6, December 1985 ("Falsified photographs"). *Svedectvi*, No. 77, 1986.

Asian Lives and Battles

Bernard Fall, *Diên Biên Phu, un coin d'enfer*, Paris, 1968. René Bail, *Indochine 1953–1954, les combats de l'impossible*, Paris, 1985. *Roman Karmen V Vospominaniak sovremiennikov*, Moscow, 1983. Roman Karmen, *Vietnam zrashetsia: zanik sovietskovo kinooperatora*, Moscow, 1958. Jules Roy, *La bataille de Diên Biên Phu*, Paris, 1963. *Diên Biên Phu*, 32-minute broadcast in the series "Cinq colonnes à la une," commentary by Colonel Bigeard and Pierre Schoendoerffer (1964, INA, no. 645839).

On the financing of North Korean propaganda, see *Le Monde*, October 19, 1976, and October 20; and *Libération*, November 16, 1976. The cult of personality and paid advertising are discussed in an article by Philip Oakes, "The Canonization of Comrade Kim" (*The Sunday Times*, September 30, 1973).

Robert W. Chandler, *War of Ideas: The US Propaganda Campaign in Vietnam*, Boulder (Colorado), 1981.

Balkan Revolutions

Emile Guikovaty, *Tito*, Paris, 1979. Vladimir Dedijer, *Dnevnik*, Belgrade, 1951; *Tito parle*, Paris, 1953. Milovan Djilas, *Tito mon ami, mon ennemi*, Paris, 1980. Thomas Schreiber, *La Yougoslavie de Tito*, Paris, 1977. Branko Lazitch, *Tito et la révolution yougoslave*, Paris, 1957. Phyllis Auty, *Tito*, Paris, 1972. David Smiley, *Albanian Assignment*, London, 1984. Shefqet Peci, *Kujtime dhe Dokumenta nga lufta nacional-çlirimtare*, Tirana, 1959. Hulesi Topollaj, *Partizanët e gramozit*, Tirana, 1968. Enver Hoxha, *Avec Staline, souvenirs*, Tirana, 1984; *Les titistes*, Tirana, 1982.

Publications consulted: *Shqiperia e re, L'Albanie nouvelle; Ylli*.

The Optical Illusions of Cuban History

Luis Conte Aguero, *Fidel Castro, vida y obra*, Havana, 1959. Fidel Castro, *La historia me absolverá*, Havana, 1960, 1961, 1964, 1973, and 1975 editions. Ernesto "Che" Guevara, *La guerra de guerrillas*, Havana, 1960; *Tres combates*, Havana, 1965; *Pasajes de nuestra guerra revolucionaria*, Havana, 1963; *El Diario del Che en Bolivia*, Paris, 1968; *Le socialisme et l'homme à Cuba*, Havana, 1967. Carlos Franqui, *Ritrato de familia con Fidel*, Barcelona, 1981. Maurice

Halperin, *The Rise and Decline of Fidel Castro*, Berkeley, 1972. K.S. Karol, *Les guerrilleros au pouvoir*, Paris, 1970. Robert Merle, *Moncada, le premier combat de Fidel Castro*, Paris, 1965. Herbert Matthews, *Revolution in Cuba*, New York, 1975. Mario Llerena, *The Unsuspected Revolution, The Birth and Rise of Castroism*, Ithaca, 1978. Theodor Draper, *La révolution de Castro*, Paris, 1963. Carlos Alberto Montaner, *Informe secreto sobre la revolución cubana*, Madrid, 1976. Juan Vivès, *Les maîtres de Cuba*, Paris, 1981. Armando Valladares, *Mémoires de prison*, Paris, 1986. Francisco Arrabal, *Lettre à Fidel Castro: an "1984,"* Paris, 1983.

Publications consulted: *Bohemia*, from 1954 to 1968; *Hoy, Revolución, Cuba* (renamed *Cuba internacional*); *Granma*, weekly selection from *Granma* in French; *Casa de las Americas. Paris-Match*, 1959–1968. *Life*, 1959–1964.

Files: *Tribunal Cuba*, Internationale de la Résistance, Paris, April 1986.

The Soviet Tradition

Nikita Khrushchev, *Souvenirs*, Paris, 1971. Wolfgang Leonhard, *N.S. Khrouchtchev, ascension et chute d'un homme d'état soviétique*, Lausanne, 1965. Pierre Daix, *L'avènement de la nomenklatura, la chute de Khrouchtchev*, Brussels, 1982. Hélène Carrère d'Encausse, *Le pouvoir confisqué*, Paris, 1980. Michel Heller and Alexandre Nekritch, *L'utopie au pouvoir*, Paris, 1982. James E. Oberg, *Red Star In Orbit*, New York, 1981. Jaurès Medvedev, *Soviet Science*, New York, 1978. Leonid Vladimirov, *Russian Space Bluff*, London, 1971.

Publications consulted: Soviet: *Pravda, Izvestia, Ogonyok, Etudes soviétiques*. Others: *Aviation Week and Space Technology. Spaceflight, Air and Cosmos, La documentation photographique* (no. 6045, February 1980, "La guerre froide" (no. 6076, April 1985, "L'URSS depuis 1945"), *Problèmes politiques et sociaux* (La documentation française), *Est et Ouest*.

When Methods Are Exported

Grierson on Documentary, edited by F. Hardy, London, 1946. F. Hardy, John Grierson, *A Documentary Biography*, London, 1979. *Creative Camera*, no. 247-248, July-August 1985, "Information and propaganda." Philippe Robrieux, *Maurice Thorez, vie secrète et vie publique*, Paris, 1975; *Histoire intérieure du parti communiste français*, 4 vols., Paris, 1980–1984. André Marty, *L'affaire Marty*, Paris, 1955. Charles Tillon, *Un "procès de Moscou" à Paris*, Paris, 1971. Auguste

Lecoeur, *L'autocritique attendue*, 1965; *Le PCF continuité dans le changement*, Paris, 1977.

Liaisons, no. 23, December 16, 1963. For information on newsphotos see the *Presse actualité* interviews with Gérard Blanchard (no. 101, May 1975), Albert Plécy, Paul Almassy, Jules Coritti and Anne-Marie Thibault-Laulan (no. 113, November 1976).

Publications: *Presse actualité, Creative Camera, News Photographer, National Press Photographer*.